1000 BEST WEDDING BARGAINS

Sharon Naylor

SOURCEBOOKS, INC.
NAPERVILLE, ILLINOIS

Published by Sourcebooks, Inc.
P.O. Box 4410, Naperville, Illinois 60567-4410
(630) 961-3900
fax: (630) 961-2168
www.sourcebooks.com

Library of Congress Cataloging-in-Publication Data
Naylor, Sharon.
 1000 best wedding bargains / by Sharon Naylor.
 p. cm.
 Includes index.
 ISBN 1-4022-0298-9 (alk. paper)
 1. Weddings—Planning. 2. Weddings—Costs. 3. Bud-
gets, Personal. 4. Deals. I. Title: One thousand best wed-
ding bargains. II. Title.
HQ745.N3868 2004
395.2'2—dc22

 2004012303

 Printed and bound in the United States of America
 ED 10 9 8

For Lucky

TABLE OF CONTENTS

ACKNOWLEDGMENTS

Many thanks to my editor at Sourcebooks, Deborah Werksman, for her vision, drive, and dedication to this book series and for inviting me to be a part of it. And special thanks to Kelly Barrales-Saylor at Sourcebooks, whose editing guidance was golden.

Also, much gratitude to my agent-supreme Meredith Bernstein; my publicist Scott Buhrmaster; my literary attorney Sallie Randolph; my Web master Mike Napolitan; and my helpful colleagues at the American Society of Journalists and Authors, the Association of Bridal Consultants, and the International Special Events Society. You are all gems.

And welcome to the world Nicholas Darrin, Alexandria Tatiana, and Samantha Paige!

Introduction

Weddings can be expensive. According to several national surveys, the average bride and groom's wedding budget hovers between $25,000 and $45,000. That would be a nice down payment for a house, or an amazing two-month long honeymoon in Belize. It could pay off your school loans or get you a new car. These are the things that so many newly engaged couples think about when the shocking reality of the wedding's cost hits them square in the face. It's so much money. Do we really want to spend so much on JUST ONE DAY?

The answer to that is it's not just one day. It's not just a party. It's a supremely important ritual to celebrate the joining together of you and your fiancé, and it's packed with meaning, sentiment, and importance for both you and your families. Couples who let the money issue get to them and

either eloped or "played it small" with their weddings ultimately have some nagging regrets that they didn't find a way to make their dream wedding a reality. And these are the ones who renew their vows a year later to have the big event, the gown, the cake, the champagne, and the pictures they'll someday show their kids.

Are the memories you'll make at the wedding, those that last forever and bond you for the rest of your lives, worth the investment? Absolutely. Do you need to spend $45,000 for that? No way. You can have your dream wedding for a fraction of that price, using the secrets within this book.

Use these ideas, and you can copy expensive ideas celebrity brides and grooms have shown off on television specials and in the pages of magazines. You can have twice the wedding for half the cost. You can "trick" your guests into thinking you spent a fortune on the reception, your gown, and the cake when, in fact, you found great ways to save without the savings showing. And you can get many things for free.

If you aren't the star of a reality dating show, a bona fide movie star with more money than several small countries combined, and if a network isn't paying for your wedding, then you can use the following insider wedding planning secrets to make your budget go a long, long way—no matter what your money situation may be.

This is great news if you're among the many couples who will be paying for the wedding themselves, with no financial help from Mom and Dad. It's great news if you are getting a cash infusion from your parents, or even from the groom's

parents. The more ways you can find to save them money along the way, the better for all of you. It's just ridiculous not to search for and implement budget-saving tips for your wedding when there are so many easy ways to do it!

You can beat the money trap for your wedding. You can erase your financial fears and guilt. You can plan your wedding without getting buried in debt or putting your dreams of owning a house on hold for years. And you can achieve more for your wedding dream starting right this moment. You have all the answers right here in your hands, just waiting for you. Let's get started...

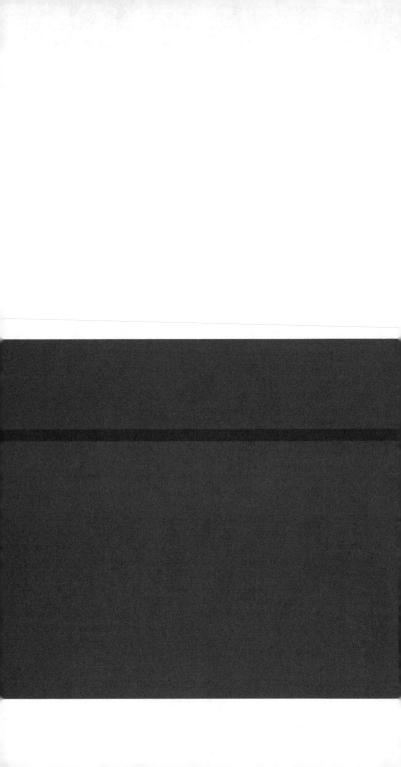

Part One:

Setting the Stage for
Big Budget Savings

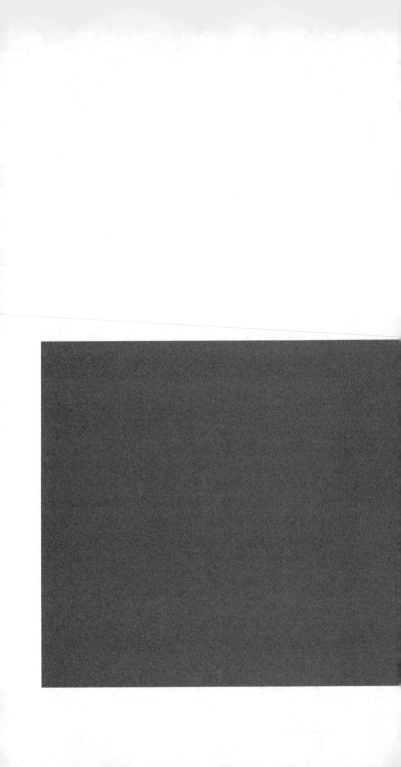

1

Size, Style, and Formality

Call these the Big Three. So much of what your wedding will cost depends—obviously—on how many guests you will invite, the type of wedding you'll have, and how formal it will be. When you make these decisions, you're laying the groundwork for every one of your decisions about the wedding. For instance, a formal wedding will call for a formal full-length gown, which is extremely likely to cost a few thousand dollars more than the pretty white sundress you'd wear to your informal outdoor wedding. Inviting three hundred guests to your wedding means you'll spend more than if you invited twenty-five or fifty guests.

But it's a lot more complicated than these simple formulas, as you'll soon find out. If you plan an informal wedding for twenty-five guests all accompanying you to Belize, it could still cost

more than a formal wedding for one hundred back in your hometown. See how that works?

All the puzzle pieces fit together differently, with each of your big decisions working together in the way that fits your wedding dream best. Not every category has to be "the least expensive option possible." That would leave you with ten guests eating hot dogs in your backyard. Not your wedding dream, I'd imagine. So go through all of the options in each of the next few chapters, fit your puzzle pieces together, and lay the groundwork for a wedding that allows you more for your dollar in all of the remaining categories.

YOUR WEDDING'S SIZE

We've established that it's not an automatic guarantee that you'll save more if you have a smaller guest list, because the second half of that equation is how formal a wedding you're planning. You can spend a fortune with the most elegant, formal wedding decorated in a sea of white imported roses, the finest champagne, a designer dress, and only fifty wedding guests. Once that's established, then you're dealing with the original question of how many guests you will invite. That's where you get the price per person, and that's where your totals start adding up.

Once you have all your ducks in a row and find out, say, that your price-per-head is $55, then you can look at the number of guests you want to invite. Obviously, at this point, two hundred guests will cost you more than one hundred guests. That's where the pure math comes in. But what's important for you to realize is that you

must not sacrifice the most important part of your wedding just to save money. And that most important part is the people with whom you want to share it. People are more important than money. For many brides and grooms, they'd rather have a less formal wedding than even dream of cutting certain relatives and friends from their guest list. They'd rather have their friends from college with them than buy a designer wedding gown.

Consider your guest list to be a defining factor for your wedding plans, not the other way around. At minute one, right now, you should create your desired guest list and then use the following tips to make your budget work.

1. If you're considering planning a destination wedding, it might already be in your mind that your guest list will be limited to just a few close family members and friends. Most brides and grooms limit this guest list to under twenty-five people, which obligates fewer of your loved ones to shell out for a trip to the Cayman Islands to join you (or saves you a fortune if you're offering to pay for their airfare and lodging!), and also costs you less for those per-guest catering fees at the reception site.

2. Don't forget that the wedding reception is not the only event for which you will be paying a per-guest price. With the spread of wedding weekend events, like cocktail parties, brunches, and picnics, you can wind up paying a small fortune for the other events you'll invite your guests to. So keep that added expense in mind as you decide on your total guest tally—you will be paying for more than one party for each of them.

3. Choose a smaller bridal party with fewer bridesmaids and ushers. With four bridesmaids in your party instead of eight, that's four fewer presents you'll have to buy, perhaps even four fewer gown purchases and tux rentals for the guys if you're among the couples who generously pick up their bridal parties' expenses.

4. A smaller guest list can open doors at less expensive wedding locations, like restaurant party rooms that can hold only eighty-five guests as a matter of size and safety standards. At sites like these, catering costs and wedding packages are much more likely to be lower-priced per guest than at the cavernous ballrooms that can hold your 300+ wedding guests. At some of these smaller-sized, but still equally beautiful locations, it can be as much as 45 percent less per person.

5. Leave kids off the guest list for the official reception. ● Hosting kids other than the flower girls and ring bearer adds up when you consider that caterers will often charge you a full guest fee for each child in attendance. Even a caterer's cut-rate children's fee is often too pricey to justify. Why pay $50 per child when that child is just going to pick on a few bites from the buffet and then run around with the other kids? Your guests' kids can be invited to other, less expensive wedding week-end events like picnics and cookouts. You can pay for a kids-only pizza party and DVD movie night with hired babysitters during the wedding celebrations for less than what it would have cost to pay for just one or two of those kids to attend the reception. It's a huge savings for you, and parents will enjoy the kid-free night.

6. Fewer guests, naturally, means having to buy fewer favors. The choice is up to you ● whether you'd like to translate that savings into getting better favors for the smaller number of guests you do invite!

YOUR WEDDING'S STYLE

An upscale wedding with tuxedoed waiters, a five-course dinner, and the best of everything will naturally cost more than an informal cocktail party, right? Nope. If you make the right choices in each category from menu to drinks to décor to desserts, you have the power to plan a gorgeous formal wedding—lacking nothing you ever dreamed of. You can have a formal wedding and perhaps spend less than other couples out there having informal weddings without access to the money-saving ideas in this book.

7. Skip the five-course sit-down dinner and just plan a lovely, elaborate, and delicious cocktail party reception. Here's where you find out your next big secret: doing something different from every other bride and groom's wedding will add panache to your event, making it more valuable in the eyes of your guests! You're giving them a unique experience, not a re-run of every other wedding they'll attend that year (and for the past five years before that). So choosing a cocktail party reception is not "cheaping out"— don't fear that your guests will think that. They'll be thrilled at your innovation, at the exotic serving stations you've selected, at the different style of your wedding, and how happy they are that they don't have to sit down to the same old menu this time. Go different and save money without the savings showing. Surprising your guests adds more impact than expense does.

8.

Consider a traveling cocktail party, another new surprise for guests who will love the natural mingle factor and the different styles of menu attractions at each stop along the way. Here's how it works: at a traveling cocktail party, your guests may have champagne and hot passed hors d'oeuvres on the terrace. After an hour, you'll all move to poolside where a tropical buffet has been set up: shrimp cocktail, clams on the half shell, exotic fruits, and the like. After an hour, you'll all move inside to a party room where a hot buffet has been set up. Finally, you'll all move back out to the terrace for cake, champagne, and desserts.

Using just a cocktail party menu, you can save anywhere from 15 to 45 percent on your per-guest charges, depending on the menu you select. Take out the fees for a live band providing three hours of dancing time, and that's another few thousand dollars removed from your budget. All you need is that one pianist or guitarist playing at each of your stops: a talented performer can play classical choices at the first stop, island music at the second, Latin-inspired music at the next, and back to classical at the last. And you're only paying for one performer. It's a perk.

9. A dessert and champagne party is the ultimate in style and class these days, also giving guests something different by way of the decadent menu and freedom from the sit-down dinner. Rather than meal-type food and hors d'oeuvres, you'll offer wedding cake, chocolate mousse, crème brulee, bananas foster, chocolate-dipped strawberries, fresh whipped cream, pastries...ahhhh! Giving your guests a buffet of desserts and fine champagne is a welcome change, pure pleasure, and can translate into a mouth-watering 40 to 50 percent smaller budget than if you'd gone with the sit-down dinner! Someone pass the truffles!

10. A brunch reception is another unique twist, something new for your guests, and a wide range of breakfast foods like eggs benedict, crème brulee waffles, and other morning treats most people don't get every day, plus hot servings of seafood, carving stations with ham, and a full dessert bar. It's a hot new trend, and one that saves a fortune per guest. Plus, very often, the champagne and coffee are free.

11. Don't forget the option of a casual beach party or backyard barbecue if you're more the laid-back type with guests who would enjoy themselves more without having to get all dressed up.

IS OUTDOORS A BETTER OPTION?

Is an outdoor wedding always less expensive than a traditional indoor wedding in a ballroom? No, that's not a hard-and-fast rule. When you add in all the things you'll need to rent (like tents, tables, chairs, silverware, china, lights, etc.) it can add up to even more. So don't rule this option out, as you can make it work in your budget, but don't look at this as an always-cheaper answer to your prayers. The same goes for an at-home wedding. Once you add in extra rental expenses and the costs for before and after site cleaning, it can run you more in the final budget.

12. For ethnic weddings, check out ethnic associations and cultural clubs where you can find terrific bargains like inexpensive catering that's authentic and homemade, but still at discount prices traditional wedding caterers can't beat. Perks are often members-only, so sign up now to qualify for discounts on food, drinks, even bargain prices on hiring the group's own authentic musicians, singers, dance groups, and entertainers. In addition, you can get free, borrowed ethnic wedding items like ceremonial robes, crowns, and décor items. Ask relatives for referrals or do an online search to find these active ethnic associations. Beyond getting bargains, you may just re-connect to your roots, too.

13. For a theme wedding, the savings are available through all the categories of this book, and you may find savings out there in the world of rentals because you're going with nonbridal requests. As you'll find out, very often prices are higher when you're shopping for wedding items than when you're shopping for party items. Once you slap on the label of "bridal" for something you want to rent or buy, the price may be higher. That's the allure of theme weddings...it may be cheaper to rent theme items from a rental shop just because you've veered away from the white, lacy stuff.

14. For a destination wedding, you might find a fabulous, all-inclusive destination wedding package out there that gives you your dream island or international wedding at half the cost of the wedding you would've planned back home. This one takes research, but as evidenced by the huge upswing in destination weddings these days, this style of wedding is one with a financial advantage.

FORMALITY

Ultra-formal and formal weddings can be done with every high-priced item out there, but with the smaller guest list lightening the financial load. We've covered how every style and formality of wedding can be done on your realistic budget level, and how going with a different style of wedding can allow you the budget space of going more formal with it (such as that formal traveling cocktail hour). Now let's look at the issue of formality from a different angle.

15.

Don't feel like you have to compete with your sister's or friends' formal weddings. What's your personal formality style and preference? The wedding has to be all you, so don't try to fit yourselves into a too-formal wedding just because that's what everyone else expects of you, or is pressuring you to have. A unique, less formal wedding might be more a reflection of who you both are and how you like to celebrate. Your less formal choices (like forgoing the ultra-formal twelve-piece orchestra in favor of a great jazz trio at one-third the price) translate into terrific bargains that still impress your guests.

16.

Let your location dictate the formality of your wedding. Sometimes when you're searching through unique and nonbridal settings you'll fall in love with a place and then that will show you the setting for the perfect informal garden wedding or the perfect formal wedding at a rustic barn that has been decorated with fine linens, flowers, and a rented chandelier. (Note: inexpensive rustic locations are the new hot pick of wedding locations, since coordinators and decorators can turn them into something special like an unexpected blend of down-home country and elegant formal. Plus, there's no $10,000 site reservation fee like at some botanical gardens!)

17.

If you do wish to go informal and less expensive for the wedding, you can get that taste of high society by planning the engagement party as a formal affair for a smaller collection of your closest relatives and friends. It's the best of both worlds all enveloped in your extensive wedding experiences throughout the year.

JUST SAY NO

Here's a tip that's going to save you a bundle in every area of your wedding plans: the ability to gracefully say "No" when parents or others try to get you to make changes to your plans, add in just a few more flower arrangements, add another serving station, go more formal, etc. So many brides and grooms get so much outside interference, especially when parents are helping to pay for the wedding, that the plans and the budget can spiral out of control when they say "Yes" to just a few, and cringe afterward when the wedding budget has skyrocketed out of control. This is your time to set your boundaries and make good use of your assertiveness. When someone starts nudging you to make a major (or minor) change you don't want, just simply say "You know what? We've been dreaming about this day for a long time, and we already know what we want. I appreciate your input, but we're going another way with that." Then smile graciously and continue on, congratulating yourself for defending your own wedding dream.

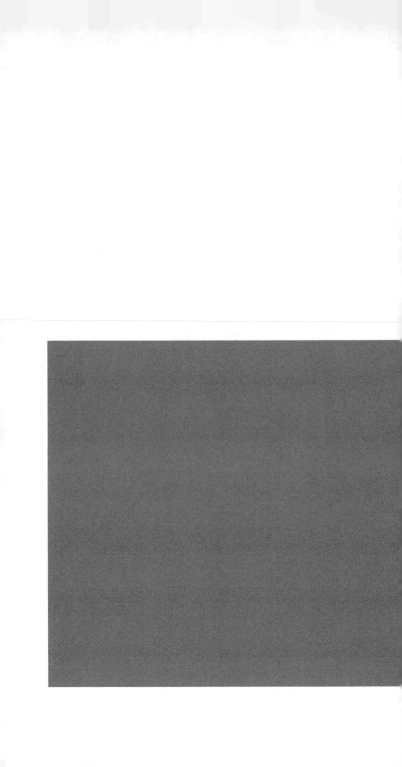

Paying for the Wedding

The money has to come from somewhere. Who's contributing to the wedding fund? You? Your parents? His parents? Here's where you take your financial contribution sources, add it all up, and then see where you can find even more advantages for your wedding foundation. Remember, it's not about what you have to work with, it's sometimes who you have working with you that's the real advantage. Most weddings today are paid for and planned by the bride and groom, the bride's parents, and the groom's parents. With weddings so expensive, the more contributors, the better. So many brides and grooms are stepping away from the old traditions of the bride's family paying for nearly everything and opening up the doors to additional financial contributors, including—in many cases—their grandparents who are kind enough to offer their help.

If you're among the brides and grooms who are the independent types—you want to pay for your own wedding, and thus plan it your way completely—look at how other brides and grooms are going about this impressive financial undertaking. They're planning long engagements, one to two years in length, during which time they're saving for the wedding. It can be done, and done quite well for small to large weddings. Many couples tell me that it's worth the wait in order to avoid parental hassles with the money and the plans. Not having to hear "We're paying for it, so we want it our way" from pushy parents? Priceless.

18. Tax refund checks make the perfect cushion for a wedding budget. See if yours and your fiancé's would add even more value for your wedding.

19. Once you get engaged, it seems everyone you know offers their help if you should need it. Take them up on it! Grandma can make her lasagna for the rehearsal dinner. Cousin Paul the concert pianist can perform the music at your ceremony. Your friend with the great convertible can drive you and your new husband from the ceremony to the reception, top down, and a big "Just Married" sign on the back of the car. Your aunt with the great shore house might offer up her oceanside house as the setting for your wedding and get to show off her fabulous interior decorating to the

whole family. Make these contributions the donor's wedding gift to you, and know that participating in your wedding is another kind of gift to them: they become a special part of the day. They have also saved you thousands of dollars at the same time.

HOW TO ASK FOR FAVORS

20. We don't want to obligate our friends and relatives to work on the wedding day, so use your best judgment when you approach Aunt Sarah about your using her shore house. It's best to be direct: "Aunt Sarah, this may be a reach, but we love your shore house so much...if only we could have our wedding there!" Aunt Sarah might offer up the house right away, all too happy to help. If you're sensing her hesitation—perhaps she just had all-new white carpets put in—then let her off the hook by asking her for referrals to restaurants and other ocean view places she's familiar with where you might hold your wedding. She's released from a too-big obligation, you tried your best, and she still gets to help by perhaps recommending the perfect beach-side restaurant where you will hold your wedding. If you don't ask, you don't get. Don't be shy, but be considerate and always provide the gracious "out."

21. Use your networking skills. Think about who you might know in the flower industry, in catering, which of your friends owns a bed and breakfast. Who's married to a manager at the Hilton? Networking is how you get things done in business or a job search, so use nepotism to your advantage. At my own wedding, my parents went to high school with the man who owns the nicest restaurant in town. We dropped in for a drink with him, and he gave us 50 percent off each guest's dinner just for the honor of hosting his old friends' daughter's wedding. That's how it works. So brainstorm your network of friends, family, and your own six degrees of separation links to see who you might be able to ask for a favor. Encourage your parents and other close loved ones to do the same with their own networks. The more people you have searching their contacts for you, the better.

22. A big new trend in wedding planning for less is bartering. If you build websites for a living, perhaps you might offer your services for free to that caterer you're approaching in exchange for a discount off your order (or your order for free!). If you're an accountant, that calligrapher might see more value in having you do her estimated tax assessment than the time it would take her to address your envelopes. The big trade-offs are taking place all over the country, and more and more brides and grooms are trading their time and skills to gain services and items for their

weddings. See if you have something to offer, and use your negotiating skills and sales savvy to perhaps swing big discounts and freebies your way.

Again, see if your groom or your parents might be able to do the same for you. They may have specialized skills they can barter out as well, like pet grooming, baking, yard work, taking publicity portraits of small business owners, and so on.

HIRE FOR EXPOSURE?

It might be tempting to approach beginners in various wedding fields, thinking that you can hire them for peanuts in exchange for the value of their having worked your wedding and using it in their portfolio. Sure, that's an attractive offer for them, but always hire a professional based on their talent and quality of work, not the fact that they're "cheap labor." This isn't a game. Cutting too deep can leave you with a wobbly cake, a spine-hurting violin concerto with sour notes, and maybe even a caterer who gets overwhelmed at serving over one hundred guests at one time. This is your wedding, so consider every investment an important one. Never cheap out in your frenzy to save money. Hire all of your experts for their proven talent.

23.

See what you can get for free. Use your smart negotiating skills to ask for a few freebies here and there—a free tux rental for the groom if your eight groomsmen are renting at that establishment, coffee at the dessert hour, even a welcome cocktail party at the hotel upon guests' arrival. Here's another little secret and a powerful one: professionals in the wedding industry depend on word-of-mouth referrals to bring in their clients. If they make you happy by giving you a free cocktail party or tux with a smile, you're going to recommend them to your four sisters and your eight friends. So they have a vested interest (no tux pun intended there!) in making you happy. Knowing this gives you a tremendous edge, as it will certainly make you a bit braver when it comes to asking for freebies. If you ask at all of your wedding experts' offices, you could save thousands of dollars. You just have to do it in a nice, respectful way. Wedding professionals are not stupid. Hundreds have told me about the bossy bride and the grating groom who tried to steamroll them into discounts, both of which they turned down and either refused to work with or didn't do as much as they could to help them save money or get the best deal. Shady? No, it's reality. Attract more with a "honey" personality than with a "vinegar" personality and you'll get further than you thought.

24. See what you can get for free for yourself, not through an expert. If you can use your own convertible, that's thousands of dollars back in your budget. If you can have your mom's wedding gown altered instead of buying a new one, that's thousands more back in your pocket. This book is filled with freebie ideas where your best resource is you, so start recording the possibilities now and be open to even more along the way.

NO CUTTING CORNERS ON THE IMPORTANT THINGS

Never allow the hunt for discounts to cost you something. Skipping insurance? Not a wise move. Not tipping as much as you should? What goes around comes around. Always be sure you're slicing out expenses where you can, not where you shouldn't. Insurance is an important issue, especially if you're having an outdoor wedding. Some things should not be cut out in the name of saving money. They can cost you more in the long run.

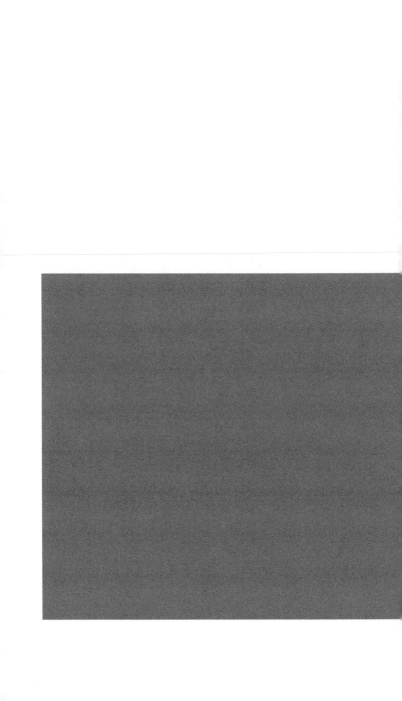

3

A Wedding Coordinator Can Save You Money

It might seem like a waste of your available funds to hire someone to help plan your wedding. The usual fee of 15 percent of the entire wedding's cost can tally up to quite a sum. But look at it another way—sometimes hiring a wedding coordinator can turn out to save you a fortune in your valuable time, plus additional savings this in-the-know expert can find out there in Wedding World. Consider the following perks as you think about whether or not to bring in professional guidance.

25. Perhaps the biggest perk is that a wedding coordinator has a lot of contacts in the wedding industry. So he or she will be able to guide you toward the best-priced, best-quality professionals out there that you might not have found through your own personal contacts and research.

26. Wedding coordinators know the best places as well—those out-of-the-way gems of locations that you might not have found on your own. Extra points if she can find you great package deals and all-inclusive plans that save you money in the long run.

27. When you go to a wedding coordinator and explain that you want a big wedding on a small budget, she has a mountain of money-saving ideas and resources at her disposal. They could be great tricks she's used at other weddings, or ideas she just picked up at a conference or through wedding coordinator friends of hers. She's a great generator of additional money-saving ideas that fit with your location and your theme.

28. The help of a wedding coordinator can save you a fortune in pain relief or anti-anxiety medication! With her handling the many, many details—and also perhaps running interference between you and your meddling mother-in-law-to-be—her assistance is invaluable in terms of removing your stress and giving you more of your own time back to devote to your career or other obligations.

29. A good wedding coordinator is an expert when it comes to the many contracts you'll have to sign with the various professionals you'll hire. Your coordinator can go through these contracts, read the fine print, negotiate to eliminate extra wasteful charges, perhaps get things for free, and save you from throwing money away on unnecessary choices.

30. A good wedding coordinator is hands-on. She may be able to help you make the pew bows or favors instead of you having to buy expensive ones.

31.

Here's a budget-saving option if you do want the help of a wedding coordinator, but don't want to spring for the full-service package: you can hire a coordinator for partial help. That means you just hire her to help you find those inexpensive locations or professionals. You can also hire a coordinator for the wedding day only, as the person who will organize the setup of the sites, show the caterer where to work, decorate, and direct everyone from the florist to the guests, keeping the show running on time, which also saves you money. Having a pro on hand can help in case bad weather or a location problem requires you to move sites. She's the calm in the storm and a good investment for the many things that can cost you on the wedding day itself. Consider it an investment in your peace of mind, to make the most of the budget you have spent on the day.

FINDING A GOOD WEDDING COORDINATOR

Ask a friend to refer hers, or go to the various associations where wedding and event planners are listed, rated, trained, and accredited: www.bridalassn.com and www.ises.com. Just keep in mind that there is a different between a wedding coordinator and an event coordinator. Some event coordinators only do corporate parties, awards show dinners, conference parties, and fund-raisers, not weddings. So save yourself time and stick with experts listed specifically as "wedding coordinators, planners, or specialists."

4

Selecting Your Wedding Date

The date you choose for your wedding can make all the difference in your wedding plans, and that can make all the difference for your wedding budget. As you may already know, prices are higher for weddings planned during what's called "peak wedding season," as supply meets demand and everyone is charged more to be a June bride. Do you want to marry during the most expensive time of the year? Does it really make a difference if you're finding so many other ways to save money on your wedding? Can you have your wedding on New Year's Eve or Valentine's Day and not pay top-dollar to be on the hot trend of holiday celebration weddings? Here's where you'll find out more about choosing the right day for your wedding, since this is the biggest foundational first decision you'll make that really has the biggest impact on your wedding budget.

SELECTING THE SEASON

32. The peak wedding months are May through September. It used to be that June through August were top picks, but times have changed and the September wedding enjoys the same kind of great weather on which that "peak season" is based. So those are the months where you're likely to find wedding industry prices elevated. If you so choose, avoid these months and look instead at the remaining ones to find slight dips in fees and package prices.

33. The good thing about looking outside the warm weather months is that you're open to winter weddings, which is a hot trend these days. Beyond the expected snowfall and associated travel delays that could be the downside to this time of year, you may enjoy lower prices and terrific wedding weekend activities (skiing, horse-drawn sleigh rides, ice-skating, etc.). In addition, your wedding pictures will be fabulous in front of that ski slope, with trees in the background glittering with ice crystals, and with ice sculptures decorating your reception site's grounds. It's unique, it's exciting, and it's getting more popular now.

HOLIDAYS

34. Holiday weekends are alluring for weddings when restaurants and hotels offer special discount rates to couples who want to take advantage of long weekends. Add in the many additional bargains of free access to extra-special holiday weekend activities, concerts, festivals, and planned township fireworks in the area, and you're getting plenty of perks by choosing that particular holiday weekend. However, be warned before you shout "Sign me up for Memorial Day Weekend!" Some sites do go the opposite way and charge *more* because it is a long weekend and there is so much extra going on in town. This terrific bargain can only be found by researching individual packages and deals.

35.

New Year's Eve and Valentine's Day are the two most popular holiday choices for wedding dates, so know that you're facing a lot of competition, demand is high, and so too might the prices be higher as well. Not just for the site, but for flowers, champagne, and other items associated with the "supply and demand" rules of big holidays like these. Choose wisely, and see if you can work your budget in other areas to allow for these higher prices—and still be able to plan that Valentine's Day wedding without breaking the bank.

ONE BARGAIN DAY TO AVOID

You'll see great prices, perhaps amazingly great prices, available at many hotels and ballrooms and restaurants on a certain Sunday in January— Super Bowl Sunday. As the least popular day for weddings (obviously, since everyone wants to watch the game), price packages are bargain friendly. Steer clear of it even if prices are lowest on that day! Couples who did grab the Super Bowl Sunday bargain have reported that their guests deserted the ballroom and dance floor to watch the game (and the commercials) at the bar. They drove up the bar tab tremendously and did not eat very much of the reception food or desserts the couple paid for. (When they did come into the ballroom, it was to grab a bunch of appetizers and then head back out to the bar.) In hindsight, that bargain choice of wedding day was a big mistake and a big regret.

36. Other holiday weekends and special events could mean higher travel fares and higher prices around town for you and your guests as well. So be sure the day you're choosing doesn't coincide with a holiday festival (check www.festivals.com to be sure your chosen location is clear of huge crowds and huge prices).

DAYS OF THE WEEK

Saturday evening is the most popular time for formal weddings. What you might not know is that you can gain huge discounts by going outside of that most popular pick.

37. Having an earlier reception on Saturday, one that starts at 1PM and goes to 5PM, still allows you the same formal options as the Saturday evening wedding, but for up to 20 percent less. Once your wedding clears out, another couple paying much more than you starts theirs. You both can have identical weddings right down to the bacon-wrapped scallops on the serving trays, but you got the better deal. And your guests are likely to drink less earlier in the day.

38. Friday night weddings are gaining in popularity, allowing the reception site to host another wedding that weekend and allowing you a 15 to 20 percent discount for the same wedding as the formal Saturday night one.

39. Sunday weddings are also on the rise, with the formal wedding in the evening a possibility, a luncheon or tea in the afternoon, or the Sunday early afternoon brunch—which is also a wise and wonderful choice.

40.

Get married on a Thursday night? It could work if all of your friends and family live in your area, or if you're planning during a holiday week when people have off of work. The weekday wedding is becoming a strong contender out there in Wedding World, as more and more couples discover the enormous discounts given at reception halls, hotels, and restaurants for big weddings held outside of the weekends. We're talking more than 30 to 40 percent off in some cases. So take your pick of Monday through Thursday and see if the day works for you and your guests. Remember, though, that guests often have evening obligations, and their kids might have evening obligations like sports practices and games, club meetings, and the like. It's something to keep in mind. You don't want to wind up with no one coming to your wedding. That's not the kind of savings you're after. Make a smart move when you're choosing the ideal day.

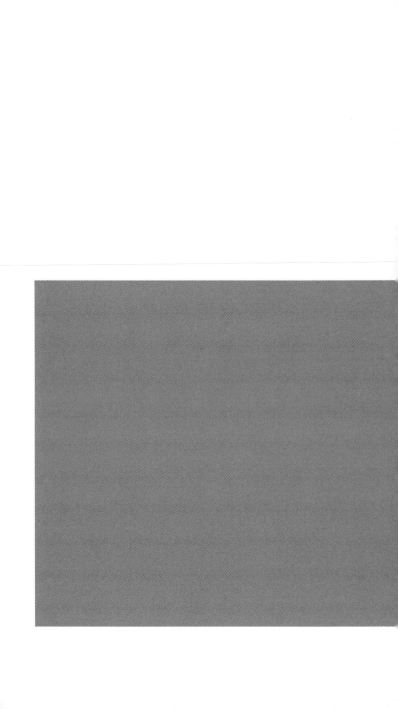

Some Locations Cost Less

As any businessperson can tell you, it's all about "location, location, location." Choosing the right spot for your event can make all the difference in the world when it comes to your budget. You could choose the ritziest five-star hotel in town, but you're likely to be charged a five-figure price. You could look outside the boundaries of the usual wedding locations to find the ideal place at a fraction of that price and it will be just as lovely, because it's more you. Again, we're talking about the added flash and value of something original, not a cookie-cutter copy of every other wedding you and your guests have ever been to. Originality scores big points, so check out these tips to help guide you toward the wedding location of your dreams.

41. Planning your wedding at a hotel ballroom can bring in extra perks ● like discounts on your guests' hotel rooms, free use of their shuttle buses to take guests to and from the airport and the wedding sites (which means you don't have to worry about arranging their transportation), amenities to use for your wedding weekend events, maybe even a free honeymoon suite for the two of you. Look into the bonuses and freebies afforded by a hotel location. It could wind up saving you money in other areas of your budget, making it a smart money move.

42. When you start looking at potential wedding sites, you'll find that ● some are "all-inclusive," meaning that you get the site, but you have to use their caterer, their cake baker, and their florist. These kinds of packages can be winners. It depends on the deal you have in front of you. The only way to tell if it's truly a smart money move is to comparison shop, line item by line item, to see if you could do better choosing a different location and hiring your own caterer, baker, and florist. Here's where the investment of your time and research comes in, but it's a good investment if you discover a great deal for yourselves.

GO SOMEPLACE UNIQUE

43.

Look at sites that do not specialize in weddings. Banquet halls and hotel ballrooms do much of their business from weddings, so their packages and plans might be priced higher. If, in contrast, you look at unique locations that are not primarily wedding settings but instead host all kinds of events, you'll likely find savings per-guest. And there's that unique thing again—adding something extra special to your day, even at a lower price.

Here are some unique and alternative locations to check out:

Bed and breakfast	An apartment with a
Winery	great view of the city
Alumni club	Lighthouse
social room	Marina clubhouse
Aquarium	Jazz club
Botanical garden	Farm
Museum	Historic estate home
Art gallery	Gazebo at the beach

These are just some of the unique locations that can be yours to decorate and fill as you please. Look in your area for additional ideas and get creative!

44.

Outdoor weddings are romantic and fantastic, the choice of many celebrities. You've already learned that an outdoor wedding can be pricey if you have much to rent and if you make exorbitant catering and décor choices, but you should know that it is still a great choice for your wedding. With smart shopping and rentals, it can be done! So look at various sites where your outdoor wedding can take place. Check with your state park bureau to ask about sites and permits. See if a country club will even allow you to set up a tent on their grounds. If you look around, you might just find a site that specializes in outdoor weddings with tents of their own! They might be among the gold standard of sites with both outdoor and indoor facilities, such as tents on the lawn, and then French doors leading to an indoor banquet room. This location can be yours with smart budgeting.

45.

If your outdoor wedding will require you to rent a tent, do not skimp on the quality of the tent! It's so important to have a sturdy structure that's reliable in wind and rain. Where you can save some big money is in choosing a plain plastic liner to the inside and ceiling of your tent, rather than spending triple the money on a silk or chiffon liner that the rental agent will certainly offer you. Once you add lights and your other décor, that plastic liner won't look so bad. You can meet in the middle by having the tent decorator set up fabric strips that drape across the ceiling area of your tent. This gives a terrific decorative impression that hides the plastic liner to a great extent, but still costs only a fraction of what you'd spend to line your tent with pure fabrics.

SHE DID WHAT?!

A recent bride wrote in to tell me that she spent $20,000 on fabric alone to line and decorate her tent—unbelievable.

46.

Think twice about locations that charge site fees. Some of the more major botanical gardens in the country can charge up to $10,000 just to use their grounds! That's before you even purchased one dinner for one guest! Beaches, state parks, and arboretums might charge a smaller fee that you'll find worth the investment for its setting and picture perfection.

47. Permits are another factor. You might need to get a permit to use state parkland or a beach, and then another permit for public gathering, then another for the preparation of food...oh, and then there's the one for parking and the one for consumption of alcohol. These are the restrictions on some sites out there. You have to pay for multiple permits just for the use of that site. Research well to find sites that won't have you paying the town hundreds of dollars just to walk on their earth or sand. Perhaps your own backyard could be the answer to that.

48. Choose a site that offers much in the way of its own natural décor, gorgeous just as it is and not needing a florist to come in with a sea of flowers and garlands to dress it up. Selecting an existing place of beauty can save you a fortune in décor. Look for sites that have a view of the ocean (nothing can beat the scenery of that sunset), a forest where the leaves will be changing colors, a pool lit up at night, a beautiful terrace with marble stairs, fountains, snow-covered slopes, and glistening ice-covered lakes. You won't need to do much improving on these locations. Your décor budget is nominal, saving you thousands of dollars.

49. A restaurant may have a beautiful private party room that fits your eighty guests perfectly. So many couples have written in to say that they didn't even know their favorite restaurant had such a nice party room upstairs—it was a surprise when the manager showed it to them. So search well and see if the restaurant answers your wish list.

50. A hotel penthouse suite could be the perfect setting for your small wedding, with a guest list under twenty-five people. You'll use it for the cocktail party, then go downstairs for drinks while house-cleaning works their magic, then the two of you use the suite for your own overnight stay (and free breakfast in the morning).

51. Your hotel might have smaller ballrooms that can be booked for your wedding, with a lower price package offered to you. See if they have a separate party area. Perhaps they'll offer you their enclosed pool area and atrium.

52. Get out of the city. With just an hour's drive to the mountains or the beach, or a quaint little town with bed and breakfasts, bistros, and antique shops, you can save hundreds on your wedding. It's like landing on another planet when you see the lower prices. Call this a mini destination wedding, where you'll all travel just a short distance away for a change of scenery, and you'll reap the financial rewards and get extra Wow points for the quaint scenery and uniqueness of the wedding.

53. A wedding on a boat is the ideal unique celebration for smaller-sized weddings, and you'll be surprised at how affordable their wedding packages are. Some yachts-for-hire offer terrific packages at half the prices you'll find at hotels and ballrooms. See if the yacht company has its own caterer or if you can bring in your own. Some tourism industry schooners regularly do dinner cruises, so they have a galley on board and they do offer formal cocktail parties or dessert and champagne menus at bargain prices. A yacht, with its light-strung masts, mahogany libraries, and brass accents, gives the impression that you spent a fortune when you've actually saved money with the right choice of yacht company. Take your wedding to the waters and sail off into the sunset. Your location is then the amazing view of the cityscape at night, with that gorgeous sunset in the distance.

54. Consider your own membership in various professional and social clubs, like a golf course or your alma mater. Very often, membership means big discounts for your special events in their party rooms and on their grounds. Plus, it's a way to work more of your personality into the wedding itself.

55. An at-home wedding is always charming and exciting. See if your setting will be your home; your parents' home; or even the home of a friend who owns a shore house, a lavish home in the mountains, a gorgeous house with an indoor pool and lovely gardens, or a fabulous apartment in the city with a great view and terrific style.

56. Still need help finding a great location for your wedding? Talk to a coordinator, or go to a professional site scout for special events. Check out www.charmedplaces.com (in NY and NJ) or www.getawayweddings.com for more information on unique and special wedding locations near you. Check your state and regional wedding guides online and in print for articles on the best places in your area to hold ceremonies, receptions, and picture taking.

57.

I saved the best for last in this chapter. Rather than searching for two different locations for your ceremony and reception, have them in the same place! If you don't wish to have your ceremony in a house of worship, it could be a tremendously smart move to have your ceremony held in a separate part of the ballroom at the hotel, with an independent officiant performing your rites. You'll only need to book one site, perhaps save on decorating, no one has to travel to another location, and you don't need to book transportation to take you from one place to another! It's one-stop shopping, ideal for everyone, and gets you to your celebration a little bit faster.

6

Timing is Everything

As with most other things in life, timing is everything. The time of day when your wedding will be held can also be a money-saving factor when you consider that time fits in with the style and formality of your wedding. Obviously, a nighttime wedding is likely to be a formal affair, while a 10AM wedding ceremony can be followed by a brunch. It doesn't end there. Read on to find out how the hands on the clock affect so much more of your wedding's budget.

58.

Holding your ceremony and reception at the same location could add up to great savings on décor and travel, but it also saves you money when you have wedding professionals on the clock. Eliminating travel time and delays between your ceremony and reception means you're paying for that much less of your photographer's and videographer's time, perhaps even your wedding coordinator's time too. No limousines are needed after the ceremony drop-off, so you're not paying for two more hours of service for each limousine hired. This one choice in location also affects the time, which affects your budget.

59.

Also in the realm of timing your day, you can have the most photo-worthy moments of your reception—cutting your cake, tossing your bouquet—done closer to the beginning of your reception than the end. That way, your photographer and videographer have captured all the major events and can be sent home two hours earlier. The rest of the evening's action can be captured on guests' cameras, throwaway cameras on guest tables, and by whoever picks up their videocamera. So shuffle the action at your reception—no one will mind—and add up those savings.

60. Have a three-hour reception, rather than a five-hour reception. You always want to leave them wanting more, and three hours is just perfect, especially for weddings held earlier in the day. Five hours can often be a little bit too long for some wedding guests who choose to leave early! Some styles of weddings lend themselves to shorter receptions, like the brunch, luncheon, tea, and dessert and champagne party. Three hours of endless dessert munching is enough! That's a further saving on top of savings when you put style and time together.

61. Consider time when you're making your plans and hiring your experts. If you hire a photographer, videographer, or wedding coordinator who works far away, that one hour ride to your wedding and the one hour ride home can be included in your per-hour package deal. Always ask if travel time is included when hiring any experts.

62. A reception that lasts late into the night can often mean added expenses for guests (and for you as well). Late-night weddings where lots of drinking will take place can mean that guests may opt to book hotel rooms and stay over. In some families, it's tradition that the hosts pay for guests' hotel rooms and travel. You might be able to avoid this obligation by planning your wedding for earlier in the day. Guests may still stay over, but it's likely that most will not when the wedding ends earlier in the day.

63. Late-lasting weddings can mean a higher bar tab as well, so keep that in mind when you're looking at times for your wedding. This factor alone is edging more couples toward brunch and luncheon weddings, since bar tabs are much lower earlier in the day.

64. For the ultimate in great timing, you may want to time your outdoor wedding to coincide with a dazzling sunset. The sky is filled with pinks and purples and an amazing light show you could never hope to create with a lighting designer. For this free, mood-setting radiance at your wedding, check out the Farmer's Almanac or the U.S. Navy's website (www.usno.navy.mil) for their observation reports and exact sunset times for every day of the year.

Part Two:

What to Wear on the Wedding Day

Getting Your Gown and Veil

Celebrity wedding gowns run in the tens of thousands of dollars. Oh, wait, those aren't just gowns for celebrities, they're the ones that will be shown to you. Some designer gowns can cost more than many people's entire wedding budgets, and—bless their hearts—there are some brides out there who have the budget and the blank check to afford them. Since you're holding this book, it's pretty clear that you want to find the gown of your dreams at a price that is not a budgetary nightmare. In this section, you'll get great tips for finding the perfect, gorgeous gown that will make you look and feel ethereal—including designer gowns! There are secrets for getting that Vera Wang, that Michelle Roth, or that Reem Acra for less! Did you know that only 2 percent of brides buy their gowns for full, original retail prices? The

rest are out there on the hunt for discounts. You need to join them, perhaps beating them to the perfect find and the deal of a lifetime.

MY OWN GOWN

For my wedding, I fell in love with a Scott McClintock gown I'd seen in a magazine. At a big bridal salon, it was priced at $5,000—way out of my budget. A friend recommended a different, little dress boutique right around the corner from that flashy, fancy salon...and I found it—my dream gown in my size—for $300! Sold! Twelve years later, and I'm still proud of that budget-saving moment!

THE GOWN

65.

Know what you're shopping for. You wouldn't go out shopping for a car without knowing the style of car you want, right? So it's the best investment possible to spend a lot of time looking through bridal magazines and wedding websites, gown designers' websites, and celebrity wedding magazine issues to get a feel for the perfect style of gown for you and for the formality of your wedding. Do you look better in halter styles or strapless? A-line or fitted? Traditional or sexy? What kind of style is calling out to you? Do you want to show off your great arms or your tiny waist? Both? Spending a good amount of time exploring the possibilities so that you can narrow down your choices will save you money in the long run. You save the time it would take to go to the wrong stores, try on the wrong gowns, and then go out to lunch afterwards with your mom or your maid of honor to complain about how you can't find your dream gown.

GOWN DESIGNERS' BUDGET LINES

66.

Visit wedding gown designers' websites to check out their styles and prices, and (this is the important part) see if they have a budget line of dresses—a collection they've created just for brides like you who want to wear a designer dress without the astronomical prices. If you see a designer style you like in the high-budget zone, chances are they can direct you to a more budget-priced similar gown in the same room. You need to be aware that many designers are doing this—they're mindful of the budget constraints of most brides, so they've adapted to offer gowns in a wide range of prices. Don't think a designer gown is out of the question for you. The bridal market has opened up new doors for you, so check designer's sites for their "silver line" as opposed to their "platinum line."

67. Here's another way to fulfill your dream of wearing a designer wedding gown: be aware that designers' showrooms and bridal gown salons need to clear the room of their sample gowns in order to make way for their new seasonal collections of dresses. Every few months they hold a sample gown sale. While it's true that you'd be buying the gown that dozens of other women have tried on in the fitting room, you'll likely find that there is hardly any wear and tear on these gowns. The fitting room attendants are extra cautious helping women in and out of these dresses and they're aware that these sample gowns will be up for sale soon, so they take extra precautions to keep their "selling tool" spotless. It's quite common to find designers holding sample gown sales with their gowns priced up to 85 percent off! These sales are so popular with the vast majority of brides that some brides even fly into a major showroom city like Manhattan for these big designer sample sales. They sign up for business trips that will take them to the city. They book a family vacation to a big city. They get there somehow to take advantage of these sales right in the designer showrooms. As one bride told me, "It was worth an $85 plane ticket on CheapTickets.com to find a $3,000 gown for $400!" You should know that it's not just the flagship salons in New York City that hold these sample sales. Your local wedding gown salons hold these sample sales as well, often for just as great a discount, with a variety of designer dresses on the racks.

WHERE TO FIND SAMPLE SALES

Check the websites for your favorite designers as seen in online photo galleries and in bridal magazines. On each designer's home site, you'll find listings and locations for their sample sales. Nearby wedding dress boutiques also advertise sample sales, so take the time to sign on to their mailing lists for advance notice (an extra bargain!) and additional discounts and coupons offered only to brides on their mailing lists.

68.

You'll sometimes hear the term "trunk sales," which is not the same as a sample sale, so don't let your know-it-all cousin try to convince you that it is. A trunk sale is a sale of designer gowns where a selection of new styles are offered at a discount, so keep an eye out for these big-bargain opportunities. (Experienced brides advise that you go ready to try on the gown right there in the middle of the room. Wear a yoga tank top and stretchy yoga pants, and be ready to jump into dresses right there. There's big competition at these trunk sales and there are no refunds, so don't be surprised when you walk in and everyone's stripping down to their workout clothes to try on dresses.)

69. Check out J. Crew's new line of wedding dresses. Yes, I'm serious. J. Crew (www.jcrew.com), known for its all-American style, has launched a wedding dress collection, with gorgeous informal and beach-appropriate designs in linen jacquard, French lace, and cotton. Their price range for these designer name dresses? At the time of this writing, dresses are priced at $175 to $275. Compared to many other designers' informal dress prices, that's an incredible bargain.

70. What about those big, super wedding gown sales you see on the news where the brides-to-be line up outside of the store advertising 75 percent off select gowns, and then stampede when the doors are opened? Eyes have been blackened and people have been trampled at some of these mad rushes, so figure out your own brutality tolerance before you line up to compete with a few thousand other brides-to-be as they reach and grab from various racks. You can find great savings at these types of sales and it does make for a great story at happy hour when you tell your friends about the tug-of-war you got into with some other bride's grandmother over the last strapless gown in your size. To you, it may be worth it. You may find a gem at this sale, and your black eye will heal before the wedding. Of course, I am exaggerating the comical dangers of these stampedes, but the competition can be fierce. So fuel up and be agile when you go.

OUTLET BOUND

71. You can find gorgeous wedding gowns and formal gowns that can be used as wedding gowns at outlet stores. To search the biggest official outlet store locator for the names and locations of great discount stores near you, visit www.outletbound.com.

DEPARTMENT STORES

72. Speaking of looking at formal gowns that can be used as wedding gowns, that's a wonderful secret that can save you thousands of dollars. A gorgeous white column gown with a halter top and rhinestones at the edge of a plunging backline can be a beautiful wedding dress. So be sure to look in department stores for an array of exquisite evening gowns that might work for you.

73. For further savings, check out the formal dress section at department stores during their big sales events or use a coupon for 20 percent off, as many department stores regularly offer.

74. For better selection, visit department stores in the months prior to the winter holidays when they have a larger selection of formal gowns in stock, as well as right after the holidays when their remaining gown stock is on sale.

75. Another department store perk is to take advantage of prom time. I know, you're not sixteen anymore, but you should know that today's dress design companies are selling truly fashionable, elegant, and alluring gowns and dresses for the prom crowd. I've heard from hundreds of brides who say they found beautiful white, ivory, and colored dresses in the prom gown area, for just $100 (or even less in some cases!). Stores start stocking their prom dresses in February and March for those lucky girls who already have their high school sweethearts and a date for the prom, so shop early.

76. Take advantage of post-prom sales in June and July to get greater savings on clearance gowns and dresses—plus the matching purses, shoes, and accessories to go with them.

77.

Need help at the department store? Don't have time to go through endless racks of dresses to find a style and size that fits you? Call up the department store's free personal shopper service, tell the style assistant what you're looking for, make an appointment, and when you show up, the style assistant will have already pulled dress possibilities for you and set them up in your own dressing room. It's the Pretty Woman treatment, with all the heavy lifting done for you, and it's a nice treat worthy of a bride-to-be. Did I mention this service is free? Check with stores like Bloomingdale's, Lord and Taylor, Marshall Field's, and others near you to see if they have a personal shopper service.

78.

Smaller dress boutiques also have personal shoppers ready to help you find a dress from their selection or from one of their partner stores and designer sample sales they attend regularly. So check into that, and see if a professional fashion expert can save the day (and a few hundred dollars) for you.

79. Renting a traditional, designer wedding gown is a hot trend these days, getting you a five-figure, top-name gown for just a few hundred dollars for one-day wear. So many brides find this to be the perfect answer to their budget woes—they get the designer gown, they look great, and then they don't have to worry about preserving their gown. You can ask at tuxedo rental agencies for referrals to places that rent out gowns.

80. You can also check out costume rental agencies. Brides who want an ornate princess gown with elaborate beading or a gown that works with their medieval theme go right to the best costume rental shop in the area. Its low price might allow you to slip into something really unique and unexpected for your wedding day.

81. If you're looking for a custom dress, you can always hire a professional seamstress to copy a designer style from a magazine ad or create a dress of your own design. Brides who have their own dresses designed often spend 75 percent less total on their gowns when they're just paying for lengths of fabric, accents such as beads or pearls, and the time and labor of a top-notch seamstress who's charging way less than top designers do. Be sure to hire the best seamstress out there, get referrals, and allow plenty of time for the dress to be made.

82. We're returning to an age of family importance and family values, so many brides are asking to wear their mother's wedding gowns, which Mom may be happy to hand down as an heirloom. With just a bit of sprucing up and alterations from a great seamstress, this heirloom gown is priceless, not just low-price.

83. If Mom doesn't mind, the seamstress can redesign her original wedding gown, adding a plunging backline, removing the sleeves, adding a different train. It's still a custom job and the gown itself still carries sentimental value—only in your style now.

84. Take part of an heirloom gown and add it to a regular formal gown you've bought on sale at a department store. For instance, you might take the train from your mom's gown and have it beautifully added to that new white column gown.

85. If you're practicing smart online shopping, you may be able to find a designer wedding gown on eBay. I logged on and saw over forty Vera Wang gowns for a fraction of the retail price. These might be sellers who bought sample gowns at a sale and then ran to eBay to try to make a profit, or they might be brides who didn't want to keep their gowns after the wedding. They could also be brides who called off their weddings and can't get a refund from the dress shop—they want to make back at least part of their money. Again, I can't stress enough that you need to practice smart online shopping, and you're always assuming the risk that what you buy online might not be authentic. So check carefully before you type in your credit card number.

86. Avoid the gown style that was just worn by the newest big celebrity getting married, as dress shops and designers might hike the prices for those seeking to copy it.

87. Take a regular formal gown from the store and dress it up with a long lace overlay jacket for a more demure look. When you take the jacket off at the reception, it will be as though you changed into a whole new gown. These lace overlay jackets can be found at department stores and even for a steal at antique shops, where the real thing with a history can often be found.

88. Shop at or ask friends to look in stores in other cities. For instance, your friend in the Midwest might find prices a few hundred dollars lower than where you live in the Northeast or the West Coast. If she spots some finds, it could be time for you to visit her for a girls' weekend out and a nice dress shopping trip.

A GIRL'S BEST FRIEND

89. Your recently married friend might agree to give you her gown if she doesn't want to preserve it (or sell it on eBay). Or, you could buy it from her for a big discount. She might decide to keep the train only, for future transformation into a Christening dress for her future baby (a popular option), and let you do what you wish with the rest of the dress. You can wear it as is, or you can have it altered into a style that's more you.

90. Look for where the broken-hearted brides go with their dresses. In the case of canceled weddings, gowns go up for sale on eBay (as mentioned a moment ago), or they're donated to charities such as Goodwill or a local mission. Some are listed in the classifieds, and others pop up at garage sales. Don't laugh at this last one—several brides have written in that they found the ideal dress at a garage or yard sale. It was just hanging on a tree limb as they were driving by, so they pulled over quickly to snap it up. These brides usually had these garage sale gowns re-designed or altered, cleaned up, or even dyed to an ivory color. You have to be resourceful.

91. Check out upscale consignment shops for tremendous bargains on wedding gowns (and also bridesmaids' gowns and mothers' gowns). Since gown designers do not accept their gowns back for refunds if the wedding should be canceled, many brides put their designer dresses up for sale at consignment shops. Consider these the live versions of eBay, with no shipping charges. I visited an upscale consignment shop in New York City and found plenty of perfect designer gowns and veils for a fraction of their original selling prices. I then visited a consignment shop in my own little suburban town and found the same thing! You don't need to live in a metropolis to take advantage of great bargain dress finds at consignment shops. You get a bargain and the original owner gets some of her money back.

HOW TO FIND A CONSIGNMENT SHOP

Consignment shops in upscale neighborhoods can carry designer dresses, purses, shoes, formal jackets, and so many other top-label goodies that the rich and fabulous discard after one wearing. Consignment stores in Anytown, USA have the same types of items at terrific bargains and you may find additional items for your wedding at huge discounts. To find a consignment shop near you, run an online search for local listings, or visit www.consignment-shops-stores.com, a new and free online listing of stores nationwide.

92. If your ethnic wedding will have you dressed in a cultural wedding dress or costume, see if you can borrow a relative's or rent it from your cultural association. That's much less expensive than having an original made for you.

93. The hottest trend in wedding gowns is going with color—a blush pink, an ivory gown with baby blue accents, a white gown with lavender beading at the bodice. If this is your style and you want to avoid the all-white bridal gown, then you can save a fortune by looking through bridesmaids' dresses or those formal gowns at department stores. Beyond the style attraction of adding color to bridal gowns (which is a big trend), it's also a big savings to do so.

One very important note to prevent you from wasting money: if you will be marrying in a house of worship, you need to know whether that site has strict rules about what you can wear. For instance, some churches do not allow bare shoulders within their establishments. Some Orthodox sites might frown upon a lot of cleavage. So, before you spend a fortune on your gown, make sure it's not all for nothing if the officiant will refuse to marry you because of it. Either get a coordinating jacket to wear during the ceremony or choose another style of dress that is appropriate.

VEILS AND HEADPIECES

94.

Veils and headpieces are expensive at bridal shops, as well as through Internet sites that sell them. So don't venture to buy, unless there's a great sale at the shop or online.

95. Borrow a veil from a friend who's been recently married. Many brides are far more likely to lend out their veils than their gowns, since that's a smaller touch to your wedding day look. Some brides who will be married during the same summer actually shop for a veil and headpiece together, splitting the cost, and sharing their purchase for their respective big days.

96. An heirloom veil and headpiece can be borrowed from your mother, your grandmother, your mother-in-law, or a sister/sister-in-law who's been married before. This is a special tribute to them, as well as a freebie for you.

97. Don't forget about those sample sales where you're shopping for your designer gown. In addition to gowns, veils and headpieces and tiaras are often marked up to 85 percent off! It might be worth it for you to visit sample sales just to buy a veil and headpiece, not the gown.

98. Have your veil made for you—not by a pricey designer, but by a friend or relative with craft talents and a make-your-own veil kit from a craft store. With a few lengths of tulle or netting, some silk flowers, plus the kit, the total budget for this do-it-yourself route is under $30.

99. Another do-it-yourself tip: have a crafty friend attach a length of expertly hemmed veiling to a jeweled headband or hair clip.

SKIP THE VEIL

A veil may be too old-fashioned for you or it may not work with the style and formality of your wedding. If you're one of those brides who does not wish to wear a veil, consider the following inexpensive tips for a great crowning touch to your wedding day look.

100. A tiara is the adornment of choice for today's brides and it's being worn, at times, without the veil in the back. If you love the look of the tiara but don't have a few million dollars to buy a diamond-encrusted one, you need to know that accessory shops carry beautiful rhinestone and colored gem tiaras that don't look like fakes.

101. Wear a faux-jeweled headband, a faux-pearl headband, faux-jeweled hairclips, or faux-pearl hairclips, also from the accessory shop or on sale at department stores.

102. Check out single faux pearl hair pins at department stores, accessory stores, and especially in the bridal aisle of craft stores where they sell ten for under $5. Tucked into braids and upsweeps, these bargain-priced hairpins give the impression of a far more expensive and celebrity-inspired style.

103. Gemstone hair clips can be an heirloom gift to you from mothers, grandmothers, godmothers, etc. Again, it's a tribute to them when you wear something of theirs from their wedding day, adding something extra-special to yours.

104. Make your hairstyle the attraction, with elaborate curls or an elegant French braid or chignon to catch the admiring glances of your guests. Add in a few simple pearl hairpins, and it's the perfect formal bridal look.

105. Single fresh flowers could be the perfect accent to your chosen hairstyle. Tuck a few stephanotises into a French braid or push a daisy behind one ear to hold back your loosely flowing curls. Attach a few peonies or ranunculuses to a comb tucked into your low chignon, and you have a fresh, natural, beautiful, and inexpensive look.

106. Choose a great, fake flower hair adornment at an accessory shop or on sale at a department store or make it yourself from supplies at a craft shop. They're colorful, glittery, and all the top stars are wearing them as accessories in their hair, on their clothes, and on their purses. Even better than sharing celebrity style is that your craft shop copy of their designer floral accents can cost under $10.

ACCESSORIES AND SHOES

107. Don't spend $100 on a separate crinoline to give your gown some lift. Choose a gown that has a crinoline built in.

108. Crinolines and slips are easily borrowed from mothers, friends, and other recent brides.

109.

Buy great bras and panties not just on sale, but at the big clearance sales from Victoria's Secret (www.victoriassecret.com) when the priciest bras, lingerie sets, garters, and panties are selling for over 85 percent off. We all want the good stuff when it comes to our weddings, so I'm not going to tell you to go to an underwear outlet store (although you could if you wish). It's far more luxurious to wait for the crème de la crème to go on sale. Be sure to buy the right bra with the right cut, good support, and a pretty, sexy fabric. Panties, stockings, and body slimmers can also be bought on sale to give you a great, smooth silhouette.

You probably already buy shoes on sale or at a discount shoe shop. For a wedding, it's no different. To complete your wedding day look, choose a shoe that's stylish and comfortable, with wider heels (especially if you'll be on grass or marble stairs).

110.

Avoid those crystal-decorated frilly bridal shoes you see in magazines and in stores. They're ridiculously expensive and sometimes they're just too much "extra" for your gown's sophisticated style.

111. If you'll switch into more comfy shoes for the reception, shop for inexpensive skimmers or sneakers you can decorate with lace bows or fabric-marker-penned messages from your bridal party. When it's time to kick back and enjoy your party, you'll be happy you're in sneakers, and the festive, funky design of these sneaker styles is a conversation piece.

112. Look for other colors of shoes as an added flash of color underneath your gown and perhaps lower sale prices because they're not bridal white: blush pink, baby blue, light lavender, even a great silver or copper if you've chosen silver or copper accents in your gown.

THE REAL DEAL

113.

Some lucky brides receive from their grooms or their parents the wedding-day gift of genuine diamond earrings and/or necklace, or a string of pearls with matching earrings. Even if you're not expecting such an extravagant gift, you can create the same breathtaking and beautiful effect with Swarovski crystal necklaces and earrings or other sparkly fakes from a department store for thousands of dollars less than the "real things." (As one bride said, "Hey, my crystal necklace is 'the real thing' to me!") Today's faux jewels are so good, you'd need a jeweler's loupe to tell the difference. Authentic or not, and even though they're bargain priced, these jewelry pieces become precious possessions and they become a new heirloom for you to pass along to your children someday.

114.

Wear a family heirloom piece of jewelry, such as your mother's, grandmother's, new mother-in-law's, or godmother's diamond pendant or pearls. Many brides are choosing to wear their own favorite crosses or Stars of David, or those worn by their mothers at their own weddings.

115. If you have a specific jewelry style in mind and you don't mind wearing faux gems, search accessory stores and department stores for lovely splays of necklaces and sparkling earrings.

116. Do-it-yourselfers with specific jewelry styles in mind can string their own jewelry, or have a crafty friend make it as their wedding gift to the bride. Even celebrities have chosen this option—and they have access to the world's most elite jewelers—so don't scoff at this do-it-yourself idea! It's realistic, budget-friendly, and adds extra meaning to the finished piece when worn on the wedding day.

117. Brides are buying coordinating jackets for chilly evening hours at outdoor weddings, for their departures at the end of the night, for winter weddings, and boat weddings. It's a nicer look than slinging the groom's jacket over your gown and it won't leave him freezing in the evening air. So look at department store formal dress sections for great jacket separates on sale, and know that you can "bridal up" a plain white, dressy, fitted jacket with great satin-covered buttons or a floral or jeweled clip.

118. Winter wedding brides are returning to old style fashions by using a fur hand-warming muff in white, ivory, or blush colors. These can be bought, borrowed, or quite easily made with a length of faux fur from the fabric store and the help of a handy friend who has a way with a sewing machine. This looks great in pictures and it's a formal, upscale look that can be had for less!

119. Forget the frilly bridal purses you see at bridal gown salons. They're just too expensive (unless you get them at an 85 percent off sale). Choose instead a plain satin handbag in white, ivory, or a blush color to go with your gown at a department store when the formal and prom dresses are in or on sale. Plain is better. This item is not often in sight by others.

120. A great source for plain satin handbags: the craft store. Okay, so it doesn't have the same cache as Bloomingdales or Kate Spade, but craft stores stock these simple purses by the truckload, waiting for crafters with their glue guns to attach fake silk flowers, crystals, or other adornments to these plain purses. Brides love this source so much for its low price that they often get their bridesmaids' handbags there as gifts—and they do often grab the glue gun to attach pretty silk flowers and crystals for just a few dollars too.

121. A satin purse may also be borrowed, either from a family member or from a recently married friend. This is another one of the hand-alongs that make working your recently-married network a goldmine in savings. If you don't ask, you don't get!

122. In some families, the bride carries a larger, silk, decorated purse to hold her many cash-containing gift envelopes from guests. (In some cultures and backgrounds, wrapped gifts are not given; it's all about the check in the envelope.) You can borrow this gift purse from a friend or relative, or easily make one from a length of satin hemmed into a square using skill with a sewing machine (just thread in the satin cord drawstring and voila!).

123. If your formal wedding requires you, your bridesmaids, and moms to wear elbow-length gloves, comparison shop for prices among the bridal gown shop, department store formalwear departments, and on online wedding supply sites. Try to buy in the desired color without having to dye gloves. Some brands of dye bleed onto the skin if they get wet, and it's best to avoid the extra expense of dyeing altogether.

GOWN PRESERVATION

It's your choice if you want to have your gown professionally preserved at a dry cleaners or professional gown preservation company (if so, comparison shop and ask friends to recommend experts who do a great job) or if you want to hand your gown along to others. If you do preserve your gown, do so with your veil as well, perhaps even your gloves. You never know which future relative will appreciate your having done so. Be sure to have this done soon after the wedding so any stains do not become permanent.

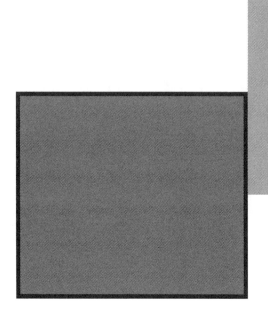

Take It Easy on Your Bridesmaids

The expenses your bridesmaids will incur as a result of saying "Yes" to your invitation into the bridal party may be a part of your budget if you've graciously offered to pay for their travel, lodging, even their dresses, shoes, and accessories. Yes, it's true, some brides do pick up the tab, as do some grooms for their men. But even if this isn't your scenario, it's a wise and gracious move to keep their expenses budget-friendly. After all, they'll be throwing your bridal shower and bridesmaid Gina from San Francisco asked me to remind you that some women are going to be bridesmaids several times in a single summer, so take it easy on their finances! Here are some tips to keep bridesmaids' expenses reasonable for whoever is paying the bills.

DRESSES

When looking at bridesmaids' dresses, it's a no-brainer that you'll search for more budget-friendly designer lines and dress styles. While you may have shuffled your budget to afford a Vera Wang gown for yourself, it's just a little bit greedy to require your bridesmaids to wear ultimate designer dresses as well. Spend some time online at bridesmaid dress photo galleries and dress designers' sites to get a feel for the going rates, and jot down the names of designers or dress labels that fit your bridesmaids' budgets.

I'VE NEVER HEARD OF HER

Check out the websites of dress designers who don't have a famous national name. Whenever you see a list of dress designers, it could be that up-and-coming new designer who has incredible dress designs at bargain rates as she works to make a name for herself in the industry. Beyond getting a great buy, you can say you "discovered" the new, hot dress designer before anyone else ever heard of her.

124.

The ultimate bargain for your bridesmaids is selecting a style and color of dress that they will be able to wear again to other events in the future. After all, you may think that floor-length, eggplant purple dresses will be gorgeous in the group photos for your autumn wedding, but will your bridesmaids ever wear them again? If they have a great, new $200 little red dress they can wear ten times (if not 20!) to office parties, dates, family parties, and other weddings they'll attend, then the amount they spent becomes a great bargain over time. So go with colors that last: black, red, pink, blue, navy, coral and the new trend in metallics like copper or dark silver, which bridesmaids can wear to festive holiday parties.

125.

Your bridesmaids can save hundreds of dollars when you allow them to choose two-piece dresses—where the top is one style and the skirt another to make a coordinating fashionable look. Check out examples at www.davidsbridal.com where you'll see a variety of tops (halter, strapless, and so on) and a variety of skirts (A-line, sheath, and so on) for mix-and-matching, with each piece priced individually. Your bridesmaid on a bargain hunt can select from the offerings a more inexpensive top and bottom that look fabulous, for less money. This is one idea that bridesmaids love, because they can pick the top and skirt style that most flatters their shapes. For instance, your B-cup bridesmaids might love a strapless top, but your D-cup bridesmaid would rather eat glass shards than worry about keeping a strapless top up all night. Once you free them to choose the skirt and top styles they prefer in the color you've chosen, you allow them:

- The opportunity to make their own choice
- The chance to choose a style that makes them look sexier or more in shape
- Perhaps more comfort on the wedding day
- Their individuality, since many bridesmaids prefer not being in a uniform look with all the others
- The chance to save a bit of money since some skirt and top styles may be priced lower than others

STAND-OUT FASHION

Allow your maid of honor to get a dress of a slightly darker or lighter hued color, or one of a slightly different style, to set her apart from the rest of the bridesmaids. You could also allow her to select a slightly more elaborate dress, perhaps one with crystal beading on the neckline, something dazzling.

126.

Again, hit the holiday and prom time dress sales at department stores. Your bridesmaids can find great styles in coordinating color dresses, in their sizes, and sometimes even use a coupon for an additional 20 to 30 percent off. (Shoppers on department store mailing and email lists get these discounts weekly, so it's wise to take advantage of them!) You can get their wedding-day jewelry sets for them here as well, or allow them to wear their own jewelry in a simple style (such as silver necklaces and pendants).

127.

Speaking of department stores, did you know that some malls now have bargain clubs you can join for free to get regular, members-only discounts at all of their on-site stores? When you sign up at the information desk in your nearby mall(s) or on their websites, you'll receive notice of sales, members-only discounts, even special events like sample sales at department and specialty stores.

128.

If you have a large bridal party ordering their gowns from one salon, negotiate for a discount at that shop! Perhaps you can earn your bridesmaids 20 percent off their shoe order, or 20 percent off dyed-to-match purses (if your comparison shop for those items determines that the bridal salon is the place to get them). One bride from Seattle said she transferred a discount that was offered to her for her gown to her maid of honor. The store wished to reward her for bringing in twelve bridesmaids to order their dresses, so they offered the bride 50 percent off her own gown. She considered the offer and, knowing that her maid of honor was having hard financial times, successfully arranged for the maid of honor to get that discount off her dress. The shop owner kept the secret from the other bridesmaids.

129.

Alterations should be free if you order through a bridal salon, but some shops do give a members-only discount to a nearby partner seamstress. If your dress shop doesn't automatically offer this information, ask about it.

SHOES

130.

Encourage your bridesmaids to find great shoe bargains at discount shoe shops or department store sales (their favorites!) rather than shopping for so-called "bridesmaids' shoes" at online sites where prices and shipping fees add up. At the discount shoe shop, for example, they may find $29 silver heels to match the same pretty style online for $49. Add in a coupon for $5 or $10 off (which you get from the shoe store you frequent, often not an option at online shoe sites!) and you've hit a bargain home run.

131.

Forget having shoes dyed to match the color of the dress. It's an added expense and completely unnecessary. Instead, your bridesmaids can wear sophisticated silver strappy heels with their cloud blue dresses, rather than getting those prom-type dyed-to-match cloud blue shoes for twice the price. Silver, copper, black, red, and pink are all high on the list of wear-again shoe colors, so be conscious of that particular factor when the topic of shoes arises. Your bridesmaids will cheer when you offer them this option.

FREE AND NEARLY-FREE IDEAS

132.

An amazing number of brides are writing in to say that they're asking their bridesmaids to wear their own little black dresses and their own black open-toed shoes to their cocktail hour weddings. No extra expense at all and the bridesmaids got to wear dresses they know they look and feel fabulous in.

133.

For fun and casual beach weddings where bridesmaids will be wearing their bathing suits and a sarong as their bridal party "uniform," brides are telling their bridesmaids to shop for coordinating color bathing suits during swimsuit sale season at the end of the summer. This is when department stores, specialty stores, and catalog and online clothing companies hold 85 percent off sales. The sarong is a gift from the bride—one size fits all and no measurements or fittings to pay for! You can get those sarongs at the same sales and stores for 85 percent off, too!

134.

Since it's best for the bride to pick up the tab at all those lunchtime meetings during dress shopping time or for planning sessions with bridesmaids, you can save a bundle by setting those meetings at less expensive restaurants, coffee shops, or even at diners or bagel shops for a casual breakfast. It's all in the planning. If you're holding these meetings at a four-star hotel for lunch, it's going to cost you. So wisely choose less expensive spots to meet up.

135.

Email is obviously free, so it's the best way to communicate with all of your bridesmaids. They're also a smarter way to keep everyone organized and saves you time when you just email directions to the fittings shop to all your bridesmaids at one time. I know this is an obvious one, but you'd be surprised at how many brides worry about their bridesmaids not getting email or not checking their mailboxes in time. A simple return receipt request keeps you informed of who got the message and who didn't, and the email serves as easily retrieved reminders for your more hectic bridesmaids.

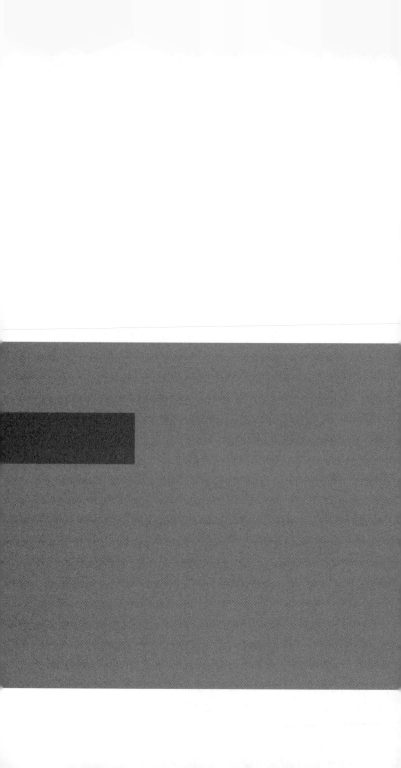

The Men Have to Look Great, Too!

The groom, the ushers, the fathers—they, too, must fit in with the formality and style of the wedding, which very likely means tuxedo rentals. Along with the tuxes and ties, there are shoe rentals, new shirts, new socks, even perhaps ethnic costumes. Add in a shave and a haircut, and all your men could see their expenses rise in preparation for your big day as well. This chapter will guide the way toward better deals, and perhaps some freebies, for all the dashing men of the wedding party.

Comparison shop among tuxedo rental agencies—using referrals from people you trust who have used their services before—for the best value, not just the best price. A rental agency that stocks old, outdated tuxedoes is, of course, going to charge less, and you'll get what you pay for. So be sure that the rental agency you approach is known for its great selection of designer tuxes, its great range of colors, its willingness to customize your order, and a very congenial working rapport. Even if you have to pay a little bit more than the going rate, it's worth it when your men look terrific in their tuxes.

136.

Comparison shop among tuxedo designer styles and colors. Encourage the groom to surf through bridal sites and tuxedo designer websites to get a real look and feel for the many different kinds of formalwear out there. Men are sometimes not aware that they have options other than the James Bond-ish black tuxedo, and an unaware shopper makes big mistakes. So look with the groom through the many different styles out there, fabrics with some sheen to them, different kinds of collars—men want to look their best, too. They don't want to look like every other groom, and they don't want to look like they belong at a 1984 prom. This is the best way to collect ideas and compare prices.

137.
Get to know the mid-priced tuxedo designers and the budget collections from top designer labels. Again, designers like to clear out their seasonal collections, and rental agency owners are right there with hangers, waiting to take in the stock. Look at Ralph Lauren's Chaps Collection for a designer style. Go through tuxedo designers' websites, and then use these names when you're looking at the merchandise at rental agencies. If you know more about the budget lines from designers, you know more what to look for.

138.
If you can't give up the designer tuxes, then you may be able to shave off some of the total price by choosing nondesigner ties, cummerbunds, and so on. There's no rule saying that you have to get top-dollar accessories for the men. Choose a classic style and color that looks like it fits with the tux, and you'll save per man.

HEY, IF HOLLYWOOD ACTORS ARE WEARING IT...

139.
Go with a classic black tuxedo rather than trendier, in-style designs that have just been seen on celebrities at the Oscars. That includes unique types of collars like Mandarin collars, long black jackets, and black shirts a la the latest sci-fi thriller. If it's been in a magazine, the rental companies are likely to charge more for it.

140. Tell the tux rental stylist that you're on a budget and ask him or her to present you with their more moderately priced selections. Why torture yourself when he brings out the highest-priced, most gorgeous style you can't afford?

141. Some couples shun the conformist look, choosing a designer tux style for the groom and best man (who are allowed to stand apart fashion-wise from the rest of the men) and then allow the ushers and fathers to rent more moderately priced, but still classy and suave, tuxedoes.

142. If you have a large tuxedo rental order, ask if you can have the groom's tux for free. Some couples arrange instead to have the father's tux rented for free if he's generously paying for the wedding.

143. See if more informal styles of tuxedoes are priced for less. For instance, if you've chosen to plan a Saturday afternoon wedding rather than a pricier Saturday night wedding, fashion options open up to you: gray tuxedoes with pinstripes are a snazzy choice for these earlier parties, and they may be 10 to 15 percent less than their ultra-formal black counterparts. Because these are less in demand, they are also lower priced.

144. Watch out for peak wedding season and prom time, when tuxedoes may be higher in price due to higher demand. You might not be able to avoid this condition if the wedding's timing is for early summer, but you need to be aware of the fact. Or, you might be able to find a tuxedo rental shop that's wisely holding a big discount for all renters as a way to compete on the market right then. So this timing could either be a blessing or a curse, depending on what your comparison shopping turns up.

145. Another thing to keep in mind as you start your wedding planning is that you will often find partnership discount offers that might give you 20 percent off your tuxedo rentals. Be wary but open-minded of these, as they might lead you to a great deal or they might not. For instance, if your florist gives you a pack of partnership discount coupons for caterers, cake bakers, and tuxedo rental places, you're smart to consider them only as part and parcel of your comparison shopping for value. Twenty percent off a tuxedo at a place that charges through the roof isn't a good deal. Twenty percent off a tuxedo at a substandard shop where their stock is limited and old is also not a good deal. So use these partnership coupons with your savvy shopping smarts to see if this discount is a great catch for you.

146.

Rent, rather than buy, cufflinks for all the men. Most tuxedo shops offer this option at a fraction of what you'd spend in a department store (even on sale with a coupon). Of course, the groom can always give cufflinks to his men as a gift. They're a wonderful present that can be used in the future for special events and dress-up business meetings. If this strikes you as a great gift idea for the men (serving double-duty as accessories for the wedding day and as a useful thank you present), you'll find greater bargains in stores like Target, Wal-Mart, and other discount stores you might not immediately consider for this purchase. Many couples report that they've found cufflinks (and watches!) at warehouse stores like Costco and Sam's Club for half the price, which can surprise even the most seasoned bargain shoppers with their notable selections. Couples who are not in the know spend a fortune by going to jewelry stores and personalized gift shops where gifts like these can cost double if not triple the bargain costs elsewhere.

LET ME SEE YOUR SHOES

147. Do a shoe review with the men to see if their already-owned black dress shoes would work for your desired wedding look, hopefully avoiding the issue of formal shoe rentals. Some brides and grooms are not so picky about their men's shoes matching, but they do want to make sure their men's shoes are coordinating and in good shape. (Some guys think their scraped-up, faded black dress shoes would be fine, while you might break out into a cold sweat.) So tell the men you're out to save them a few bucks and they'll be happy to show you their formal footwear for your yea or nay.

148. For less formal weddings, see if your men can wear smart black suits and crisp white shirts they already own, along with coordinating color and style ties that you can have them buy (instead of renting a tux), or give to them as a gift.

149. For informal weddings where men are asked to wear khaki pants and crisp white dress shirts, you're in the driver's seat again to ask for a wardrobe review. Ask your men to bring or wear their already-owned khakis and shirts for your approval. This is very important, as the term "khaki" runs the gamut on the clothing market from pale beige to a near green. Your men do need to match, so this is just a "wouldn't it be great if you didn't have to spend a dime?" research effort that might turn out wonderfully. If not, take all the men on a shopping trip to the same clothing store (hopefully a department or menswear store with great prices and sales) to buy their sizes off the same rack of the same pants—all in matching colors. For white dress shirts, this is something you can easily ask the men to buy (again at the same place, the same style), knowing they'll definitely wear it again.

150. Socks are something most brides and grooms forget (until one of their ushers shows up wearing white socks with his black shoes or Christmas-print socks as a joke). So be sure you arrange the purchase of matching black socks for your men. No need for designer socks. The ones they have at Target for $3 are fine. Extra points for those five-set packages of socks for under $10.

151.

When it comes to rentals of tuxedos, accessories, and shoes, always ask for a late return clause in your contract. Some establishments enforce a "return by noon" rule, and if your trusted return courier friend doesn't get there the next day before noon, you get charged another day's rental. So if you can't get the 4PM return time, be sure your volunteer knows that—hangover or not—all rentals must be returned on time. Or he pays for the extra fees.

TUXEDO TIPS

Check out the major wedding websites for full advice on matching a tuxedo style to the time, type, and formality of the wedding party. Learn about the rules for stroller coats, three button coats, white tie rules, what an ascot is, and whether or not the men need gloves. Using these great primers gives you the information you need to know, as well as directions on how to tie a real bow tie. The best part is that these resources are free.

152.

For an ethnic or cultural flavor to your men's look— such as family tartans, patterned vests, tribal robes or hats, and additional cultural accessories—take advantage of bargains offered through ethnic associations or specialty ethnic stores and boutiques. While you will find great websites where ethnic costumes and accents are sold, you can often find greater bargains by visiting cultural meccas in major cities where ethnic shops are plentiful. Prices are almost obscenely low ($5 for tartan sashes is a much better bargain than the $20 model online), and there's no shipping to consider. As an example, several of my brides have written in about the great Asian markets, Irish boutiques, Moroccan gift shops, and even African American bookstores where they found cultural pins and accessories for their men. All of these huge bargains were earned by thinking outside the box and taking a day trip to a cultural-friendly shopping center.

KEEP CULTURAL CENTERS IN MIND!

This bargain tip isn't just for men's hats and robes, but for all of your cultural or ethnic wedding-day supplies and décor.

153.

This is my favorite bargain secret for ethnic and cultural accents for men's and women's wedding day wardrobes. Visit cultural festivals often held in summer and fall (check online at www.festivals.com, regional magazines in your area that list upcoming events, and at your nearby convention and concert centers for schedules). Hundreds of artisans and crafters display terrific and unique imported and hand made authentic cultural accessories for just pennies on the dollar. They're great finds, and they add a terrific touch of your heritage to wedding day wardrobes (perhaps even yours, too).

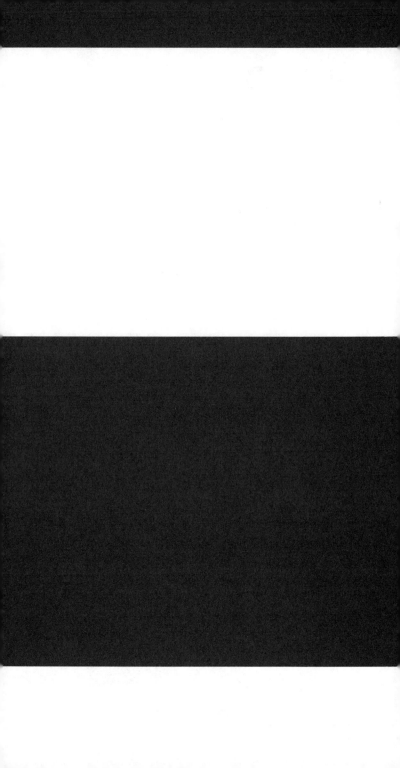

Kids Can Be Expensive

Children add an element of magic to any wedding day. From ringlet-haired flower girls in puffy pink party dresses to precocious mini-tux-wearing ring bearers with their hair slicked back, the word "adorable" just doesn't do them justice. Again, you may be one of those brides who offers to pay for the kids' outfits. If not, then you can earn the respect and appreciation of the kids' parents when you make a great effort to save them money on the kids' bridal party wardrobe expenses. Here's how to do just that.

154.

You certainly can get flower girl dresses through bridal gown salons where the newest designs and colors are plentiful. They may be priced higher than at other sources, but you could find a catch at a sample sale (while everyone else is looking for their bridal gowns, you snap up the flower girl dresses!), and you'll often get alterations for free.

155.

Look at kids' discount clothing stores and outlets (again, that's www.outletbound.com) for unbelievably low prices on kids' party dresses and suits for the little boys. Remember to look for dresses in good, comfortable fabrics, not sacrificing the little ones' comfort for price, as in the case of an itchy polyester blend dress that looks great but makes the kid miserable.

156.

Forget extra frills on girls' party dresses, like lace collars and puffy lace sleeves with elastic band hems. These may look more decorative, but the little girls will be very uncomfortable in this choice. Simpler, more unadorned dresses are often less expensive.

157. Know that children's clothing stores and outlets have big supplies of bridal-ideal white party dresses around the time of kids' First Communion (early spring), pastel party dresses around Easter and Passover, and boldly colored party dresses right before the winter holidays. So check the stores during these special times for the best selection, or right after these special times for sales on whatever's still in stock. A bride from Virginia wrote in to say that she found great flower girl-appropriate dresses at a children's discount clothing store a few towns over from her house, for 75 percent off. The grand total for each parent: under $25. She got flowers from one set of parents as a big thank you.

158. Plain white party dresses like those offered at First Communion time in the spring can be transformed into more flower girl-appropriate styles. Accomplish this with just the addition of a simple colored satin sash tied at the waist, with a cute fake flower attached to the ribbon, or simple floral appliques and accents sewn onto the tulle skirt. The cost? Under $5 for these accents. Brides love this option, since they have more control to match the color of the bridesmaids' dresses.

SECOND-TIME WEAR

159.
If you have only one flower girl, allow her to wear a party dress she already owns! Perhaps she was a flower girl in another wedding and already has a delightful little dress from that. Her parents will appreciate the second-time use for their original purchase. If you have two, see if their existing party dresses would match. Sisters sometimes own matching party dresses when parents like to dress them up in a matching set for the holidays or to get their portraits taken. Same goes for the little boys. They may have their own suits to wear to your less formal wedding.

160.
Give parents the option of finding their own child's dress within their own family. Perhaps a little cousin has a great, recently worn dress that can be a hand-me-down to your flower girl. Let parents know you're open to their networking options as well, and have them bring the handed-down dress to you for approval.

161. For girls' accessories, go to accessory stores at the mall that stock items for teens and pre-teens. You can find cute floral pins, even gemstone tiaras and hairclips for the little girl, all for under $10. Some brides invest in little angel wings and magic wands for the girls' fairy tale looks—check accessory stores as well as party supply stores where costumes are sold for these inexpensive yet charming additions. Shop around Halloween time for the best selection possible.

162. For little boys' tuxes, see if you can negotiate a lower price for kids' tux rental, or ask that the one freebie you're getting goes to the parents of the ring bearer instead of the groom or father.

163. For baby boys and very little boys, forget the tux. Just have their parents dress them in black bottoms and a white top, and get a kid-sized bow tie for the child to wear just for the pictures.

164. Little boys can wear their own khaki pants and crisp white dress shirts for your informal wedding. They don't need to get new pants to match the men; it's okay if the little guys' pants are set apart in a different shade.

165.

For shoes, let the children wear their own party shoes that they already own. If they don't own appropriate shoes, then guide parents to discount shoe stores, sales and outlet shops to buy them at a cut rate. It's a waste of money to buy specially designed "flower girl shoes" with flowers and color. That's not necessary at all and is a luxury for weddings on unlimited budgets.

Savings on Rings That Sparkle and Shine

Your wedding rings are one area where you shouldn't go to extreme measures to save money. There's a big difference between smart shopping for the best price possible on a high quality ring set and settling for a substandard choice just because it's cheap. Remember that your wedding rings are an important purchase. They'll stay on your hands forever and what they symbolize is beyond the concept of price. It's priceless. Spending a fair chunk of money on your rings is the right way to go, since you want high quality, durability, and sparkle in the most important piece of jewelry you'll ever buy in your lifetime. That said, there are ways to spend less money, if you use the following tips to get the best value for a sentimental and symbolic purchase.

166. Know your stuff. Read up about the color, clarity, cut, and carat of diamonds and the many types and grades of metals that a ring can be made from. Platinum is the top choice for ring metals, owing to its durability and shine. It's also among the most expensive for that very reason. If you're looking at diamond-set wedding bands (a popular choice), you'll need to know the difference between channel and pave settings. Jewelers have brochures explaining all this information at their stores, and you can do your own research at sites like www.adiamondisforever.com and www.bluenile.com, or the many gemological associations out there. An informed consumer is a wise consumer, so doing your homework can lead to smarter buys.

167. Consider white gold instead of platinum bands. True, they're not as durable, but they look just like platinum and the difference in durability won't make much of a difference when you plan to care well for your rings in the future.

168. Compare prices between individual, differently styled men's and women's wedding bands vs. paired sets. You can only tell if a set is a real buy once you've researched individual rings and done the math. Look for sales on sets for further savings, and only choose these if they're really the style and look you desire.

169.

Simpler styles of men's and women's wedding bands are much more likely to be reasonably priced as opposed to intricate, laser-cut and dual-metal rings. Elegance is made from simplicity, so search your heart as you're shopping to see if a more classic, unadorned style is truly you. See how these simpler bands might look up against your existing engagement ring. Some women really do desire a diamond-set wedding band to go with their engagement rings, so, together with their fiancé, decide that his ring will be a simpler band of platinum or gold while her style will be more ornate.

THE WISEST KNOWLEDGE

170.

You can upgrade your ring(s) later! It may sound crass, but you can always replace a smaller, more imperfect stone that you can better afford now with a larger, higher quality stone a few years from now when your financial standing is more comfortable. This is a popular option for many couples, many of whom either upgrade a single stone or later add a diamond-set channel to the wedding band. It makes for a great first, fifth, or tenth wedding anniversary present, and sometimes knowing that an upgrade is perfectly acceptable later down the road eases many couples' worries about not being able to afford the remarkable ring they'd like to get their partner now.

171.

When looking at gemstones for your rings—perhaps a birthstone or something more colorful and unique than diamonds if you're the nontraditional type—be sure to research the quality and grading of gemstones online. Be aware of the following popular gemstone choices that are marketed now as replacements for their more expensive (yet almost identical) counterparts:

Instead of:	Choose:
Emeralds	Green-hued garnet, tourmaline, or tsavorite
Rubies	Red garnets
Diamonds	White topaz
Aquamarines	Blue zircon or blue topaz

Ask your ring dealer or an expert at a gemology association for additional less expensive "switches" to your favorite colored gemstones

172.

Pave-set diamonds are a favorite "trick" of people who want their rings to look more dazzling. Pave-set diamonds are something like a cobblestone road in their creation, with smaller diamond pieces set flat to look more sparkly. This type of setting might give you the flash you're after, without the price tag of three large set stones or channel stones.

173.

Diamonds with flaws in them are priced lower, due to their lesser value on the market, but you should always avoid rings where their flaws are visible to the naked eye. Of course, a jeweler is going to steer you away from rings with inclusions that can be seen with a jeweler's loupe or magnifying machine. However, here's something to keep in mind: a good jeweler will be able to tell you if a stone's particular minor flaw can be covered by the prong. Once set, the ring looks amazing. The flaw is hidden from view. Sometimes there is life for a slightly flawed stone, and you can get it for far less than a stone that is graded "perfect" or "near perfect." Be diligent in your research for this, and know that having a great jeweler is key to these kinds of brilliant arrangements.

174.

That said, you should only deal with jewelers who have been around a long time, have a long-lasting reputation, are affiliated with professional associations, and enjoy a strong reputation among your friends, family, and colleagues. A quality establishment can get you a quality ring. Those fly-by-night shops? Avoid them like the plague even if they advertise rock bottom prices.

175. Take advantage of pre-holiday sales at jewelry shops. Before the winter holidays (peak engagement time, that is), many ring shops will hold wonderful sales. You might wish to time your wedding ring shopping excursion for these times when you can get the ring of your dreams for 40 to 60 percent off.

176. Ask at quality jewelry stores for their sales schedules. Some stores hold spring sales and summer sales as well.

177.

Get on the mailing list. I know, we all hate junk mail, but being on The List for jewelry shops can give you special discounts offered only to those who have signed up. Many stores offer exclusive previews and big discounts to repeat customers. That great shop where your groom bought your engagement ring could offer you terrific bargains on your wedding bands and additional wedding day jewelry. As an example, a couple from Boston tells me that being on The List at their favorite jewelry store where the groom bought the bride's engagement ring earned them 50 percent off their wedding bands, a free birthstone pendant necklace as a store giveaway (they gave that to their flower girl as a gift), and free engraving on their rings. Even better, they plan to enjoy the perks of being on The List (knowing that jewelry stores depend on your loyalty and recommendations of them to others) for all of their future buys like anniversary gifts and other family gifts.

178.

Visit jewelry stores outside the high-income bracket neighborhoods. In some areas, you could go to the high-end mall and pay $12,000 for a ring, or you could go to a ring shop in a more quaint neighborhood with great stores and get the same ring for $4,000. It's a law of real estate. Some places are just more expensive by nature of their reputation, so include some shops in other, less elite areas near you.

179. Get your ring stones at a diamond center, such as in a major city. That's where all the jewelry store owners and designers get their stones wholesale. Bring along a knowledgeable friend or someone who negotiates well in business for an even better chance at a great deal. You'll then take your own stones to your jeweler for the creation of your rings.

DO IT YOURSELF

180. Another popular option among many couples today is designing their own rings, and then taking the design (and perhaps even the stones) to their reputable jeweler who will "build" their custom rings. It sounds like it would be more expensive than buying an existing ring, but that's not always the case. So check it out and visit www.bluenile.com or www.adiamondisforever.com, where you can design your own ring according to the stones and settings you want, and then either order them online or print out your design to take to your jeweler. You can even email your ring design to your fiancé (or your mother) right through the site. It's free to use this ring design tool.

181. If your groom will be buying your wedding day jewelry gifts (diamond earrings, pendant, bracelet, etc.) at that jewelry store, he can ask for a discount. After all, he's going to be dropping a nice chunk of change at that store, and jewelry stores depend on customer loyalty to survive. Again, they want you to buy all your fine jewelry from them, and recommend them to your future-bride friends, so they might be all too happy to give you a break on the price. Again, if you don't ask, you don't get. One groom wrote in to say he saved 20 percent on a lot of jewelry for his bride, including the wedding rings, just by asking for a discount.

182. Use an heirloom stone or stones in your wedding ring. Perhaps you've inherited your grandmother's wedding band or other piece of jewelry with a collection of four perfect diamond stones in it. If you wish, you can take that heirloom ring to your jeweler and have those stones re-set into your wedding band. You're not paying for new stones (which makes up the bulk of those high prices) and you add an extra-special sentimental touch to your wedding ring, knowing your grandmother's stones from her long, happy marriage are a part of it.

183. Use an heirloom ring in its entirety, fit to your size. Again, grandma or great-grandma might have left you her wedding band. It's a tribute to her if you choose to have it cleaned, sized, and perhaps add some detailing to it if you wish, and it will cost you far, far less than buying new.

184. Use an heirloom ring, but from someone else's family. You might find the perfect wedding band in an ornate style at an antique shop or at an estate sale.

185. Ask about getting free engraving on the insides of both your wedding bands. Some stores charge by the letter, and others might be open to giving you a break. During many holiday sales, engraving is free.

186. Always get your rings appraised and insured for the smartest money move possible. You should add them to your homeowner's policy and ask about additional riders to your policy to be reimbursed in case of loss or theft away from your home. This is money well-spent and a bargain considering the price of insurance is low while the cost of buying a new wedding ring or engagement ring is astronomical—and will only be more expensive five, ten or twenty years from now.

Flowers for Your Wedding Day Look

Bouquets, boutonnieres, floral jewelry, but no corsages? What? What happened to corsages? That's what you're about to find out in this chapter strictly on budget floral tips for your wedding day look. We'll talk about centerpieces and décor a little bit later. Right now, it's all about the floral pieces that make up that wedding day look. Since many brides decide that their wedding day flowers are one of their highest priorities—and thus choose to devote a larger part of their budget toward this area—you'll find the money-saving tips in this section to really get you more for less.

SMART FLOWER CHOICES

To choose the floral makeup of your bouquet and boutonnieres (and even your centerpieces), you can

do a beautiful job and save lots of money by selecting the right flowers to comprise each. For instance, some flower varieties might cost 50 cents a stem, and some might cost $5. That's *per flower*. So it's the smartest move possible to research the prices of many lovely flowers, understand how the floral industry works in terms of where and when they get their flowers, and familiarize yourself with new and unique choices that pack a visual punch in their originality without breaking the bank.

187.

Always choose flowers that are going to be in-season for the best prices. Ask your florist for a chart on which flowers are going to be plentiful at the time of your wedding, and take advantage of seasonal prices. You can certainly order out-of-season flowers, but they will be pricier for your florist to get.

188.

Always consider first locally grown flowers over imported ones. Stephanotis is used a lot, and it is an imported flower. It's among the most expensive possible, but you can use it as accents to your bouquets and arrangements, boutonnieres, and so on because it won't be ordered en masse. Just be aware of the prices of imported flowers and make your choice of them as an accent.

189. Open your mind to nonbridal flowers. Especially in peak wedding season, all those roses and gardenias are going to be priced higher because nearly every bride wants huge quantities of these very bridal-image flowers for their big days. If you look outside the usual wedding choices—say, to clematis, ranunculus, and so on—your bouquets and centerpieces become very unique and eye-catching, again adding more value just by being original. So look through flower websites, your florists' flower charts, and at nurseries, botanical gardens, or even big flower expos to discover completely different flowers from what everyone else will be carrying. You'll discover a whole world of lovely white and colored flowers for your choosing, and they may be priced lower, giving you more for your money.

190. Still want gardenias? You can use these as part of your bouquets and centerpieces, absolutely, but then use lovely but more inexpensive flowers to round out the rest of the piece.

191. Ask to see the wide range of fillers for your bouquets and centerpieces. You already know that baby's breath is the filler of choice when you get a single-stemmed rose from your sweetheart. They're inexpensive, delicate, and provide a pretty contrast to the color of the flower. And that's exactly what you're going for when you consider the many other types of fillers out there—from Queen Anne's Lace to ivy to leather leaf ferns to that pretty little filler with the teeny tiny yellow flowers you saw at the nursery. Look at fillers with some color and texture, and your floral pieces will stand out for less. Using these in conjunction with dramatic, exotic flowers could make all the difference in your budget.

192. Wildflowers are very popular right now, especially for outdoor weddings and décor for rustic barns that have been converted to wedding locations. Check them out.

YOUR BOUQUET

Keep in mind that the tips for your bouquet apply to those of your bridesmaids and perhaps even mothers and grandmothers. The rules are the same for all, and the opportunity for unique and stylish floral bouquets should be enjoyed by all.

193.

A smaller bouquet is a bargain, obviously, because it requires fewer flowers and less labor by floral designers. Sure, a big, cascading bouquet is gorgeous, but a more modest size is not only the smarter money buy, it's smarter for style purposes. Most brides choose smaller bouquets because they want to be seen behind their flowers. They put a lot of thought into choosing a gown with fabulous necklines, beaded bodices, and silhouettes to show off their shapes and they want their grooms' first look at them on the big day to be unobstructed. If you're not dreaming of the cascading bouquet, choose a smaller model of Biedermayer (the round, densely packed bouquet style you've probably seen) or perhaps a nosegay. You're the attraction then. Another plus: it's a lot lighter to carry. Some brides complain that the beautiful, oversized bouquet they ordered turned out to be heavy on the wedding day. "I got a real workout carrying that thing around and holding it up for the hour of picture-taking!" says one bride from Chicago, who wished she'd chosen a daintier model.

194.

Which color of bouquet are you dreaming about? An all-white traditional bouquet? A mostly white one with accents of your favorite color? A dramatic all-red or all-purple bouquet? All of these options are popular now with brides, but you may find (depending on your choice of flower) that a bouquet made with several shades of color will pack more visual impact than a monochromatic one and you may need fewer flowers to make the same effect. In contrast, an all-white or an all-red bouquet will usually require a greater number of blooms to really stand out. Talk with your floral designer to see which design in your choice of blooms will have that financial break attached.

195.

Remember that the price of bouquets is dependent on the labor hours it takes for the designer to make them. A Biedermayer—or dense-packed round bouquet—is usually priced higher than a hand-tied traditional bouquet simply because it takes the floral artist a larger number of hours to create that particular style. Keep the factor of labor and crafting in mind when you choose a bouquet style, and ask which of the styles takes less time to make. A thick grouping of ribbon-tied tulips will obviously cost less than an intricate Biedermayer pinned with countless roses, gardenias, lily of the valley, clematis, and so on.

196.

Simple elegance is in. For you, that might mean a hand-tied collection of calla lilies, wrapped at the base with a color-coordinating satin ribbon that works with the color accents in your gown or those of your bridesmaids. Low in cost, low in labor prices, and a gorgeous look even for formal weddings.

197.

Forget the extras, like the top-of-the-line handle for the bouquet, the lace covering to the handle that no one is going to see, and the ribbons or lace hanging down from your bouquet (you don't need them and they have a 1980s flair to them).

198.

Some florists are showing pearlized or crystal push-pins inserted into the centers of all your bouquet flowers for extra sparkle. That's a gorgeous look, but it can be skipped when you're on a budget. Your smile will be all the sparkle you'll need.

199. Also, some florists are going with the theme thing and adding accents to bouquets that work with the wedding's location and style, like butterfly accents on a stick that's inserted into your bouquet. If you want this look, you can do it yourself! Don't pay a florist five times more than what it would cost you to buy simple push-in accents from a garden center or craft shop. You may find elegant push-ins like butterflies, seashells, even crystals on a long wire for your own accents to your bouquets (and also your centerpieces).

MAKE YOUR OWN BOUQUET

200. Some crafty brides and their planning teams will take it upon themselves to shop at a flower wholesaler for the perfect callas, roses, tulips, or daisies, hand tie the bouquet, add inexpensive ribbon from the fabric store, and keep them fresh for the wedding a few hours later. If you feel you'd be up to an easy craft on the morning of the wedding—or if you have a friend you can entrust with this task—why not? You will eliminate all labor costs, and cut your supplies cost to a fraction. Just be sure you're choosing a simple style and that you're happy with using whatever the floral mart has in stock on the wedding day. You don't want to be left in tears when the wholesaler doesn't have any white roses left in stock that morning.

YOUR BRIDESMAIDS' BOUQUETS (AND MOMS' TOO!)

201. Bridesmaids' bouquets will certainly be smaller than yours, again in the wisest color choice—either pastels or brights. You earn multiple bargains when you're using fewer flowers in each, perhaps even less expensive flowers than the ones in your bouquet, or just one or two top-priced flowers (like gardenias) surrounded by less expensive flowers all around. The look is lovely and the savings are even more attractive—especially when you have seven or eight bridesmaids, if not more.

202. Moms can be given small nosegay bouquets rather than corsages. Floral designers say they can make mini bouquets for moms at a price that's lower than the traditional market-set inflated price for mom's corsage. Beyond the bargain, moms love being handed their bouquets on the morning of the wedding (especially if it's a surprise) since there is a part of them that kind-of, sort-of wants to be like you, the bride. So choose a smaller style in a less labor-intensive design, with great fragrant flowers and have your moms and grandmothers, even godmothers walk down the aisle with their own floral stand-aparts.

203. Bridesmaids, moms, and grandmoms can carry simple, long-stemmed roses rather than intricate bouquets for a formal, classy, elegant, and inexpensive look.

204. At more informal or outdoor weddings, they can carry hand-tied bunches of tulips, daisies, or even sunflowers.

205. If you still want their bouquets to be traditional, then they can carry the less-expensive, nonbridal varieties of pretty flowers while you get the more expensive roses and gardenias for your own bouquet. See? There's a solution for everything and a way to make your own bouquet dreams come true!

206. Flower girls' bouquets should be small, perhaps nosegays or even fresh or faux-flower pomanders (an inexpensive look that can work for your bridesmaids as well).

207. If flower girls will sprinkle rose petals before your path down the aisle, there's no need to load them up with lots of petals—just a few handfuls each will do. Most brides arrange to have this portion of their petal supply taken from the amount they've arranged for their reception site table décor as one multifunctional purpose.

FAKE FLOWERS

You might have heard about using fake, silk flowers for bridesmaids and moms. Unless they're really good fakes that you will take home and use in your home décor in the future, I wouldn't advise it. Silk flowers can be more expensive than the real thing.

CREATIVE OPTIONS

Of course, there are plenty of options for nonfloral, nonbouquet items your bridesmaids can carry.

208. Candles are a simple and elegant choice. Be sure to practice fire safety if this is what your bridesmaids will be carrying.

209. Parasols can add a touch of whimsy to the ceremony as well as shade the sun at an outdoor wedding. Asian-inspired umbrellas or paper fans can be found inexpensively at party supply stores and Asian markets.

210. Purses topped with silk-flowers in a coordinating color to their dresses

211. At casual beach weddings, colorful beach balls add a sense of fun.

212. At island or beach weddings, bridesmaids can carry floral leis that they will give out to guests who line the aisle.

213. At informal weddings where you and your groom are known for your sense of humor, paperboard signs that read "If you think I look good, wait till you see the bride!" or "I'm single. Meet me after the ceremony." Get your guests laughing and the ceremony takes on a great atmosphere that is very you.

214. Choose the most adorable accessory of all: children. Each bridesmaid can hold the hand of a flower girl or of her own son or daughter.

FLORAL HAIR ACCENTS AND FLORAL JEWELRY

215. Tiny flowers tucked into your hairstyle give you an ethereal look. Talk to your hairstylist and look at your florists' picture books to see how you might arrange for mini blooms like stephanotis and major blooms like gardenias to be tucked into your hair or to accent a chignon or low ponytail. No $500 headpiece and veil for you—it's going to be $10 worth of stephanotis for your flashy, celebrity-style hairdo.

216. Outdoor and beach wedding brides love the look of a floral wreath encircling their heads. Wreaths require fewer flowers than a bouquet and are a simpler, less time-intensive job for your floral designer. Wreaths are priced more moderately and are, therefore, a pretty and romantic bargain. Choose all white or pastel colors for this wreath, so simple or dramatic in Hawaiian style, and perhaps even arrange for tiny seashells to be glued within the wreath. This money saving, beautiful look is ideal for your bridesmaids and flower girls as well, saving you potentially hundreds of dollars.

DOUBLE-DUTY FLORAL WREATHS

217. Here's a great idea for making floral wreath headpieces serve double-time for you: when the ceremony is over, your bridesmaids and flower girl (and perhaps you as well) can remove your floral wreaths from your heads and place them on guests' tables as part of the centerpieces! Place a pillar candle in the middle of the circle, perhaps set some votive candles around the outside of the wreath, and you have a supersaver centerpiece ready for each guest table if the numbers of head-pieces-to-tables match up! Or, just order the extra number of floral circles for the remaining tables, and you're all set! Very inexpensive and a lovely look.

218. Borrow from celebrity brides and skip the flashy diamond necklaces in favor of a single flower necklace, a ribbon choker with a fresh flower attached. This gorgeous option gives brides another lovely and elegant floral touch in a unique way that all your friends will be copying. This is especially popular at outdoor and beach weddings, but can be done up in strings of fresh baby roses or other flowers for even the most formal wedding.

219. Have your bridesmaids wear necklaces made of a length of beautiful color coordinating ribbon and a dramatic fresh flower as well.

220. Forget corsages for the mothers and grandmothers! That's so prom-like! Now, moms and grandmoms can sport the trendy new style of floral necklaces and the same concept in single-flower bracelets. (Again, one flower + very little time in making it = big time savings in florist fees.) Moms who have worn these tell me they felt much more stylish than if they'd worn a corsage. Says fifty-three-year-old Sasha from Bridgeport, Connecticut: "I was already feeling my age that day...I didn't need a big corsage to make me feel even older. The delicate flower bracelet was wonderful, and it didn't get in the way while I was dancing with my husband. We could get really close."

221. Use a small nosegay of fresh flowers as an accent to your gown. Attach a small grouping of flowers, for instance, to the base of your dramatic low backline, or to the hipline of your bodice. This extra-fresh touch can make even the simplest and most elegant white column gown or informal sundress look extra bridal for a very low cost.

BOUTONNIERES

222. Choose smaller, less expensive boutonnieres for the groomsmen and the fathers and grandfathers, and then a larger, more exotic and different flower for the groom's boutonniere.

223. Ask your florist for some ideas in original boutonniere flowers. Rosebuds and stephanotises are popular options, and they may be your choice. However, see if your floral designer can suggest a more unique choice, something small and eye-catching but still not in the top-priced boutonniere category.

224. Forget about extra fillers and greenery to round out the boutonnieres for everyone. Give the groom and his best man tiny portions of fillers and allow the rest of the men to go without. Done well by your florist, it won't look like anything is missing from theirs.

225. At less formal weddings where the men will wear suits rather than tuxes, you might choose to get a boutonniere just for the groom and then have the rest of the men use just a color-coordinating pocket square for their suits, together with their great colored ties. You can find terrific, inexpensive pocket squares at department stores and discount stores like Target and Wal-Mart.

Part Three:

The Essentials

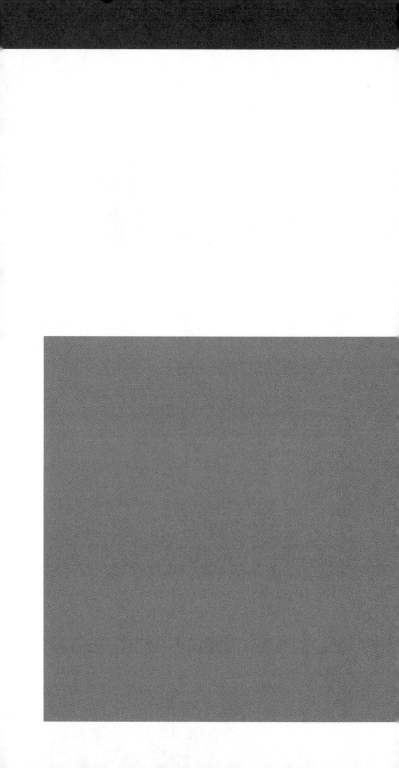

13

Invitations, Programs, Place Cards, and Anything in Print

I t's a magical moment when that big box of invitations you designed shows up in the mail, and you gingerly take one out to see it. It's just perfection. The day you first see your wedding invitation in print is a momentous day. For most brides, tears come to their eyes and they're on top of the world, thinking, "Wow, this is real. It's really happening."

Before you get to that magical moment, you have a lot of decisions to make. You need to select or design your wedding invitations—and everything else you'll put in print—with the formality and style of your wedding in mind. Your invitation conveys many things to your guests, such as the vital details of when and where your wedding will take place, but it also tells them the formality level and type of wedding you're holding so that they know what to expect and what to wear. For

instance, a formal, traditional invitation on ecru paper with formal black print says, "this is going to be a formal wedding." Your guests know to dress formally just by the style of the invitation. If your invitation says "Black Tie Requested," your male guests know they are to rent tuxes, and your female guests know it's time to break out their floor-length ball gowns. On the flip side, your playful invitation announcing your beach wedding can literally tell guests to dress casually, expect to be barefoot, and slap on some sunscreen for a margarita party in the sand.

Your invitation also conveys who you are, bringing in your personalities and a sense of style that will have your guests smiling and saying, "Now this is really them"—no cookie-cutter invitations for you. The world of personalized wedding invitations opens up new vistas of creativity for those who wish to veer away from strict tradition. What does not veer from strict tradition—even in this age of near-complete wedding freedom—are the rules for invitation wording. Etiquette still stands strong with its many rules for the correct wording of invitations in all but the most informal of wedding scenarios.

THE RULES OF WORDING

I strongly encourage you to visit the many top bridal websites (or buy my additional books) where you'll find complete primers on how to word your invitations. There are many different ways to word the invitations depending on who's hosting. For example, there's when your parents are hosting or when you and the groom are hosting or when both sets of parents are hosting and they're divorced and three out of four are remarried…and then there's the groom's newly discovered birth mother to throw into the mix. Whatever your particular situation, there's an invitation wording rule that applies. For the sake of family diplomacy—since parents lose their minds over the wording of invitations—be sure to research well before you design or order your invitations.

Now that you're warned about the many etiquette intricacies for wedding invitations, we can move back into what we're really concerned with right now: how can you get great invitations, plus wedding programs, place cards, and all manner of additional printed items for your wedding for less?

INVITATIONS

226. Order as early as you can once your wedding location and date are set in stone. Waiting and placing a last-minute rush order will certainly cost you extra. In the case of destination weddings and weddings held on holiday weekends, it's always best to send them out way in advance, even sooner than the usually advised six to eight week notice.

227. Choose single-panel invitation cards rather than fold-out ones that may hold more design, a higher price, and are more expensive to mail.

228. A new style in invitations is easy to achieve in do-it-yourself mode. A single panel invitation or several single panel pages can be hole punched at the top and then tied with a small length of ribbon. This popular style is pricey through professional invitation companies (owing to extra material and time needed for labor), but it's an easy technique to copy on your own for far less.

229. Engraved invitations are the most expensive type of printing technique out there. As the most formal choice, this style of printing produces an invitation with raised letters and the resulting indentations on the back of the page. A less expensive and far more popular option is thermography, which gives almost the same effect without the indentations on the backs of the cards. This is the smarter choice when your budget is a concern.

230. Considering hand drawn calligraphy for your invitations or envelopes? You could hire a professional calligrapher if your budget has been allocated for such an elaborate feature, or you can just as well use the decorative fonts on your home computer for the same effect. Few people are doing hand calligraphy for their invitations; they're saving that effect for place cards and other items.

231. Stick with traditional papers. A formal invitation requires a classic ecru or white paper that will cost less than all the fancier imported linen and textured papers you'll see on the market. Egyptian cotton papers; Asian rice papers; textured papers from India, Thailand, or South Africa; and other exotic types can cost two to five times the price.

232.

If you do wish to use a more unique paper with perhaps some texture, color, or shine, look for bargains on specialty paper sites (like www.botanicalpaperworks.com) and wedding invitation sites. You can also look at craft stores and art supply stores that stock unique papers in bulk, often at half the price you'll find online.

233.

The most expensive paper is archival, 100 percent cotton, which is used for engraved invitations. So look at the prices for less expensive papers, like linen blends, that give the same classic effect. You can't beat linen papers when it comes to bargains and formal style, because there is so much you can do stylistically with color, font, and design (more on that in a minute). Parchment, of course, is another bargain option that many couples are choosing for its romantic look.

234. Vellums (colored, translucent overlays) are an inexpensive addition to add panache to a simpler, less expensive invitation paper stock. Here's the bargain secret: you can buy vellum sheets in bulk at art supply houses in the color of your choice, cut to match the exact dimensions of your ordered invitations, and then overlay them yourselves. Doing this step yourself—rather than professionally ordering an easy vellum overlay—saves hundreds of dollars. You can get incredibly creative and artistic by copying expensive vellum accenting styles. With the purchase of a $5 hole puncher at a craft store, you can pop out little hearts or moons or shooting stars in the lower right corner of your colored vellum overlay—a style that's pricey in the professional design invitation world. Other brides pay $500 for these accents from invitation companies or hired artists, but you pay $5—not bad.

235. You can also look at office supply stores for very inexpensive decorative papers. We're talking $5 for two hundred sheets. Office supply stores know that 2.3 million brides and grooms out there each year are coming to look at their paper and card stock selections, so there has been a boom in their decorative paper supplies. You'll find everything from official, blank invitation card squares with pearlized borders to folded invitation papers in cloud blue and blush pink to graphic-bordered papers and cards with bridal and theme designs.

EVEN MORE AT THE OFFICE SUPPLY STORE

236. The office supply store (like OfficeMax, Staples, and Office Depot) is one of my favorite sources. It has incredibly low prices; the ability to use your corporate office supply discount cards; and the ease of finding matching envelopes, labels, even place card papers and assorted items like colored and metallic pens for your handwritten projects.

237. It's not just for the vellum overlay—you can dress up colored paper stock with a simple purchase of a $5 hole punch. I received a lovely wedding invitation where the card was a sky blue square, the wording in bold silver, and the bride and groom had used a hole punch to pop a few shooting stars in the bottom corner of the envelope. This simple touch made their homemade invitation stand out, and its originality was a home run. Other craft hole punch designs you'll find at craft stores are very intricate. I could hardly believe the detail in one butterfly design, or of a Cupid design. Just $5 for a hole punch, and you have a tool that can save you thousands of dollars in laser-cut invitation options.

238. Another bargain crafting tool is artsy scissors with a scalloped design cutting edge, also making your homemade invitations something special. At the craft store, you'll find these special scissors in scalloped and other designs for $3 to $10.

239. You may find "make your own wedding invitation" kits at office supply stores, complete with lovely formal papers and envelopes, a range of colors and styles, software with templates for invitation design, twenty-five or so different wedding-appropriate fonts you can use, and advice about correct wording. If it is not on sale, skip it. Most often you can beat this price by buying papers and envelopes separately and use your own skill with your computer's fonts and graphic design programs.

240. When you order invitations from a professional invitation source, choosing color ink instead of black ink is likely to cost you extra. Many companies, knowing that the trend now is for color to be used in the words of even formal invitations, have added more color options like burgundy, hunter green, deep purple, and deep red, but for a higher price.

241. Of course, color printing can be yours for free when you use your own color printer to create your "looks like an expert did it" invitations. If you don't have a high quality, color laser printer of your own, use a friend's. This step saves you hundreds of dollars and gives you terrific, colorful invitations and complete creative control over design and wording.

242. Stay away from raised graphic cards, which are more expensive than flat, printed graphics.

243. Invest in buying a proof of your designed invitation before you place your official order. Most companies will send you an emailed proof, but you should request to see a real one in print. I'm told that some send a proof on plain printer paper and some send a proof on the actual invitation card you requested. Ask which it will be when you make the wise move and request a proof—even if you have to pay for it. This is an important investment because it will save you from buying a new set of invitations if there is a mistake on the ones you received.

244. If you'll be creating your own invitations, consider using graphics from your own supply of digital photo pictures in jpeg format. Have a friend take great pictures of the two of you (perhaps at the beach, if you're holding a beach wedding), download the pictures to crop and edit the shading and brightness (even remove the red in your eyes!), and then just place the image on your invitation as you see fit. It's a great, free design move that other less savvy couples are actually paying for at other sources.

245. Regarding fonts, I spoke with Leslie Vismara, the owner of VismaraInvitations.com for the following tip. Leslie says, "As long as you're choosing fonts from the supplier's existing list, they should all be the same price. The price would go up if you requested something different from their list. It takes them time and money to find that font, perhaps even purchase it, and then work it into their layout, and that cost comes back to you."

246. Most invitation companies will not charge you extra for using two different kinds of fonts on your invitation. If you want one font to make your names stand out and another for the rest of the invitation wording, that should be free.

247. Many invitation companies limit the number of lines you can use on the front of each invitation for visual attractiveness so your invitation doesn't look cluttered. If you'll need more than two lines to list all of your parents and their new spouses, for instance, make sure that the invitation design you choose allows for an extended number of lines. You don't want to pay extra for a special layout.

248. If your wedding is going to be informal and fun, buy graphic party-style paper at an office supply store with matching envelopes, and design it to your heart's content. That could be a cost of only $15 to $20 for over seventy-five invitations.

249. If your wedding is informal and/or very small in size, you can handwrite your invitations on nice note cards or pretty papers. Office supply stores have perfect, boxed blank note cards with matching envelopes. You can often find a box of twenty for less than $10.

EXTRA INSERTS

Order your inserts to match the invitation. It might make budget sense to order professional invitations and then make inexpensive response cards and reception cards on your home computer, but it really can look tacky if the styles don't match. As an example, if you do wish to print out directions or hotel information on separate papers, make sure they match the invitation color. Never put a bad quality black and white photocopy in with a tan-colored invitation. Consider this a reputation-saving tip: don't go too far in the name of saving money.

250.

See which kinds of inserts you really need. A reception card is usually a must. Invitation experts say a separate card with reception time, place, and details is vital for formal weddings, but you can skip it for informal wedding invitations where "Reception to Follow" printed on the invitation itself is sufficient. For further savings, print your new address and phone number on your wedding programs instead of purchasing separate "at home" cards.

251 See which inserts you can get for free, such as nicely printed driving directions provided by the hotel or ballroom's managing staff as a freebie for couples holding weddings at their establishments. Ask to have them printed by the site (for free!) on a color of paper that matches your invitations. Most sites will be able to print them out on off-white paper or white paper if you ask. I've even heard about sites printing out their directions and maps on light pink or cloud blue paper they have on hand in their offices, or that the bride and groom bring in themselves ($5 from the office supply store).

252. Another free move: informal wedding invitations can provide the website where the guests can find all directions and hotel information links. (An added plus: it also links them to where you're registered for wedding gifts.)

OTHER INVITATION TIPS

253. Order enough invitations. It's best to aim for 10 percent more than you think you'll need for your guest list. In case some guests say "No," you have more invitations to send out to other guests on your B-list. Reordering later will cost a lot more than adding a few extra invitations now. Another use for extra invitations is for keepsake material and crafts such as framed invitations, embedding your invitation in a front plastic frame on your unity candle, or opening gift photo albums with an invitation.

254. Don't put any glitter or confetti into your invitation packets. It's a wasted expense and guests hate it.

255. When you fill out your invitation order form, triple check to be sure you have everything spelled correctly, your printing is clear, and you have every fact correct from the address to the time and location of the wedding. Mistakes that are your fault mean a second ordering of your invitation, and a second payment for them. It's a preventable waste of money.

POSTAGE ISSUES

256.
Keep in mind that your invitation will not be the only thing in your envelope. When you add in reception cards, response cards, maps, and other items, your invitation packages can get heavy and expensive to mail when you have to add extra postage. So stick with lighter, thinner card stock for all and keep the inserts to a minimum. Remember that many things (like directions to the hotel) can be posted on your wedding website instead of put into print.

257.
When you're buying those pretty "Love" postage stamps (or a stamp that has a design fitting to the theme of your wedding), remember to add up how many stamps you'll need for both the outside envelope and the return of the response card. Failing to do so could mean a time- and money-wasting trip back to the post office.

258. When you assemble your invitation envelopes with all the included inserts, take one to the post office to have it weighed. The clerk will be able to tell you how much postage you'll actually need. Couples who skipped this step invited disaster: their invitations came back to them as having insufficient postage, and the envelopes were stamped with horrible black smeared notices to that effect. They had to buy new envelopes, address them, buy more postage stamps, reassemble the invitations, and mail them all out again. Don't put yourself through that added stress and expense. Get one packet weighed first.

259. Always go to the post office to get your stamps. Buying online might be convenient, but then you have added shipping costs.

ENVELOPES

260. Leslie Vismara at Vismara Invitations.com asks that you keep in mind that square envelopes are almost always more expensive to mail than rectangular ones, which are the cheapest.

261. Leslie also says that an A6-sized envelope (4-3/4" x 6-1/2") is less expensive to mail than any envelope in a size A7 (5-1/4" x 7-1/4") or larger.

262. Lined envelopes are pretty, but they add an unnecessary expense. So skip the option of having your envelopes lined in a coordinating color to your invitation. People just throw out the envelope anyway.

263. Decorative envelopes are more expensive than classic plain ones. The envelope doesn't have to be art since it just gets tossed by the recipient. The good folks at the U.S. Postal Service tell me that their processing machines sometimes have trouble reading envelopes with lots of swirls, designs, and accents on them—or even silver ink used to address them.

264. Order 20 percent more envelopes than you think you'll need, in case you or a volunteer makes a mistake when it comes time to address them. After handwriting one hundred invitations, it's easy for your eyes to get blurry and for NJ to look like NY. Tear that one up and start over. Why is this a money saver? It's cheaper to order a few dozen more envelopes early on with your invitations rather than place an emergency rush order for twenty-five more later in the game. Extra shipping and a special order mean higher prices.

265. Etiquette standards used to mandate that second envelopes holding all of your inserts inside the main outer envelope were the way to go. Guests would be listed by name on the inner envelope. Now, more couples are choosing to skip the inner envelope and just have everything inside the larger one. It's up to you if you want to stick with tradition or skip the paper waste. It's not a huge expense to have second inside envelopes, but if you're looking for little ways to save, this could be your choice.

266. A response card and its separate envelope is going to be more expensive than a response postcard, which is coming into vogue right now and being used by many couples out there. Add into the savings here: a postcard stamp is cheaper than one (or two or three) first class stamps.

PHONE IT IN

267. Some couples are choosing to skip the response card and are instead providing a phone number for RSVPs. Some are asking for emailed RSVPs as well, in the case of informal wedding invitations.

SAVE THE DATE CARDS

268. These have become a must in today's busy world, especially if your wedding will be held during peak wedding season, holiday times, or at a destination site. Brides and grooms are sending these cards out months in advance, and they're saving a bit of money by making them themselves using good quality card stock and their home computer. This card should reflect the formality and style of the wedding (guests can tell your wedding will be formal by the ecru paper and formal black print), and you can print hotel and website information on the back of the card.

269. For less formal weddings, "save the date" cards can be postcards, which is a fraction of the cost of formally ordered cards and envelopes with postage. If you do wish to order great graphic, custom designed postcards, start your research on the Internet. A website like www.VistaPrint.com creates a wide range of great postcards using your or their graphics, some formal, some funny, all a great buy at reasonable prices.

270. "Save the date" cards don't have to be cards at all. A well-designed email to all your friends and family could do the job in a blink for free, and give guests the links to hotel reservations and registry sites. (Just don't send it as an attachment—some people won't or can't open them, depending on their firewall systems.)

PLACE CARDS AND OTHER PRINTED ITEMS

Place cards

271. Buy appropriate card stock for place cards from a stationery store, craft store, or office supply store. You can find designer styles online at bridal websites, but they can be pricey, and there's always shipping charges to worry about! Comparison shop to see if your local stores can beat online prices.

272. Check out designs of full sheet sets of pop-out place cards that can be run through your home computer's printer, using mail merge for your guests' names and table numbers. Don't use printed-out computer labels (colored, white, clear, or designed) for your place cards. I know it's an inexpensive and timesaving option, but it rarely comes out looking good and announces that you're cutting costs.

273.

You might wish to challenge me on the last tip if you find great graphic laser-print labels from an office supply store. Depending on your choice of place card stock and the color-coordinating look of the label, you might be able to make it work. Here's an example: use a sky blue place card stock, and add winter-themed labels with lighter sky blue and silver snowflake accents. If you can do great things with color and graphics, then you have turned a "Don't" into a "Do." Such is the freedom of creativity and access to terrific graphic labels.

274.

Handwrite guests' names on place cards using a colored, metallic, or calligraphy pen, rather than doing the computer thing. Some couples prefer the classic look of handwritten over mass-produced. You can find great, unique pens and gel pens for next to nothing at craft and office supply stores.

YOU HAVE GREAT HANDWRITING!

275.

Ask a friend with great handwriting to pen your place cards as her gift to you. Perhaps someone you know does calligraphy as a hobby or just has a terrific style in print. Her artistic gift to you saves you hundreds of dollars.

276. Spruce up your homemade place cards by gluing onto the corner a little something special and theme or location appropriate, such as a:

- Tiny silk flower
- Miniature seashell
- Miniature starfish
- Butterfly applique
- Faux-crystal star
- Any other unique, tiny item found at a craft store

Look at that little corner of the place card with your creativity on high. One couple wrote in from Miami to say they glued on M&M candies, all in green to match their theme, and sporting the "M" imprint since that was their new married last initial.

277. Speaking of initials, monograms are the hot trend and will continue to be so for long into the future. So affix a shiny, colored initial sticker (high quality only, please) that you can find at a craft store.

278. You can use an inexpensive rubber stamp with the monogram letter, in colored or metallic silver ink (both found for under $10 at a craft store).

279. Rubber stamps are not just for kids. Look through the many designs of inexpensive rubber stamp words or graphics, flowers, stars, moons, Victorian images, butterflies, and the like at your craft store. Search through ink colors and embossing powders to make do-it-yourself accenting something special.

280. While you're at the craft store, look through the scrapbooking section to find colorful cutouts of graphics and felt designs that you can use on your place cards and menu cards to make them match.

FORGET CUPID

281. Forget ordering those little pewter place card holders from bridal websites. While it's cute to have a little silver Cupid with a prong sticking out of his back to hold the card, what is your guest going to do with that afterward? And why are you spending $15 for six of them? You don't need those cutesy place card holders when it's fine to go without or choose something more creative.

282. A common place card holder that does double duty as a wedding favor is putting place card papers in small photo frames for guests to take home and replace the place card with a favorite picture of their own. Get these in silver, acrylic, colored, and even theme matching frames (like hunter green grapevine motifs for a vineyard theme wedding). Buy them in bulk at the craft store, which always has a wide variety of these popular favor items.

283. Don't forget your craft options. For example, crafters can buy inexpensive wooden frames and line them with seashells, colored stones, or fabric daisy heads.

284. Instead of using printed place cards, some couples use a metallic silver pen to write guests' names and table numbers on red Christmas ornaments (a very inexpensive idea for holiday weddings). Steal this idea with different colored ornaments, like pink, purple, or clear with white snowflake designs.

285. Use pine cones for an outdoor or autumn wedding. Glue gun the place cards to each pine cone, and it's a lovely natural look. Either collect pine cones from a friend's property where they're plentiful (that's a fun afternoon out, too!) or get them very inexpensively at a craft store.

286. Fruit is a very popular place card holder option among couples who love the natural look of shiny, fresh fruit for their weddings. (They may even use them in their centerpieces, so this is a great tie-in to the theme of their décor!) Use a thick knife to cut a slice across the top of a green or red apple, and set your laminated place cards in that slice so the fruit becomes a holder. (You can get an inexpensive laminating machine at office supply stores, or—better yet—borrow a friend's who will be relieved to get extra use out of theirs.) You can also cut a thin slice off the bottom of a lemon or lime so that it sits still on the table without rolling, and then make a slice across the top to hold the laminated place card. Also ideal for this bargain tip:

- Pears
- Kiwis
- Oranges
- Grapefruit
- Star fruit

287. Get your fruit at farmers' markets for the greatest discounts possible. A bag of thirty lemons costs about $4. It doesn't get better than that!

288. For autumn weddings, names and table numbers can be written on large, fresh oak or maple tree leaves.

Menu Cards

289. Get the exact menu from your caterer and add a beautiful, informative, and appetizing touch to your guests' tables by creating a menu card on your home computer. You'll only need one for each table or two for a long table.

IF YOU HAVE TO BUY THEM

290. If you like the look of professionally created menu cards or you don't have time to design and make them on your home computer, visit www.PSAEssentials.com, where menu cards are priced reasonably low and come in lovely, decorative styles.

291 You can also print up cards to let guests know what dishes are on the buffet, or the sauces and flavors available at serving stations. Again, this do-it-yourself option is a big money saver.

Table Number Cards and Options

292 Print up these large numbers (or table names) on stiff card stock, using your home computer and printer. Practice on regular paper until you get the number size just right. Don't order table number cards, which you might be offered at stationer's shops. Sure, expertly designed graphic cards are attractive, but guests are only interested in finding their table, not admiring how beautiful that #6 is. Skip this add-on expense.

293. Some creative couples with theme weddings use items to designate their tables, rather than printed numbers. For instance, at a "Golden Age of Hollywood" party, you might get classic black and white or color postcards of famous actors, letting guests know they're at the Audrey Hepburn table. These great postcards are often only $1 to $3 each at chain and independent bookstores, sometimes 50 cents each at flea markets and collectors' shows—you'll find an enormous variety of them there. For a bargain price, you've added an impressive touch to your tables that could mean additional savings when you make that a part of your centerpiece design.

294. One couple from Philadelphia loved the idea of using enlarged pictures of themselves holding numbered signs to indicate each table number, but the cost of having forty different 8 x 10s printed up was prohibitive. A friend stepped in with a free rescue: he'd take their pictures on his digital camera, print them out on his own color laser printer using glossy brochure paper he had on hand in his office, and call it his gift to the couple. Consider this free printout option using your own digital camera and printer to save lots of money and impress your guests with your custom, creative table cards.

Maps

295. Print out and size a map from Mapquest.com, then use a highlighter to trace the route. Take this one page and duplicate it on a color copier to save you time. Avoid expensive color copy charges at office supply and printing stores by using a friend's color copier.

296. A note of advice from a groom in Portland: "I just asked my boss if I could use the color copier at the office to print out my one hundred maps, and she said 'no problem.' She was glad I asked her permission first and told me I could use the office printer for my menu cards too." Office perks are a sweet deal, but be sure to ask permission first. Even if the boss charges you 10 cents a copy (as several couples have reported), it's still a huge savings compared to what you'd pay at printing shops.

297. If you have no access to free use of a color copier, cut your printing expenses in half by printing two maps on a single page (no more than that, though, or directions will be too small to see clearly) and cut each page in half later.

298. Have an artistic friend create a great map filled with terrific graphics and landmarks. Photocopy it in color, and distribute. This can be your artistic friend's wedding gift to you.

Wedding Weekend Itineraries

299. Print these out inexpensively on regular copier paper, perhaps in sweet pastels from the office supply store ($3 to $8 a ream). Use each page to list the wedding weekend activities, times, places, dress code, and the RSVP information for the hosts. Mail them in regular envelopes and, again, no confetti inside these either.

300. Rather than itineraries, list the events on your wedding website for free.

301. Fill out store-bought invitations for each event planned. Packet invitations are very inexpensive, especially if you use a club card like your Hallmark member discount card and resulting coupons from that program.

302. Handwritten invitations are fine for smaller guest lists.

303. Use postcards to invite guests to wedding weekend activities. Look for postcards that feature a big city skyline or the beach if the event takes place in those areas! Check at card shops, gift shops, and at hotels for a great selection of appropriate location postcards.

304. Wedding weekend activities can be announced through free online invitation sources like www.evite.com instead of printed announcements or invitations. Just send weekend activity invitations to those people on your guest lists for each. The site keeps track of "Yes" and "No" responses and gives the guests' feedback (like "Can't wait!" and "I'll bring tiramisu!").

305. For after-parties, you should choose a style of invitation to reflect the style of the party. For instance, a party at a jazz club might be conveyed through a rich red invitation with a cool font. These can be printed, but you can save money by using services like www.evite.com for free.

SIGNS

306. It's home computer time for any directional signs. Create your own signs like "Parking This Way" or "Sarah and Jeff's Wedding" with an arrow sign to direct guests along a sandy pathway to the ceremony site.

307. Skip the helium balloons to decorate outside sites or the driveway to an at-home wedding. Balloons may be festive for kids' birthday parties, but they're an extra expense not needed for a budget wedding. Just stick one oversized bow on the front door if you must. That's plenty of money saved.

FAVOR NOTES

308. Along with your names and wedding date, attach notes of thanks to your favors. You can use your home computer to print these out on simple small squares of card stock.

309. Another option is to print out labels to attach to favors, using pretty print-ready labels from the office supply store. Choose from rounds to ovals to long rectangles and even wine bottle labels.

310. You can also find specialized labels for affixing to music CDs at your local office supply store. You design these and, using the label information code to get the right size and shape, print them out on your own printer.

311. Use fun "word art" tools on your home computer to give your message a special 3D effect, a curved look, or your wording printed in the shape of your monogram letter.

312. Skip artsy favor labels you'll find on wedding supply websites unless your comparison shop reveals they're a good buy, including the shipping prices.

313. Personalize favor labels by attaching a monogram sticker or a glued-on accent.

314.

Try attaching something edible, like a wrapped Hershey's Kiss or a candy cane.

WONDERFUL WORDS

Leave your guests with a bit of inspiration, printing a favorite quote or saying on your favor label, such as Helen Keller's "Life is either a daring adventure, or nothing at all." Check www.brainyquotes.com for access to millions of quotes you can use, broken down into categories like "love," "marriage," "forever," and so on.

Programs

315.

Rather than order your programs to be professionally printed, this is one area where it's smart to design and print wedding programs using your home computer, printer, and pretty paper from the craft or office supply store.

316.

For added style that's still a bargain, and gives your programs that professionally made look without professional prices, enclose your homemade, printed program pages in a decorative, colorful program folder bought at a stationery store or at a religious bookstore. These sources have a wide range of program covers, with floral designs, religious themes, nature scenes, and so on.

317. Make your own program cover instead of buying one. Use thicker card stock or vellum and your own designed graphics.

318. Some artistic couples will hand-decorate their program covers by attaching a ribbon bow, doing line drawings, or even sealing them with a wax stamp for a regal look.

319. Make your program a scroll, tied with a length of color-coordinating ribbon. No cover needed.

320. Print your program pages on individual card stock pages, then punch a hole at the top and tie each with a ribbon bow. Guests can spread the pages and use the program as a fan in hot weather, too.

GENERAL SAVINGS ADVICE

321. Ask family and friends for gift certificates to office supply stores (rather than to clothing stores or coffee shops) as your wished-for holiday or birthday gifts way before the wedding date.

322. Use your credit card reward points at office supply shops or craft stores that are participants in these gift certificate reward programs.

323. Use your own or a friend's digital camera to add great images to your invitations, programs, and any other printed items

324. Always use your wedding website as a way to convey information, keep guests organized, make travel and lodging plans easier, give up-to-the-minute details, and share pictures of the planning process. This most important tool allows far-flung friends and relatives to share all the excitement of your upcoming day. Visit www.wedstudio.com to find out how you can get and design your own wedding website.

Getting It All on Film

I am not going to tell you to "have a friend take the pictures." This is your wedding day. It's once in a lifetime and it gives you tangible keepsakes that only increase in value over time. If you were to ask me, "What's the one place we should invest more money for the wedding?" I'd tell you to sink extra cash into your wedding photos and videotape. They'll bring you back to the big day. You'll display them in your home. Your kids will see them someday. You'll look at them (and to them) throughout every twist and turn of your marriage ahead, and perhaps even to remind you both of the value you have for one another during inevitable rough patches and bumpy roads in the future. That's exactly why wedding photographers and videographers charge so much money for their services. It's not just about the film; it's about the memories you're capturing being priceless.

If you try to cut too deeply to save money in this area, you'll regret it later. Instead, consider the following for both your professional photography and videography.

325. Invest smartly. Always ask friends for recommendations to the wedding photographers who delivered the goods well at a reasonable price. If your friends considered it money well spent and have the photos to prove it, that's the best way to make sure your money is used ideally.

326. While you're spending your time comparison shopping between various professional photographers' and videographers' price packages, check to see if their budget wedding package will provide enough for you. Be realistic about what you want and really look at the extras on their higher-end "platinum packages" to see if you'll really need the gold-framed portrait, the airbrushing, and the designer photo albums. Very often, the simple budget package will give you all that you need and then you can find less expensive alternatives like frames and albums on your own.

327. Never choose rush delivery. You can pay hundreds extra for this service, so be patient and wait the four to six weeks. Remember, you'll have plenty of digital and candid shots from your guests to tide you over.

328. Negotiate to keep your proofs (those 200+ picture prints your photographer will give you to look over). That is, if your photographer gives out print proofs. Many pros are putting these "proofs" online and not incurring the expense of developing them onto paper. If yours still does the thick envelope full of proofs for you to go through in selecting your favorites, just ask to keep the full set. You can use many of these (except the "I blinked" shots) to create gift albums for your bridal party and relatives as well.

329. Negotiate to keep your negatives. This is very important, since you'll gain the freedom to develop, enlarge, and duplicate your wedding and reception pictures without having to go through the photographer to place your order. Photographers tell me they make a mint when brides and grooms are forced to order through them. Some photographers charge upwards of $30 to $40 for larger portraits (if not way more in some areas of the country), citing labor and materials fees. If you buy your negatives, you can certainly get future copies for less on your own.

YOU HAVE THE RIGHTS

Believe it or not, you may have to buy the rights to your own wedding pictures. When you're negotiating to buy your negatives, make sure the ownership comes with them. A photographer can sell you the negatives, but keep the rights. That means if you want to get your wedding photos printed in a magazine or some future professional usage, you'll have to get permission from the photographer (and perhaps pay for their use). It's a copyright thing, and that makes it legal, so always ask about purchasing the rights to your photos.

330. Choose your wedding photos in 5 x 7 size, rather than 8 x 10 or larger. It's a savings in development and print fees, and no one really needs all of those pictures in an enormous size.

331. If you so choose, get your wedding album in larger sized prints, but get the smaller print sizes for your parents' and grandparents' albums.

WILL THE COLOR LAST?

A few years ago, couples wondered if their color prints would last very long, or if they would eventually fade. They chose to get a selection of some black and whites for a formal wedding portrait look that wouldn't fade over time. Now you don't have to worry about that. Color chemical development has advanced and color pictures are lasting longer. You may order some black and white wedding photos if you wish, but that's only for style now, not for survival aspects.

332. Choosing some black and whites among your wedding photos is a great idea, since black and white developing may be less expensive. It also gives you a style option in case you ever decide to change your home décor style and display classic black and whites. Making the choice now can save you future ordering and development fees when prices are even higher. It's best to get a selection now. (Be careful, though. Some photographers who don't have the ability to process black and white prints need to send them out to separate labs for a higher fee. Always ask up front if black and whites can be processed from digital shots on site.)

333. See if special prints, like sepia tones, are much more expensive to develop. Some couples love the artistic effect of sepia or hand-colored black and white photos, but these special effects will cost you extra. So skip it now, and know that you can do more artistic things with your wedding pictures later, perhaps as an anniversary present. Leaving room for upgrades now can create special choices in your future.

SKIP THE SUPERMODEL TREATMENT

334. Limit photo editing. Photographers can now edit your pictures with an airbrush, just like magazines do to their cover models to make their thighs look as thin as their forearms and remove wrinkles without the shot from the dermatologist. It's great if you have an endless budget, but it's really a vanity expense, and one you don't need. Skip it.

335. Omitting special effects can save you a bundle. Adding borders or wording onto your pictures, especially with those old-fashioned wedding pictures where your faces are superimposed onto sheet music of "your song," have come to be seen as cheesy and very unnecessary. You don't need any embellishments. Go with the real deal.

336. Skip the formal bride's pre-wedding portrait. If you don't know what I'm talking about, you should know that in some regions, it's tradition to hand out wallet-sized portraits of the bride in her gown at the wedding. This is unnecessary since all of your guests will take their own pictures of you in your gown on the wedding day, or order online from your official collection. So, skip the sitting and development fee for this one.

337. Skip the fancy photo albums your photographer may try to sell you. Unless they're free from him or her, as might occur during special sales and in some packages. You can almost always find less expensive photo albums in card stores, at discount stores like Target, and online.

338. Don't end up paying for photo restoration in the future. When you're looking to buy your own photo albums, either for yourself, for parents, or for friends, always make sure you're purchasing albums that are acid free and archival quality. In some cheaper models of albums, the chemicals used in their production actually speed up your photos' aging process. So check for archival treatment, nonmagnetic pages, and chemical-free construction. One source for these is www.exposures.com.

339.

Negotiate for free gift albums, such as those for parents. Depending on your order and the package you choose, you may have some bargaining power for freebies. It can never hurt to ask, and you may wind up with at least a discount.

340.

Limit the number of gift albums you'll give out. Give one album to each set of parents, perhaps one to grandparents, but don't order specially made albums from your photographer for all the people that your mother is going to request of you. Godparents, aunts, uncles, and family friends can be given a framed portrait, a selection of prints, or even a photo album that you make using inexpensive flip albums and your proofs.

341. With color photocopying so easily available and inexpensive using the photo paper or glossy print paper you can get at the office supply store, you might find it silly to order prints when you can make them yourself. Consider copying your own for your more informal thank you notes or to share images with friends who won't mind photocopies.

THE #1 MONEY-SAVER IN PHOTOGRAPHY AND VIDEOGRAPHY

342. Need less of their time. Since photographers and videographers work in timed packages by the hour, schedule your day so that you'll only need them on hand for three hours, rather than five. Limit the number of time they'll have to take pictures before the ceremony, and then plan your reception so that all the major footage (like cutting the cake, tossing the bouquet, and so on) takes place earlier in the night. After the big photo ops are complete, your picture pros can leave. The clock stops and you're not paying these experts to film and shoot three hours of your reception at several hundred or thousand dollars per hour. After the expert departs, the rest of the festivities can be captured on one-time-use cameras you've supplied for your guests.

ONE-TIME-USE CAMERAS

343. Purchase one-time-use cameras at a bulk store like Costco or at a craft store where these items are stocked by the case.

344. Comparison shop among prices in your area for one-time-use cameras. I found a wide range of prices at a craft shop, a bulk shopping center, a pharmacy, and Target.

QUALITY CAMERAS

Look for quality with these cameras. Go with a brand name even if you have to pay a little bit more. It's quality you want, especially if you'll be counting on these pictures to capture the best moments of your reception's later hours.

345. Compare prices between truly bridal-designed cameras with doves, rings, and roses on the camera face and those that are equally fitting (and sometimes less cheesy) in plain pastel colors like tangerine, sage green, lemon yellow, and baby pink. Often, you'll find better prices with these more appealing designs than you will with bridal graphic choices. In the wedding market, whenever something is specified as "bridal," it often means the prices are higher. You'll get much better bargains by shopping at a party supply or craft store for a case of pastel throwaway cameras.

346. Shopping for throwaway cameras at a craft or party supply store also means you won't have to pay for shipping.

347. One special offer that could make a certain brand of throwaway camera more appealing...free developing. Be sure to shop around.

348. Place only one throwaway camera on each guest table, rather than two or three. You'll have plenty of photos when you develop over twenty rolls of film, especially with cameras that offer a higher number of exposures. (Check! There is a difference! Some pretty throwaways only have twelve exposures each.)

349. Look into throwaways that offer the option of having pictures put onto a website or on disk. You can then email them or print them out on your own.

WIDE-ANGLE LENS

Get one of the cool throwaway cameras that provide a wider, panoramic picture. I love these for their unique, sweeping shots. Today's panoramic cameras can get you that shot of all your guests that you wanted, or a great view of the reception hall's grounds. For under $10, sometimes under $5, your panoramic camera can capture the same effects your professional photographer gets with his or her very expensive camera lens.

USING YOUR OWN DIGITAL CAMERA

350. Use your own digital camera to get shots from the reception—or have a relative or friend use their digital camera, since you'll be busy. Just download these shots onto your wedding website to share images with all of your guests right away...for free!

351. Check the prices of online photo download-to-developing. Wal-Mart has it, Target has it, and check out www.Ofoto.com, where you can download your shots for developing priced at just pennies. These online developing sites often provide discount coupons when you use them regularly as well.

YOUR MUG SHOT

Check these online developing sites for their gift lines, such as mugs or mouse pads that you can have your wedding picture printed on. These items (especially when used with those coupons) can make great gifts for friends and family, and these sites often email out regular 15 percent off coupons and holiday-timed special prices when you use them to develop your everyday digital pictures.

352.

With photo development you'll order yourself, again don't rush delivery. Wait a few extra days and save a bundle in shipping fees.

353.

Check out the developing prices at discount stores near you. After a bit of checking around my house, I switched to have my print pictures done at Costco rather than at a photo shop. The savings for your big order could add up.

354.

Email your friends and family a link to a page where they can view your downloaded wedding weekend pictures and order their own. This includes Ofoto.com, Target, Wal-Mart, and many other online sources. They order, and they pay, which saves you the cost of paying up front and the awkwardness of asking for payment later.

SPECIAL TIPS FOR VIDEOGRAPHY

355.

Again, limit the special effects. Video editors love to showcase their editing talents with titles, color and timing effects to make your wedding video look like a music video, and even some baffling effects like animated characters popping into the frame while you're dancing your first dance. Your wedding video isn't going to be up for an Emmy, so limit the video editor's freedom with effects and save a ton of money.

356.

Editing is where all the cost is. If you so choose, elect not to have your wedding video footage edited at all—not right now, at least. Your videographer can give you what's called the "raw footage" he or she has shot, so that you have your entire wedding in real time, as it was shot. Some couples prefer this format at this time, since they don't lose precious footage to an editor's allotted forty-five minutes of tape time for the final product. You don't miss a thing, and very often you capture memories that would have wound up on the cutting room floor, so to speak. You can always have this raw tape professionally edited later—perhaps as an anniversary present—and then have both versions in your possession forever.

357. If you will choose titles and special soundtrack songs, you can save money by providing the music CD to the editor. If he or she has to locate the music, that's extra time and money on your bill.

358. Don't order a special videotape or DVD case for your wedding video. Some bridal versions are pricey, especially those designer fabric-covered cases. (No joke—these exist on the market for lots of money.) Use a plain or white case, and make a label on your home computer.

359. Skip the engraved marker for the front of your video case. A label works fine, and this is an unnecessary effect.

A PLACE TO SPEND, NOT SAVE

Don't plan to copy your master tape for everyone who wants a copy of your wedding video. That adds wear and tear to your original and can age it or ruin it. Hire your videographer to duplicate your tapes professionally, and pay extra for this service. It's worth it in order to save your master copy.

360. If you do wish to copy your videotape yourself, saving yourself the $15 to $25, some videographers and camera shops charge per copy, make one copy directly from your master tape, and then put your master aside. Make your additional copies from that copied tape, saving your master from wear and tear, and sometimes complete destruction.

361. Buy blank videotapes at a bargain from stores like Costco, Sam's Club, Target, or Wal-Mart. A pack of fifteen blank videotapes can cost you less than one professionally made copy of your wedding video.

FOR EXTRA PROTECTION

Protect your wedding video with these smart steps:

- Order an extra copy of your wedding video for yourself, and put that in a safe deposit box at the bank for safe keeping. If anything tragic happens, you'll have your own second copy.
- Insure your wedding videotape or DVD on your homeowner's insurance policy, just to be on the safe side. Some insurance policies, depending on conditions, might give you the money on your claim to re-stage your wedding ceremony for pictures, believe it or not. Ask an insurance professional for details on this type of coverage.

362. Some videographers offer a three-camera option. This means that a videographer might have three separate cameras to capture the ceremony and reception action. These three cameras collect every moment from three different angles, and—just like the way they shoot TV shows and movies—give the editor more footage for more creative editing. Sounds more expensive, right? It is. So, be choosy when it comes to one-camera or triple-camera filming—the latter choice is likely to multiply your bill. With both types of photo experts, know that you'll pay extra for any assistants they bring along that day. Ask each pro whether they bring an assistant and at what cost, and know that the assistant gets added to your headcount for the caterers' bill (yes, they get to eat, too). You might be able to cut this expense if you choose a one-camera videotaping option rather than a three-camera option.

363. Skip any videotaping or phototaking at the after-party—guests can always use their cameras. However, you might want a break from the intrusive camera lights and you'll certainly be tired from posing for pictures all night. Take a breather from the cameras and just enjoy the party.

364. After the professional videographer leaves, have a friend or relative capture the remaining hours, and the after-party, on his or her own video camera. Especially in these later hours, great footage is still to come, so don't miss a moment.

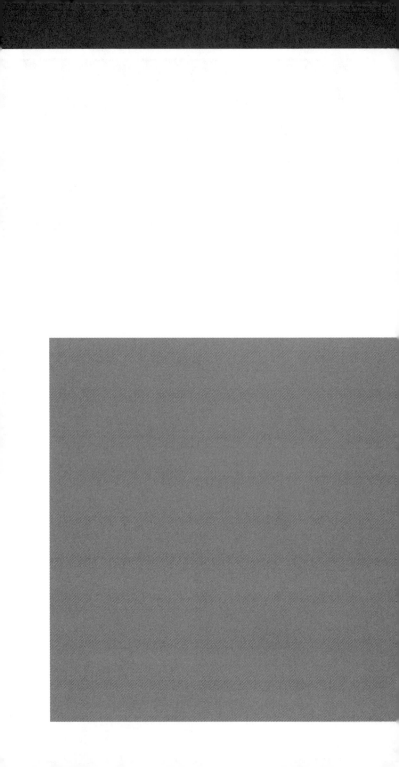

15

Wedding Day Wheels

For you, the perfect wedding dream might include a gleaming stretch limousine, a horse-drawn carriage or even a regal Rolls Royce to deliver you in style to your ceremony and to whisk you away after you're married. But can you have any of these high-style rides when you're on a tight budget? Absolutely!

365. Find a great, reputable limousine company or classic car rental agency through the referral of friends (always the best way to go), or by asking your nearby upscale hotel's concierge to recommend the limo companies they use to transport their most important guests. Hotels have a built-in reason for finding a company with great service at the best rates, so they're one of those inside-secret sources and a great advantage in finding the best company for you.

366. Check out car rental companies, and find additional companies to add to your research, through the National Limousine Association. You can reach them at 800-NLA-7007 or at www.limo.org.

367. Tighten your schedule. You can save a fortune if you can plan your day so that you need fewer hours of by-the-hour services from a limousine. For instance, you might just book limos for the ride between the ceremony and the reception. Skipping the "to the ceremony" ride and their one-hour wait during your ceremony means thousands of dollars saved.

368. Only book a limousine for the two of you. The rest of your bridal party can travel in a decorated van, the hotel's shuttle bus, or their own decorated convertibles.

369. If you don't like that idea, book only the real amount of limousines you'll need. Some cars can fit twelve passengers, which might mean you'll only need to book one extra car instead of two.

370. Instead of renting a stretch limousine, rent a regular size limo.

371. Check for price variations in the color of the limousines you'll rent. Bridal white is usually more expensive to rent during high wedding season than black limousines. As an added bonus, brides say they loved the color contrast of them in their white gowns standing against a shining black limousine in all of their pictures. A white car wouldn't have looked so terrific. Gray and shaded limousines are also a price break.

372. On the same front, novelty color limousines (like purple and pink) will be more expensive to rent, so find another way to express your individuality (unless you're in Vegas where that kind of thing is not uncommon!).

373. Skip the "loaded" limousines. Companies will charge extra for the use of limousines with a wet bar, satellite TV, skylights, mood lighting, special sound systems, and the works. This isn't a nightclub, it's a ride to your wedding. Go with the lower-frills models for better price breaks.

374. Skip the extras, like snacks and liquor stocked in your car. Negotiate those additions out of your contract unless water, soda, and snack mix is included as freebies in the car.

375. Decide what to do with those bridal extras, like the red carpet, champagne stand, and the horn that plays "Here Comes the Bride." They may be offered for free as part of the company's bridal package, or you might be able to negotiate a discount if you don't want them. Never pay for these! They're not necessary!

376. Check with classic car clubs to see if members are in the practice of renting out their mint condition Mustang convertibles or Rolls Royces for weddings. Some proud collectors do make a side living doing just that, so make a few calls and see what you can find.

377. When you're looking at renting truly upscale luxury cars, comparison shop like wild and schedule for fewer hours needed. You may be able to get your (or your groom's) dream car for just an hour or two of use for the same price as a bargain limo for five hours.

378. Couples today love the arrival in a romantic horse-drawn carriage, so they book it for just the arrival or just the getaway. Comparison shop, ask for minimum hours and budget price packages—don't forget the cost of any extra permits—to see if you can make this wedding dream of yours a reality.

YOU'RE GIVING US A HORSE?

379. Parents are always looking for ways to make your wedding dreams come true. Why not ask them to make the booking of a horse and carriage for your day their wedding gift to you? Grandparents have gotten in on this generous gift, delighted that they could give you your heart's desire and something special that all the guests will love seeing.

NO PAYMENT NEEDED!

380. Don't hire any limousines or classic cars at all! Use your own (or borrow friends') convertibles for a more personalized ride to your wedding. You also have more options to decorate the cars and really grab attention while riding through town.

381. If you're a couple that loves your motorcycles, speed off on the groom's while you hang on tight to him from behind.

382. If your wedding will be by a marina or a dock, perhaps a friend or relative can decorate his or her boat with flowers and lights and deliver you by water as a gift to you—great image, great pictures, no price!

383. The hotel's shuttle bus—if you can use it for free—can deliver your bridal party and guests to and from the wedding sites, as well as to and from the airport during their arrivals and departures.

384. Here's an idea that city dwellers are using more and more: they're taking public transportation as a group. Hop on board a trolley with your bouquets and your tuxedoed men for an unforgettable and camera-worthy ride.

385. City couples do it for fun and to pay homage to the city they love: they take a yellow cab to their reception.

386. Don't forget the very Old English and Mediterranean tradition of leading a walking procession from your ceremony site to your reception if the two sites are less than a few blocks apart or just across the grounds of one establishment or park. These processions are a lot of fun for guests, provide great mingling time, and give great picture opportunities.

A SAFE RIDE HOME

387. The hotel's free shuttle bus is perfect for getting guests who have been drinking home in a safe manner.

IF NO FREE RIDE IS AVAILABLE

Arrange with the reception site to have a reputable cab company's number on hand, and then you'll pick up the tab when guests need to be driven home on a fare.

388. Before the wedding, arrange for several good-hearted guests to refrain from drinking during the reception and serve as designated drivers for any guests who need to get home safely. (I know this is asking a lot of your guests, so consider this option only if you know you have friends who wouldn't mind volunteering.)

NO RIDES NEEDED

389. If you're planning your ceremony and reception for the same site, such as at home or at a hotel where you'll be getting ready for the wedding beforehand, you might not need to book any cars for anyone. All of your bridal party and guests are already at the hotel, and no one will need to leave the premises for any part of your wedding day. Now that's a huge savings!

Travel and Stay for Less

You're not a novice at traveling. You know how to find the great deals on airline tickets and you know how to book through discount travel websites. I'll simply remind you to use your budget travel smarts, with a few reminders for travel and lodging deals that you might be able to use specifically for your wedding and for your wedding guests. Remember, it's gracious of you to try to save them all money, even if you're not paying for their expenses.

390. Look at the new wedding group discount packages popping up at various airlines. The marketing gurus at American Airlines (www.americanair.com) know that today's brides and grooms choose destination weddings and that they also might be living far away from the old hometown where the wedding will take place. We live in a global society, and we travel for work and for love. Our weddings might not be held in our own cities of residence or our guests are scattered across the country and they'll need to travel to get to your wedding. So, these new wedding-based group discounts are an idea whose time has come! Check around and see if you can get great discounts as a wedding party.

391. Plan now to use your credit card reward points or frequent flier miles for your own wedding-related travel. Since you're charging most of your wedding purchases anyway, be sure you belong to a rewards program that can give you a travel or hotel freebie or discount.

392. If you're not familiar with discount airfare sites on the Internet, start getting familiar with them. (A selection of them is listed in the resources section to get you started). Ask friends and family if they can recommend a great discount travel site that gives them the freedom to choose their own flights and travel details.

393. If you're not a flier, look into the discount travel packages offered at Amtrak. This national train service runs special discount packages that may also give you a free night's stay at a hotel, plus free or discounted certificates to area attractions and restaurants in your destination city. Depending on the distance you're traveling, this could be a great move with extra fringe benefits.

394. Use your hotel club membership to get lodging freebies or discounts. (See the resources section for hotel and resort websites to look into partnership programs.)

395. Use your AAA discount for hotel and airline discounts.

396. Students, military members, and veterans might also get extra travel-related discounts by showing their active ID cards.

397. For your guests' hotel accommodations (and yours as well if you and your family will be staying at the hotel), look into booking a block of rooms at discounted prices for all of your guests. Wise and considerate brides and grooms are reserving blocks of rooms at a range of two or three different hotels—one more upscale for guests who travel and stay in style as a part of their natures, and another family-friendly or more moderately priced hotel chain. Guests love being given a choice so that they can stay where they are more comfortable.

WHAT WAS THAT IN THE CORNER?

Never book moderately priced hotel rooms for your guests without seeing them first. Going too cheap can land your friends and relatives in shoddy rooms with no cable or air-conditioning, a bad bed, and very thin walls. Several couples have written in with the nightmare story of guests telling them later about seeing a cockroach in their room. Avoid the truly low-budget lodging and always tour the rooms. I was surprised to see that a well-known business hotel actually didn't maintain or clean their rooms very well. So never go on the strength of a chain name alone, always tour.

398. If you have reserved a block of rooms at the hotel where your wedding will take place, you might be able to negotiate for your wedding night suite for free as the marrying couple. Many hotels and resorts will offer this as a freebie, even giving you complimentary champagne and free breakfast the next morning as an enticement to book your twenty guest rooms with them.

399. Many couples are asking their parents to give them a truly luxurious wedding night suite at the hotel as the parents' wedding gift to them. Especially now with more brides and grooms paying for all or part of their weddings, parents are all too happy to give the couple a five-star room to start the marriage off in celebrity-worthy style.

400. Choose hotels that offer many amenities for free, such as use of their gym and spa, pool, tennis courts, and so on. I already mentioned that doing so gives you a built-in opportunity for wedding weekend activities, but it also gives you access to a spa where you can chill out or a gym where you can work off some of that immediate pre-wedding stress.

401.

Negotiate for unique freebies. Talk to the hotel manager to see if you can trade in elements of your honeymoon suite or room package—the free dinner and free breakfast (since you'll be attending pre-wedding events at both times), the free champagne and flowers in the room (a nice touch, but you'll have enough champagne and flowers on the wedding day), and the morning newspaper (*you're* the big news of the day, no need for any more!)—for a free massage at the spa. You'll be surprised at how willing hotel managers are to trade freebies and offer discounts, so ask for them!

402.

Facilitate room sharing by your guests or bridal party members. You or a trusted, organized friend can serve as the "room sharing ambassador" by lining up rooms with two double beds that two couples can use. You can also book a suite with two separate bedrooms and let two or three couples share that room. Per couple, it's a savings for them (or for you, if you're paying). Guests can choose whether they want to share a room with others, which is often a great way to extend the fun of the weekend for all. Post this option on your wedding website or spread the news through word-of-mouth, and then give guests a deadline by which they should respond with their willingness to room share.

403. A popular new option is reserving rooms at a nearby bed and breakfast, which is often less expensive than hotel rates and provides a warm, cozy, quaint atmosphere (not to mention a great gourmet breakfast every morning). Some couples are reserving the entire bed and breakfast establishment for their wedding party, particularly if the wedding will be held on that B&B's grounds. Research well to find grand, sprawling B&Bs or adorable, charming Victorians with just enough bedrooms and a leather-chair sitting room with a roaring fireplace. Guests love the unique lodging, and are often surprised that such a lovely place is priced so inexpensively.

YOU CAN STAY AT THEIR PLACE

404.

If you have only a small number of guests coming in from out of town, perhaps only your parents, a relative or friend would be willing to open their home to them. You might be surprised that many people love sharing their homes, showing off that new guest bedroom they just redecorated, and they welcome the chance to spend extra time with guests who are friends to them as well. You'll give them the gift of more quality time, easy lodging arrangements, and even a chance for both families' kids to play together. If this arrangement works, be sure to get the generous hosts a special gift from the two of you as a thank you: a great bottle of wine, flowers, a gift certificate for a nice dinner out on the town, or something special for their home. Just a word of warning: think twice about opening up your home to overnight guests. There's going to be a lot going on in the last few hours before the wedding, and you don't want to stress yourself out by playing hostess at the same time.

405.

If you're planning at a distance, limit the number of times you'll need to fly out there to make wedding arrangements. Of course, I would never advise you to plan without seeing the site or meeting with professionals in person. That's just not wise. You can, however, arrange to see some things using a 360-degree, interactive tour tool on your computer. Many hotels and ceremony and reception locations have very useful tools on their websites where you can view a slow, sweeping view of interior rooms or the exterior of the buildings. Your on-site wedding coordinator can show you certain elements online (like cakes and flower arrangements), giving you a link to the page where the design is shown. Web cams can be used for virtual meetings with your coordinator, baker, or site manager, just like in the world of big business. Use modern technology to save a bundle and prevent you from having to take too many trips out to the other side of the country. It's not a replacement for being there, but it can save on some elements of your viewing and meeting needs.

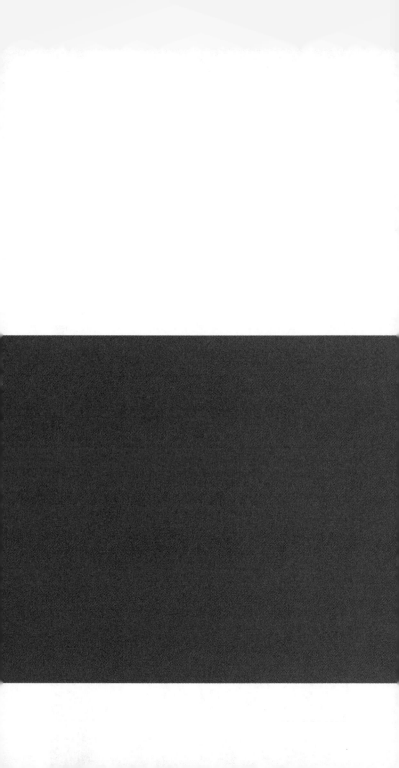

Part Four:

Planning the Ceremony

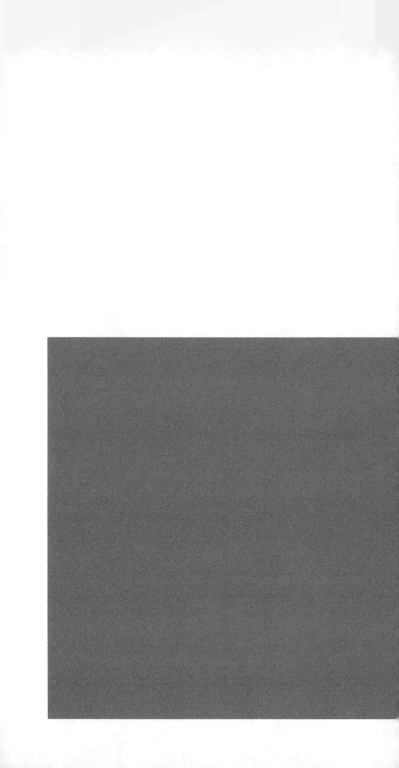

Ceremony Expenses and Décor

You may be so focused on the expense of the reception right now that you've forgotten the ceremony has many elements that cost money. True, they won't be as large as your reception bill, but the little things can add up to big bucks. That's always the best place to look for savings and freebies. In this section, you'll look at all of your ceremony expenses to see where you can earn yourself more for less money.

406.

For your chosen ceremony location, the officiant's fee and the site fee are almost always nonnegotiable. At many churches, officiants expect a $50 to $200 payment for their time and services, and some houses of worship do ask for a "donation" to use their grounds for your wedding. If you are not attached to a specific church or synagogue, research the going rates at area houses of worship. If it's a must to marry at your church, for instance, you'll pay the fee and find other places to cut your budget.

HIRING AN OFFICIANT

If you'll hire a nondenominational or interfaith minister, shop around to find the best personality match first, taking their fees into consideration second to make your decision. Notice I said to find a "personality match" first. It's very important that you have a good rapport with your ceremony officiant, that he or she is invested in giving you the service you want, and that you agree with his or her style and self-expression. Sure, you could hire the cheapest person in the phone book, but will you stand there slack-jawed when he pulls a puppet out of a bag and performs your ceremony with the help of his little friend? Don't laugh. This happened to one couple in New Jersey, who report in that they still hear friends joking about their wacky wedding vows.

407. If you're stuck paying the officiant's fee, see how much you can get for free. Some churches allow free use of their pianist or organist, and all you have to do is tip them appropriately.

408. See if you can get the church choir to sing at your wedding in exchange for a donation to the church.

409. Some churches have children's choirs, which you can book for just a small donation to the church or to their affiliated children's programs. (It's always a plus when you know your donation is going to a good, helpful cause.)

410. See what the church or synagogue has on hand for you to use. If their storeroom houses an aisle runner that's in good condition, ask if you can use that on the wedding day. That way, you won't have to rent it from your florist.

411. The same goes for an existing chuppah that you can use "as is," or add some simple floral decorations. This borrowing adds up to big savings when you don't need to rent a fancy chuppah.

412. See if the church has existing pew bows. Some churches stock these for their own use and special occasions, like holiday Masses. If you're allowed to dip into the box of pretty tulle bows, you'll get this accent for free. You always have the option of adding simple, fresh flowers to these pew bows to make a prettier statement for less.

413. Churches and synagogues may hold candlelight services as a regular part of their mass schedule. See if they have candleholders attached to their pews or seating rows, along with a supply of candles. They may allow you to use them for no charge or for a small donation that will cost way less than if you bought these items yourself. Kerry from Los Angeles wrote in to say that her church offered her a choice—she could buy her own fresh white candles or utilize their used supply. "When I saw their 'used' supply, the candles were only burned down about an inch, so they were definitely good enough for my wedding. No one would ever notice they were used. It just looked like they'd been lit earlier in the day. So we took the free offer!"

414. Depending on the season of your wedding, see if the church will already be decorated for the holidays, saving you from ordering any floral arrangements or other décor. In the weeks before (and the weekend after) the Christmas and Easter holidays, you could find that the church is overflowing with gorgeous potted flowers, poinsettias, red candles, Easter lilies, and so on. With good timing, the church's efforts will take the place of your own, and you don't have to spend a dime.

415. If possible, see if the church or synagogue will put you in touch with the other couple marrying on your wedding day so that you can broach the subject of sharing the design costs to decorate the site. I know, it sounds odd that you'd want to use some other bride's tastes in floral décor, and it might sound like a major headache to add another person to negotiate with into the mix. Here's the secret: you arrange to split the cost of some of the ceremony site décor. This could mean that you'd order a grouping of beautiful white flowers for the altar décor and side arrangements and split that expense. Then, she's free to bring in her lavender colored flowers for her 11am wedding as an accent to the white floral backdrop. After that wedding, her lavender floral accents are removed, and your deep pink flowers are brought in to accent the backdrop of white. You've both saved a bundle, and you arranged to have your choices in your colors for a fraction of the cost to decorate the entire site yourself.

416. Some brides arrange for their wedding coordinators to transport their ceremony site flowers to the reception site for double use. It's a smart move! That oversized altar arrangement would be great in the center of the parents' table or on the gift table. You've just made $100 work double-time for you.

PERMISSION FROM A HIGHER POWER

417. Before you plan to buy or share the cost of any ceremony site décor, check to make sure your particular house of worship allows you to bring it in. Some houses are very strict about what they will and will not allow to be brought in, and how they'll allow people to "dress up" their altar. Some sites don't allow décor at all! That's important to know before you invest any time and money in ceremony site décor plans.

418. Go minimalist. Use the natural beauty of the church or synagogue, plus its great daytime lighting through those decorative windows, and have one floral arrangement at the altar. Choosing a simpler décor style with one focal point is often a more elegant look than crowding the site with enough floral arrangements to make it look more like a funeral. Less is more, so just design one eye-catching arrangement.

419. Make your own pew bows. Buy a length of tulle or satin ribbon from the craft shop and tie the bows yourself. Anyone who pays high prices for this item is wasting lots of money.

420. If your wedding will be held outdoors, there's no need to place decorations on every guest's chair. That's fine for upscale and celebrity weddings where satin slipcovers and floral bouquets are used on each chair, but it's an unnecessary expense when you can add a simple pew bow to the side of the first chair in each row.

421. With a smart rental strategy and the location of a great rental company (start looking at www.ararental.org), you can rent chairs with colored seats like blush pink or sage green. No extra adornment is necessary for something you need to rent anyway.

422. Ask for a discount from your rental agency. Across this industry, it's widely known that you can get 10 to 15 percent off your rental order if you offer to pay your entire balance up front, rather than half on order and half on delivery. Just be sure the rental agency offers this policy, that you're dealing with a reputable rental agency, and that you have a rock-solid contract. Hang onto to your receipt marked "Paid in Full," get the attendant's name and signature on it, and you've just netted yourself a bargain.

423. If you'll decorate your site with candles, buy them in bulk at a craft shop and freeze them before use. That's right, freeze them. With this preparation step, candles will take longer to burn.

424. Always practice safety steps when you're using candles at your ceremony site. Encase them in glass hurricane lamps or set them high enough so that they can't possibly light your veil on fire when you pass by. Buy inexpensive hurricane lamps at the craft store, where they can be found for less than at home design stores.

425. Decide whether you really need an aisle runner. For some couples, it's tradition and good luck. For others, it's not necessary at all. Your gown will look prettier in pictures when you have a color contrast below and around you, rather than the all-white backdrop an aisle runner provides.

426.

Use the site's natural décor, such as a view of the mountains or ocean, a pond or waterfall, or an existing gazebo on the grounds to eliminate your extra décor needs. All that's necessary might be a few floral touches or a garland on that gazebo, but otherwise the place is pretty on its own. No extra décor or rentals are needed.

427.

Ask for the church's or synagogue's outside fountains or inside waterfalls to be turned on for your ceremony. Some sites have taken great strides to add water features to their establishments (it's symbolic and attractive, after all), and some feature amazing waterfall walls as an added breath taker. Ask the site manager to flip the switch for a peaceful and beautiful scene at your site.

428. Ask whether the church will ring their church bells for you as you exit after the ceremony. At some establishments, the church bell is real, and you may be allowed to pull the rope and ring the bell together. At others, it's a recording or automatic bells that ring without the rope. Whatever the case, ask for the church bells to announce your big step into married life.

429. Before you rent out sound equipment and speakers so that everyone can hear your vows, ask to see if the site has an existing sound system you can plug into. So many couples don't know to ask whether this is an option. At an outdoor wedding, especially by the beach, you may need to pay for microphones and a sound system. Comparison shop in that case or arrange to use the sound system your musicians will be using. With one question, they may allow you use their microphones and sound system while they are not performing.

SOUND RESTRICTIONS

Make sure before you rent any speakers or sound systems, or pay extra for your musicians to bring their own, that your site doesn't have any sound restrictions. Believe it or not, some sites in residential areas and near restaurants with outdoor dining actually forbid the use of any sound systems that can annoy others nearby.

430. Arrange to make anything else you might need for your wedding location instead of renting. For instance, it doesn't take much in the way of materials to make a chuppah. Your handy father or the groom can pitch in with some wood and nails to make the frame, while you and friends decorate it with beautiful fabric, or even flowers and greenery. Check craft stores for the materials you'll need to decorate and look at less expensive wood sources like Home Depot or Lowe's for the frame.

431. See what you can borrow to decorate the site. Some brides and grooms have arranged to borrow a friend's wooden trellis, for instance.

432. Mark your aisle not with a runner, but with a line of potted flowering plants that you or your parents will keep and plant later. I found beautiful potted mini rose plants at my supermarket for $3 each! Placing one at each row of chairs makes for a great aisle marker and gives you something to keep forever when you plant it.

433. If it's a beach wedding, use the sand itself to delineate your aisle. Use the back of a rake to smooth out the sand, and then line the pathway with shells (available in bulk at the craft store or free from the beach itself when you recruit friends and kids on a gathering mission). Another idea is to use a kid's plastic sandcastle mold to pack damp sand into sandcastles that a friend can place at each row. Decorate with mini shells or flowers, and it's beach-appropriate aisle décor that's something special.

IT'S THE LITTLE THINGS

434. Use a basket you already own to hold the wedding programs, if you wish to have a basket rather than an attendant handing them out. I've seen decorated "bridal" program baskets at bridal stores, and I'm amazed that anyone would pay $20 for a basket wrapped in satin with a bow on it!

435. Don't pay top price for a decorative unity candle that you'll find on bridal websites or at card and gift shops. These marketed "bridal" choices are almost always going to be more expensive at these resources due to their sentimentality and slick design. Instead, choose elegant, simple candles for your unity setup. Two plain white tapers for the lighting candles, matched with an unadorned center pillar candle—all placed on a colored platter or a mirror you get cheaply at the craft store—makes for a classic look. It won't cost you more than $20 if you do it right. Check out the going rates for unity candle sets and see if you don't agree that some designs can be way too busy and ornate, some slightly gaudy. Going classic could be more you.

436. Some couples find it more symbolic if they make their own unity candles. By this, I don't mean pouring melted wax into molds to make tapers and pillars, but rather buying candle décor accessory kits or individual pearl push pins at the craft shop for under $5, and adorning your pillar candle together. You can create your monogram in pearl or crystal pushpins, which is an added bonus the freedom of do-it-yourself gives you.

437. Check interior décor shops like Pier 1 (www.pier1.com) or specialty candle sources like Illuminations (www.illuminations.com) for nonbridal designed candles that are your choice for your unity candles. You'll find great colors and design options like cranberry red pillars and tapers, candles with seashells and starfish embedded for a personalized touch to your beach wedding, candles embedded with pine cones and sparkling gemstones, or whatever you desire. Even with these decorative extras, you're still likely to pay less than if you bought a strictly marketed "bridal unity candle."

438. For your ring pillows, again avoid the bridal market. You can find a simple satin pillow at the craft store and embellish it yourself using a silk rose or gardenia and some delicate ribbon or lace. With a few stitches, voila! Your ring pillow is complete for a third of the price of a bridal ring pillow.

439. Ask a recently married friend if you can borrow her ring pillow from her wedding. That's one of the things most brides have no problem lending out for a second use.

440. If drinking a toast will be part of your ceremony or a part of your post-ceremony ritual, forget those decorative bride and groom toasting flutes in the bridal market. You can use plain champagne flutes that you'll decorate with a flower ringlet around each stem. Make these yourself using fresh or silk flowers and a length of ribbon.

441. You can create custom designed toasting flutes by using etching cream, which is available inexpensively at craft stores. These etching kits allow you to design and create beautiful etched glass designs that become priceless, lasting keepsakes.

442. If you want the real deal, engraved or monogrammed wedding toasting flutes can be a requested gift from a grandparent or siblings. Relatives love providing special items like these, so drop your hints, or—even better—make a direct request to any relative or friend who asks what they can contribute to your ceremony.

443. Ethnic items like a crown of olive leaves or roses that you'll wear on your heads, a rosary to entwine your hands during your vows, decorative shawls, or other important cultural symbols and items can be borrowed within your family or from friends.

444. Try making these ethnic items yourself. In addition to saving money, it could help you get in touch with your ethnic heritage.

445. Check with your heritage association to see if you can get a better price direct from an authentic cultural group, rather than out in retail land. Some associations give members terrific deals, and even lend these items out for free, because they are glad that you as a young couple are keeping your most cherished family traditions alive.

446. If your parents used a cultural shawl or crowns during their wedding, see if they'll lend them to you as an important and symbolic family heirloom. Parents (and grandparents) love this gesture and are usually very willing to comply and appreciate the honor of you asking.

MUSIC AT THE CEREMONY

447. See if your location offers its own pianist, organist, vocalist, or choir that you can use for free or for a nominal donation (after you audition them, of course). In addition, ask about the different types of soloists and choirs that they have available. Many houses of worship employ different groups like three opera sopranos or a group of chamber singers, harpists, and cellists that they can recommend to you. Many couples tell me that they were surprised the church had a list of approved musical groups, soloists, and musicians that cut down their research time tremendously.

448. If you'll hire wedding musicians or singers for your ceremony, audition all possibilities and comparison shop to find the best-priced package. Look for musicians who offer by-the-hour price packages and not those with a two- or three-hour minimum. Most often, you'll only need them for half an hour before the ceremony, a performance during the ceremony, and then for the recessional. It's only an hour you're paying for, not three in a padded-for-profit plan. That could add up to $100 in savings.

449. Look in unique places for musicians and singers that you can hire for your ceremony. One bride found her pianist at a brunch held at a fancy hotel. She took his card, called him, inquired about his wedding rates, and chose him for her ceremony and cocktail hour. He was fantastic. Other places to find musicians: free concerts at museums and art galleries, bookstore music nights, coffee shop music nights—all of which might introduce you to a fabulous guitarist, singer, pianist, or musical trio.

450. Check at universities and musical colleges, where talented young performers are eager to show off their talents and add a performance to their resumes. Audition well and you might just discover a celebrity in the making.

451. Ask at your local high school to see if their most talented flutist or trumpet player might be hired for your wedding. This option is low expense, but keep in mind that you'll have to get the board of education's okay first. Schools are rightfully protective of their students and may require you to sign waivers and get parents' permission.

452. Have a friend or relative perform a song at your ceremony as their wedding gift to you. A father who plays guitar for his daughter, a sister who sings a song, a friend who composes a song for your wedding and plays it at your ceremony...money can't buy those special additions to your day.

453. Hire ethnic singers and musical performers at a bargain through your ethnic or cultural association to give your wedding an authentic traditional soundtrack.

454. If the site has a sound system, you may be able to play a CD of Vivaldi's "Four Seasons" as the guests are seated, your favorite recording of "Ave Maria" during Mass, or a playful original song as you and your groom run back down the aisle together. One couple played Etta James' song "At Last" as the bride walked down the aisle. Every one of her friends knew that was her favorite song, and she'd been talking about walking down the aisle to it since she was about fourteen years old. For less formal weddings, using your own CDs and a sound system can be the perfect answer to your budget woes, still giving you the songs you love at your ceremony.

Post-Ceremony Expenses

The expenses for the ceremony don't end once the vows are said and the rings exchanged. A few extra touches still remain to be dealt with.

455.

Don't buy pre-packaged pouches of bridal birdseed. You can save a fortune by making your own pouches (or buying little tulle pouches at a craft store) and filling them from a big bag of generic birdseed from the grocery or bulk foods store.

456. Forget the special, new brands of "organically-safe," puffed rice as a post-ceremony toss-it. This trendy new item on the market claims to be safe for the earth and for birds who might eat it, but it is pricey beyond belief. Birdseed is the best bargain alternative.

457. Ask the site first before you buy or prepare any post-ceremony toss-its your guests will shower you with. Some sites do not allow birdseed, rice, flower petals, or anything else you imagine for your showering as you run for the limo. Buying anything for this use before you get permission could add up to a waste of money when you can't use it.

458. Get bridal bubble-blowing bottles from a craft store in bulk, not from a bridal web-site. You can create your own personalized labels on your home computer—using little graphic labels from the office supply or craft store—for far less.

459. Given a choice, go for plain bubble bottles instead of the fancier ones that look like little champagne bottles. Comparison shop between standard and décor styles to find the better buy.

460. Buy little bells at the craft or dollar store, and let guests ring them as you go by.

461. Don't plan to release balloons after your ceremony. Not only are helium filled balloons pricey, but they're bad for the environment when they float back down to earth.

462. Hand out very inexpensive pinwheels bought at a toy store for guests to hold in the breeze while you dash by.

463. If you love the idea of a live butterfly release, you can get the effect with less of the expense by choosing only a smaller purchase of butterflies rather than enough for all the guests to open. Some brides and grooms elect to have their mothers or grandmothers open one box of a half dozen monarchs, which is actually a lovelier effect than hundreds of butterflies flying free.

464. If you're interested in the symbolic release of doves, know that you're going to spend a lot more than if you bought, say, the bubble bottles. Comparison shop and choose a reputable company for this service.

465. Time your ceremony for an already-planned town fireworks display, such as at the Fourth of July or during one of the many summer festivals that might be planned in your area. Since this is a night concept, this option might work great if you're holding a dessert and champagne party with a view of the fireworks.

SHOOTING OFF SPARKS

466. Giving guests inexpensive sparklers to light as you exit your ceremony is a popular budget idea, but I must caution you to exercise great safety and caution with these. Firefighter friends of mine say burns are common (those things get hot!) and it's never a good idea to have so many flames and sparks near your veil.

467. Applause works just as well as anything your guests may toss at you, and it's free. So, if your site does have restrictions for toss-its or if you'd rather save the money completely, just have your bridal party start a round of applause as you dash down the steps. The bridal party can also start singing a song to send you on your way, and guests will join in. You make the moment special, and there's no expense at all.

POST-CEREMONY PICTURES

468. Remember that your photographer is on the clock, so skip the receiving line after the church and get right to the lengthy picture-taking session.

469. Set a firm limit on the amount of time it will take to get through the picture-taking process. Time is money!

470. During your receiving line, have a friend with a digital camera hovering nearby to take pictures of those first congratulatory hugs. Often, that's the first time you're greeting your friends and relatives on the big day, so there will be something more radiant in your smile when, say, you're hugging your friend from college. Having a friend take these pictures saves you money, since the photographer you hired can be taking other portraits and family photos at the same time.

471. You could choose to hire your photographer for your wedding ceremony only. Your guests can take the reception pictures using their digital cameras and the throwaway cameras on their tables. Ask a trustworthy volunteer to snap the "big" pictures—like your first dance and cutting the cake.

Part Five:

Planning the Reception

19

Pre-Reception Details

Here are just a few extra little details for when the doors to the cocktail hour or reception open, and your guests file in before your arrival. You and your groom may be off in a private room enjoying a toast in one of the last quiet moments you'll share alone for the next few hours, or you might have your bridal party, parents, and kids in that separate suite with you for some valuable private time as a group. In the meantime, your guests are filing in and starting to enjoy the beginning of the celebration.

472. Rather than buying an official wedding guest book with "Our Wedding" or "Wedding Guests" scrolled in italics across the cover, you can simply set out a plain or lined journal that you'll get at the bookstore for less than half the cost of the bridal version.

473. Skip the feather-plumed pen for guests to use as they sign the guest book. A regular black ink pen will work well, as will a selection of pens in different colors.

474. Pre-personalize your guest book by writing in your favorite quotes on the tops of every other page or a message of thanks from you and the groom.

475. You can put your photo or wedding invitation on the first page of this guest book to make it a graphic keepsake as well.

476. Instead of a guest book, set out unique papers or parchment squares and request that guests fill out each with their messages of good wishes and love. Use paper punches in theme shapes (perhaps getting double duty from the same hole punches you used on your invitations!) to pop decorative cut outs into the corners, tops, or bottoms of the pages. These papers can then be used in your homemade wedding photo album, along with your picture proofs, as great matched messages you can put next to each guest's picture.

KEEP IT MOVING, PEOPLE

Set out guests' place cards on two separate tables so there's not a logjam when they're trying to find their names. Guests get through the entrance more quickly, and they enter your beautiful cocktail or reception room sooner.

477. Use a plain journal as your guest signing book and decorate the pages with stickers, such as sage green "dots" to match your wedding's color scheme, pink hearts, or your choice of theme stickers bought for just a dollar or two at a craft store. You can also use decorative rubber stamps and pastel, bright, or metallic ink pads (all inexpensive from the craft store) to stamp the pages of this guest book for added accent.

478. Make the front cover of your no-frills guest book something special by gluing on a seashell or starfish. Use a shell you both found at the beach during a vacation or when you got engaged, or buy inexpensive shells from the craft store for under a dollar.

479. Create a guest book just for kids. Use a plain, unlined journal from the bookstore or dollar store, and set it out with crayons and magic markers. The kids can draw pictures for you and parents can fill in the "artists'" names so that you have a lasting keepsake of priceless artwork created just for you on your wedding day. The kids can play with this at their own table.

480. Also in the kids' guest book department, set out sheets of colored construction paper with the kids' names on them, crayons, and markers so that they can create artwork that you'll add to your photo album later. Kids' portrayals of your wedding day can be a terrific keepsake.

481 Get great, decorative pens, like tri-color inks and colored-ink calligraphy pens, very inexpensively at office supply stores for your guests' use when they sign your book.

482 A hot trend right now in place of a formal guest book is to set out squares of dark-colored papers like black, cherry red, deep purple, or navy blue. Guests then sign each with silver or gold metallic pens for an unforgettable effect at under $5 for ALL your supplies. These papers (dark or pastels) can also be found in ovals, circles, and other unique shapes.

483 The guest book table is often the first thing that guests see when they arrive at your reception. Make it special by sprinkling rose petals all over the surface of the table and placing the guest book on top.

484 For an autumn wedding, tie in your theme by sprinkling gorgeous fall leaves on the top of the guest book table (as well as any family picture tables, the gift table, and so on). You can gather these lovely orange, yellow, and cinnamon-colored leaves yourselves the day before or the morning of the wedding, or get them at a florist shop.

485. For a summer or beach wedding, sprinkle the guest book table with seashells or colored stones (inexpensive from the craft store) to resemble "sea glass."

486. Use these same sprinklings for the family picture table or on a family tribute table where you'll place a floral centerpiece in memory of departed loved ones.

487. Confetti may be a no-no for invitations, but you can sprinkle the top of the guest book table with great colored confetti, including metallics in bright colors or black-and-white confetti cut into the shapes of words. As a twist, use (I love this idea!) swirls of long, shredded strips of pastel or bright-colored paper that you make yourself. Use inexpensive, colored legal-sized paper at the office supply store and a paper shredder machine. (See if you can use the one at the office for your special event.)

488. Use the guest book table as a place to display something fabulous you already own, like a trickling Zen water fountain. Many couples arrange to bring in their own, or borrow a friend's. One couple with great foresight registered for a Zen water fountain, received it as a bridal shower gift, used it to add great ambiance to their guest book table, and then brought it home for future use. It served as a daily reminder of their wedding day. Always think about what you own that you can bring in for the guest book table—you might have something terrific in the attic, like an old-fashioned parasol, an oversized Asian fan, a silver candelabra, or an ornately framed mirror.

489. Since you're decorating the guest book table with sprinklings or paper strips, there's no need to rent a table linen for this table. If you're renting higher quality linens for your official reception tables, you can skip this expense by using the site's free, plain linen tablecloth for this one. The same goes for the gift table and the family picture table.

490. Here's a terrific accent to your guest book table that will thrill guests immediately and let them know this is going to be one fun event: on your home computer, print up dance cards for each guest! Use plain or pastel-colored index cards—perhaps leftovers from your own home office or planning process! Just like the old days, guests will line up who they're going to dance with throughout the reception, recording names with mini pencils you'll get at the craft shop for just a dollar or two. This gets guests mingling and asking "Would you like to dance?" right away.

491. Speaking of using leftovers, you probably have a dozen extra wedding invitations in a box in the bottom of your closet. Make great use of them here by framing them and displaying them on the guest book table, on the family picture table, in the restroom, or on top of a grand piano in the entryway. Using frames you already own, or inexpensive acrylic or silver ones you'll use in the future to hold your wedding pictures, this special touch costs nothing extra and gives a great celebrity-style accent to your reception area. An unframed copy of your invitation can be displayed at the reception site as part of directional signs ("The Kelly-McGuire Wedding This Way—>").

492. Since the entrance to your reception spot is the "door-way" to a magical evening (or afternoon), you can make it special to your guests before they even walk in the door! If your reception site has a fountain into which coins may be thrown, set out a brass bowl of pennies and display a sign inviting your guests to make a wish (for you or for themselves) by tossing one into the fountain before they come inside.

493. Another way couples are making their reception hall entrance extra-special is by borrowing a top celebrity wedding idea and filling the hallway with a beautiful scent. While celebrities are renting $500 scent diffusing machines, you can have the site set up plug-in air fresheners in hallway outlets so that the entryway smells like roses, gardenias, vanilla, lavender, or an ocean breeze. That first impression is priceless, and you've spent under $10 for a $500 effect!

494. Here's something you can often get for free: when guests walk into the reception site, servers are standing by with glasses of ice water (with lemon or lime slices) or ice-cold iced tea for guests' enjoyment before the actual cocktail party begins. Since many guests arrive early or have a little bit of time to kill, being handed a cool beverage right on the spot is a treat—especially if it's a summer wedding.

Reception Décor

Décor is one of the areas of your wedding where you have the greatest number of options to save money. It's all about skipping the overkill, going simple and elegant, and having that look better than the décor at many million dollar weddings. Simplicity is an art form. It's also about creativity and vision, going unique and personalized, and using color and texture wisely. I don't mean to sound like an art teacher, but there really is a similarity to the whole artistic analogy. You're painting a picture with your reception décor. You're taking a blank slate of a room and painting it with your choices.

Let me throw in a slightly different analogy: if you've ever painted a room in your home, you know the ultra-expensive designer wall paint looks the same on the wall as the more moderately priced wall paint. Red is red and blue is blue. It's a

matter of whether or not you're going to pay triple for your choices when you can get the same effect for less. That's what we're after in this chapter.

495. First and obviously, use the natural attractions of the site: a window overlooking the seascape, gardens and lighted grounds, fountains, a lavish poolside area, a terrace. You chose the site because it's the perfect location, so use its existing elements as the foundation and backdrop for your décor. With great lighting, these could be all that you need with just a few simple accents like your centerpieces. See how important choosing a great location can be? It can save you thousands of dollars.

CENTERPIECES

Those enormous, overflowing floral centerpieces that are more like mini gardens and with their dense spreads keep guests from being able to see the people across the table—or you on the dance floor—are not only overkill, but they're also out of fashion. The days of everyone having a floral masterpiece at the center of the tables are gone, especially when you factor in that these particular floral centerpieces with dozens of flowers in them can cost over $100 each in some areas of the country. Here are some beautiful and original ideas for your centerpieces, some of which can cost under $20 each.

Floral Centerpieces

496. You can have floral center-pieces on a budget! Just scale them down a bit so that there's less material and less labor involved. Go with smaller bunches of flowers, like tightly clustered peonies or tulips cut low and sitting in a simple, round glass vase. Longer tables can have two to three of these along the center of the table. This look is the essence of classic simplicity, and you can surround it with a sprinkling of rose petals on the tablecloth, along with a selection of votive candles.

497. Build your floral arrange-ments around two or three expensive flowers, like gar-denias, and then fill in the rest of the arrange-ment with less expensive but still attractive and unique flowers that you'll discover with the help of your floral designer.

498. Use unique flowers instead of the usual bridal choices like white roses, stephan-otises, gardenias, and lilies. Remember that going unique makes it look like you've spent more money on your blooms just because the individ-ual flowers are something your guests aren't used to seeing.

499.

Use more unique greenery like feathery ferns and leatherleaf. Done well, using a coordinated selection of greens will make your smaller number of beautiful roses or gardenias really stand out. It makes for great contrast, and couples love the more natural look of having lots of green in their centerpieces.

500.

Using a range of colored flowers in your centerpieces will make more of a visual impact than using all-white or all-pink flowers. Monochromatic arrangements require a greater number of flowers to make a good visual appearance, and that's more expensive. So mix up your hues to make your centerpieces more interesting without added expense.

501.

Use flowering branches to give your centerpieces unique texture and height. These very inexpensive additions can turn a lower budget, smaller centerpiece with fewer flowers into something really remarkable and artistic. Ask your floral designer to show you some samples of flowering branches.

502. Floral designers are also using unique tree branches, not just flowering branches. With eye-catching offshoots and great bark colors, these branches become so much more than "sticks."

503. Moss is also being used more and more to fill out floral centerpiece bottoms to give smaller, more modest flower arrangements something extra in the form of texture—and it costs next to nothing.

504. Use light to make your centerpieces sparkle. Your modest, smaller floral arrangements can be spotlighted with pin lights from above each table to make them really stand out and look much larger than they are.

505. Multiply that sparkle by adding simple, delicate crystal accents within your floral centerpieces. Floral designers can insert tiny crystal stickpins or crystals on stiffer floral wire into your arrangement. When these prisms meet with light, your centerpieces shine like diamonds, also fooling the eye into thinking they're more substantial.

506. Add something unique to your floral arrangements. Check at the craft store or in florists' design books to get examples of crystal or appliqued butterflies to add into your arrangement, or colored crystal stones set in the planter.

507. Make an all-white floral centerpiece something unique by tucking in $2 faux, feathered birds (doves, cardinals) or colorful butterflies on wire sticks from the craft store.

508. Place a single round glass bowl in the center of the table, fill it with water, and place one fully bloomed gardenia in it. Now that's elegance.

509. Rent, buy, or make flowered topiaries for the centers of your table. You can go with a range of themes for this popular, upstanding design: spring pastels, brights, or winter holiday colors.

510. Rented potted flowering plants can be used for your centerpieces, and then returned the next day. Check with florists to ask about their potted tree and flowering plant rentals.

511. For informal or outdoor weddings, use a vase full of colorful daisies for that bright, sunshine look with minimal expense.

512. Place groupings of wildflowers in a vase, which may be perfect for your wedding's style and theme (and location if you're outdoors, in a converted rustic locale, or a bed and breakfast) and also costs a fraction of traditional wedding flowers.

513. For long tables, you can line up an arrangement of long-stemmed roses or flowers lying flat on the table, surrounded by rose petals, greenery, or pine cones.

514. A circle of tiny, inexpensive glass bud vases from the craft store can be filled with single roses in each or alternating roses and lily of the valley for a lovely floral look at less than $20 per table.

PETALS ONLY

515. For a lovely and inexpensive look, create a heart-shaped mound of rose petals in the center of the table with a range of different colors, such as whites, pinks, and reds. You can also choose different color combinations using the free paint sample strips from home improvement stores. That's right, I said home improvement stores, where you'll find a wall of hundreds of color ranges from pales to deeper colors. Bring your chosen color scheme strip to your florist and order petals in those tones. (For example, select whites to light sage greens to slightly darker sage greens; whites to pale yellows to deeper yellows to slight sage greens; whites to the palest purple to deep purple with a little bit of deep pink thrown in—it's all in the color contrast to give this arrangement visual punch.)

516.

For an all-natural look, center your reception tables with rectangular or square planters filled with healthy, bright green grass, trimmed straight across the top. You can get these popular décor accents at florist wholesale shops or do as many couples do and buy inexpensive planters from home supply stores (like Home Depot or Lowes) and then grow and trim the grass yourselves.

517.

Create all-greenery centerpieces, using unique and beautifully textured greens like ivy, leatherleaf ferns, and other terrific greenery your florist recommends for another all-natural look at 50 to 60 percent off the cost of mostly floral centerpieces. Use texture wisely, perhaps putting moss-covered rocks along the bottom of the planter, going for ranges of greens and yellows in your choice of greenery, adding fragrant greens like mint and chives as well.

Using Candles

518. Use large, three-wick pillar candles for your centerpieces, surrounded by a ring of votive candles—all bought inexpensively at the craft store. Sprinkle rose petals around the base, or place individual flowers around the base of the candle. The cost? Under $25 per table. Don't forget that these candles can be found in great colors, with embedded texture and sparkle, and even with seashells. Design choices are up to you, so search at the craft shop, at www.pier1.com, or at www.illuminations.com.

519. A ring of single-wick pillar candles adds romantic lighting to the table.

520. A ring of colored votives in great, decorative glass votive holders gives the same effect, and can be visually enhanced by flower petals sprinkled on the table around them.

521. Multiply your candle effects by placing all of your candles on a large mirror, which will reflect the shine of the flame and the shape of the candle and make your simple centerpiece really stand out. Choose rectangular, square, oval, round, or beveled mirror shapes from the craft shop or from inexpensive home décor shops like Bed Bath and Beyond or Target.

522. You can have large mirrors cut into your desired table-top shapes (those ovals or squares) at Home Depot, where their expert cutters can create just what you need for a surprisingly low price.

523. Use floating candles in a water-filled glass bowl at the centers of your tables.

524. Look into inexpensive shaped floating candles. Check craft stores and sites like www.illuminations.com for the season's new styles and colors of floating candles. In spring and summer, for instance, you might find butterfly-shaped candles in bargain-priced packages of six or eight.

525. With floating candles, you can multiply the effect by placing several handfuls of colored glass stones at the bottom of the water-filled bowl. You can find bulk bags of these pretty colored stones in craft shops and at Bed Bath and Beyond, Target, and other discount stores.

526. Brides tell me they love the simple elegance of having clear glass stones at the bottom of their centerpiece bowls, as they give just enough of a visual detail to make it interesting, reflect light, and showcase a floating candle or flower above them. The clear stones, from the sources mentioned earlier, may even be less expensive than the colored variety.

527. Check out the do-it-yourself candle centerpiece projects at www.michaels.com, the site for the popular craft store chain. They have over thirty simple craft projects you can consider for mixing candles with floral for your wedding. It's a great site for the crafty types.

528. Votive candles can be lovely (and inexpensive) flickering accents for any of the following noncandle ideas.

Other Centerpiece Items

529. This one is my favorite for its color, its ease, its natural beauty, and its low, low, low price: a silver or glass bowl (or basket, for informal weddings) of fruit. That's right, I said fruit. Fill a glass bowl or silver platter with a pile of lemons if your wedding color scheme is in the yellow family, or use limes, oranges, grapes, or shiny red apples. When you buy fruit from a grocery store or (even more cheaply) at a farmer's market, your money will go a long way. A generous pile of green Granny Smith apples, for instance, might cost you under $10 for a guest table. A bag of lemons costs under $3 at the supermarket, and that will take care of a table centerpiece as well. Even celebrities are looking to fruit and natural bounty as their centerpieces since it's a gorgeous natural look. Check into it.

530. If you love the concept of the fruit bowl, but you still want something a little bit more bridal, just imagine how pretty it will look when that bowl of light green Granny Smith apples is accented by white flowers and lily of the valley tucked in here and there. The cost for the added flowers: not even $5 per centerpiece, depending on how generous you are with the add-ins.

531.

For winter weddings, consider making sugared fruit. The look with this one is as though the fruit was covered with snow or ice crystals, and it's all accomplished with egg white and sugar. Check out the instructions for how to create sugared fruit (a great look for winter weddings and for afternoon teas!) at online craft sites and at www.foodtv.com, where celebrity chefs share their best food garnishing and décor effects with you for free.

532.

Of course, sugared fruit is always very attractive when you tuck in tiny white flowers in the fruit arrangement.

FRUIT ON YOUR SHOPPING LIST

This isn't a budget tip, but rather a primer to get you thinking about the many different kinds of fruits you can use in your bowl, basket, or platter centerpiece. Choose all one kind of fruit, or mix-and-match two or three different kinds for a beautiful coordinate with your wedding colors:

Red apples	Pears	Grapes
Lemons	Green apples	Strawberries
Raspberries	Blueberries	Kiwis
Star fruit	Blackberries	Limes
Oranges	Grapefruit	Bananas
Pineapples	Plums	Tangerines

533.

Use your wedding favors as your centerpieces. Pile those elegant Godiva boxes (www.godiva.com) in the center of a silver platter.

534.

You can also place them on a platter that you've covered with a square of velvet. Choose your velvet colors—red, black, burgundy, deep purple, hunter green—at a fabric mart for low cost, and then don't even bother hemming the squares. Just tuck the ends of the fabric under the round or square platter, and then add a length of gold cord and a tassel (also from the fabric or craft store). This high-end look won't even cost you $20 per table.

535.

An oversized martini glass can be filled with a selection of chocolate truffles. Guests won't even wait for dessert before they start picking on them. Look at the various shades and designs of chocolates and truffles (such as Godiva's striped starfish filled with raspberry sauce) to coordinate your selection.

536.

For a beach or summertime wedding, fill a glass bowl with sand and place a few seashells and perhaps a starfish (all bought in bulk from the craft store) inside.

537. Use a glass bowl filled with unique seashells that you found on the beach or bought in bulk.

538. Oversized conch shells can be the centerpiece, surrounded with votives and a sprinkling of seashells around it on the tablecloth.

539. At some summertime and outdoor weddings, couples choose living centerpieces in the form of goldfish swimming in glass fishbowls, with color coordinated rocks in the bottom. (Do not use this idea if it will be hot outside, or the fish will literally poach in the sun.)

540. At the craft store, pick up inexpensive ceramic figures (like sandcastles), which you can get already painted or paint yourselves. One couple from Boston wrote in to recommend the vast array of ceramic figures and statues in the craft store that they spray-painted themselves in a color to match their theme. The cost for each: some as low as $3. Check out the offerings, since you could find something that's just perfect for your theme. Plus, it's a fun craft to do together as a couple.

541. Rather than spend a fortune for an elaborate ice sculpture, you can make—or commission an ice sculptor to make—small-sized ice sculptures to place in the center of each table. Before the big day, experiment with plastic molds and kits that you'll find in the craft store. Check toy stores for items that would work as plastic molds. Get creative and do some practice runs first.

542. Center your tables with mini wedding cakes. This is a popular new trend even among celebrities. Rather than ordering one giant wedding cake, couples are ordering several smaller, decorated bridal-style cakes in a variety of designs and fillings, and using those for guest table centerpieces. This is a tasty double-duty purchase, as guests get to dig in when you cut the mini cake on your table (and they'll probably swipe some icing throughout the party).

543. Fill the bottom third of a large glass bowl with a collection of colorful beads. Today's beading supply companies offer lovely designs in pastels, brights, ranges of whites, pearlized, patterned, and metallics in every color of the rainbow for a beautiful and inexpensive effect. Check craft stores for bulk purchases or visit www.2beadornot2bead.com for your order.

544. Center your tables with oversized mosaic coasters or platters that you'll make yourself, using craft store mosaic tiles and stones in your color scheme. Try creating your own monogram designs for celebrity effect. Set glass bowls of floating candles on top for a see through effect. This is a deceptively inexpensive craft idea that many couples love to work on together.

545. Fill glass bowls with colored feathers, available in great pastel colors from the craft shop. This celebrity wedding idea brings in the whole angelic, ethereal look, and while celebrities may pay hundreds of dollars for theirs, you get yours for under $15 total.

546. Borrow another hot celebrity wedding décor look, and center your tables with oversized acrylic cubes, rather than glass bowls. These hollow squares can be filled with lemons, limes, oranges, green apples, red apples, and then expertly dotted with little tufts of baby's breath or white chrysanthemums throughout for color contrast. This high-style celebrity décor idea costs hundreds from a celebrity-wedding designer, but for you, it's going to cost under $20 per table—very stylish. Get the cubes from the craft store, and get the fruit in bulk from a farmer's market.

547. Set out pitchers of colorful drinks (like red punches, water pitchers filled with lemon slices, or sangria) in the center of your table for guests to serve themselves. This colorful option allows guests easy access to their drink of choice, adds color to your table, and can be spotlighted from above.

548. An arrangement of breads, grissini, crackers, and spreads like tapenade, olive oil, salsas, and garlic butter can be set in your table centers, rather than on the buffet table. Add a few uncorked bottles of red wine, and it's a gourmet centerpiece worthy of a magazine cover. This Tuscany-inspired look is a favorite among guests who love having multiple choices in front of them. It may already be included in your catering menu, which eliminates the cost of centerpieces entirely.

549. Move the cheese and fruit platter from the buffet table onto guests' tables, with separate displays set up on each. Again, it's part of your catering, so you won't have to pay anything extra for centerpieces.

550. Center your tables with framed photographs of you, your parents' wedding, family portraits, and the like. Add some fresh white or colored flowers and votive candles, and you've just taken your separate photo table and divided up your framed pictures to serve double-duty as your centerpieces. Plus, it facilitates mingling when guests come by to see the pictures on others' tables.

551. Center your tables with sand-filled Zen gardens, with little stones and a tiny rake. The "winner" at the table will be happy to get to take that home.

552. An oversized Asian fan can be propped up or laid flat on the table, with votives surrounding it.

553. Bamboo shoot plants are considered good luck, but they can be pricey. Look for smaller sized bamboo plants in ceramic or glass vases, and surround them with votives.

554. High-end chopsticks, usually ceramic or enamel painted in elaborate designs, can be placed in a vase or highball glass. Guests can take them home as favors—double duty, low price. Set this glass on an Asian-inspired plate for even more effect.

555. Center your tables with sombreros or piñatas, strewn with flowers.

Theme Centerpieces

556. At autumn weddings, go with natural bounty again: pumpkins and gourds are plentiful, and you don't have to carve them to display them.

557. Also available in the fall for low expense: lots of apples, colorful corn, and bright-colored leaves for an impressive autumn décor collection. Visit a nearby family farm and stock up.

558. At Christmastime weddings, center your tables with bowls or platters of shiny holiday ornaments. Search stores for inexpensive boxed sets in a range of colors and a range of accents to work with your style.

559. At golf-themed weddings, a bowl of golf balls—either plain white or colored—can be the foundation of your centerpiece, with candles or flowers rounding out the look.

560. For winter weddings, look at Accolyte lighted balls and battery-operated lighted ornaments that can be placed inside a glass vase or platter, glowing from the center of the table, or as a luminous addition to clear flower vases. You'll also find waterproof lighted balls, so check these out.

THE ART OF CENTERPIECES

561. For art-themed weddings (or if you're just an art buff), center your tables with framed prints of your favorite artists' masterpieces. Go to www.art.com to select from small- to medium-sized prints (Monet, Degas, and new artists to discover together), and then frame them yourselves in inexpensive frames from the craft store. Add some votives and flower petals and it's a masterpiece for under $25 per table.

562. For weddings timed around Halloween, center your table with a Ouija board, inexpensive from toy stores, and a guest gets to take it home at the end of the night.

563. Speaking of the toy store, one of the most elegant black-and-white-themed weddings I've ever been to featured chess sets as the centerpieces for the guest tables. It was so unexpected, so elegant, so classy, and so *them*. The bride confessed that she bought the chess sets at a toy store for under $10 each. For the kids' table, she bought a checkers set. Brilliant!

564. At brunches and teas, or even formal weddings where pink roses abound, set out bowls or baskets filled with Victorian-themed ornaments, such as mini rose pomander ornaments. For added savings, shop the ornament stores during the 50 percent off sales after the Christmas holidays. It's worth facing the crowds when you're getting a gorgeous selection of Victorian-style ornaments.

565. For beach weddings, center your tables with sand or with colored craft sand designs. Set out colorful drink stirrers as "sand pencils" and guests can play with their centerpieces, writing messages in the sand, drawing hearts with their initials in them, or drawing pictures.

566.

For any wedding, fill a bowl with sand and as you're creatively pouring in those colored layers, place inside the sand arrangement those good luck wedding charms on lengths of ribbon that will stick out of the bowl. (As a reminder, these charms were placed inside the wedding cake and the bridesmaids would pull them out by their ribbons. Drawing the coin meant prosperity, the wedding ring meant she'd be the next to marry, the pacifier meant she'd have a baby, and so on.) You can bring back the game of chance for all of your guests by embedding unique charms, suitable for both male and female guests, attached to ribbons. The master of ceremonies can instruct guests to pull their charms out, and cards explaining the symbolism of each charm can be handed out at each table. This activity is a fun one for guests and they leave absolutely charmed by your efforts. Total cost, depending on where you get your charms (hint: go to a craft store to get both charms and ribbon): $20 to $30 per table.

567.

For kids' tables—or even at adult guests' tables—skip the flower petals surrounding the pillar and votive candles, and sprinkle candies! Get colored candies in bulk from a candy shop, or buy those massive bags of M&Ms and just use the green ones (order specific colors from www.m-ms.com). This look is surprisingly approachable even for formal weddings, adding a touch of whimsy and perhaps a bit of your personalities. One couple from Maine said they shared a bag of M&Ms while on their first date at the movies, so sprinkling M&Ms around their centerpiece candles was perfect for them—and perfectly inexpensive.

SETTING YOUR TABLES

We've already tackled your centerpieces, and that's always the crowning glory of your guests' tables. But what about the tables themselves? The linens? The place settings? All these are important for your reception décor, and here's how to set your tables in style at a minimum impact to your budget.

Tables and Chairs

568. If you're not able to use existing tables at the site and must rent them, comparison shop between the different sizes and shapes of tables. Longer tables that seat sixteen might cost less to rent than smaller circles that seat ten. Do your own math, check prices at your rental store, and choose the tables that work best with your budget.

569. Know that you're free to mix up table shapes—some round, some square, and some rectangular. You may be able to better use the layout of the ballroom by mixing and matching shapes.

NO CHEAPO CHAIRS

When you're renting chairs, never go with the cheapest model available. You want them to be sturdy, not falling apart like I've seen at some weddings where guests nearly fell to the ground. Look at mid-priced ranges and comparison shop like mad.

570. Plan to use the same chairs for the ceremony and the reception. A team of volunteers can easily move them from one area to the next when you're having both events at the same site (another reason why that's such a wise idea).

571. See if you can skip the chair slipcovers. You may be able to rent chairs that are attractive in and of themselves.

572. Check www.ararental.org to find great sources for tables, chairs, and all other items that you will need to rent.

Linens

573. When you book at a hotel, banquet hall, or at a restaurant, you'll undoubtedly be presented with a swatch card of the linens you can use at your wedding. They'll range in colors from white to brights, even black, so it's up to you to make use of these linens without having to rent a supply of your own.

574. For most brides and grooms, these linens are rather plain, and they're aware that the hottest looks out there at weddings and special events are designer linens. Silk dupioni, sheers, pearl-encrusted, crystal-encrusted, shimmery fabric, textured fabric. How do you swing that on a budget? Simple. You use the plain linens from the site, and you get the special dazzling effects of designer linens by renting sheer overlays or runners from fabric specialists. Booking just that portion is a huge savings, and gives you the décor look you're after.

575. Make your rented linens really stand out. Choose great colors, unique patterns, and something that will make your tables extra special.

576. Rent special, designer tablecloths for only the main table and the cake table. Everyone else gets the house brand, decorated with the centerpiece.

577. Use a special tablecloth for your cake table, such as the family-owed heirloom tablecloth used at your parents' and grandparents' weddings.

578. See if you can borrow a relative's designer tablecloth for your main table or for the cake table.

579. Skip the need for napkin rings by asking that napkins be folded intricately by the site's staff.

580. If you're renting a decorative overlay for your plain table linens, you don't need to rent special designer napkins as well. Using the plain fabric napkins from the site's supply is not only a sensible budget idea, it can also look better than having too much designer linen overkill at each table.

581. Create your own fabric décor for swags, accents to your tent entry, and the like. Buy inexpensive lengths of colorful fabric at the craft store, have someone do a quick and easy hem on them, and use your own draping creativity to get a designer look for next to nothing. Celebrities pay thousands of dollars for these fabric touches to their décor, but you don't have to hire a designer to do this for you.

Table Settings

582. Use the site's existing china supply, choosing your design from their stock. This is often for free as part of your wedding package. You should know that most hotels, ballrooms, and restaurants stock a variety of table setting styles and even colors from classic and elegant plain white to more detailed Victorian floral to rich-looking silver-rimmed plates and cups. Ask to see sample place settings and most sites will set them up for your review.

583. Ask if the site will allow you free use of their colored charger plates. Many hotels and restaurants especially have on site a wide range of colored plates that sit underneath your table place settings just to add color. While they can be rented, you can find other ways to add color to your table—you won't miss those chargers at all.

584. If you are renting plates and chargers, go for a unique look. Square plates are all the rage, as are great colors like deep blues and reds. Comparison shop to see which designer styles would work for you.

585. Use the site's existing stemware designs if you have a choice. Some sites are stocked with a range of designs from simple elegance to art deco.

586. If you must rent glasses, be sure to select a simpler, less ornate style that may cost less, and be sure to rent enough of them. Ask your rental specialist to advise you, and never undercut her suggestions just to save money. Trust your specialist when she says you need four glasses per guest. You don't want them having to drink out of plastic cups when the bar runs out of wineglasses, or banish a parent to the kitchen to wash glasses halfway through the night.

587. Check out the site's stock or a rental agent's price list for unique and specialty glasses, such as martini glasses and those with colored or gold rims.

588. You can use rented glasses, like martini glasses, to make your moderately priced menu items and desserts look more expensive! Get a case of martini glasses in which your caterer will serve chocolate mousse with chocolate shavings on top. With just the moderate price of extra glass rentals, you can multiply the value of many dishes you'll have served. The same goes for unique plates to rent, like small square dishes for the cocktail hour.

589. When you're offered monogrammed plates, just say no! Some sites and rental agencies keep a supply of fancy monogrammed plates on hand in popular letters like M, S, D, and A. Unless it's free, avoid these pricier rentals. Here's a little secret: your caterer can create your monogram using chocolate sauces, swirls and stencil-applied cocoa powders and spices for the same modern, sophisticated effect without extra cost.

LIGHTING EFFECTS

Great lighting is the décor effect of choice at weddings today, and some couples are even hiring lighting specialists to transform their sites and ballrooms. If you don't have the budget to hire a lighting professional, you can request or arrange some specialty lighting on your own.

590. Ask the site manager to show you the different lighting effects they can make using their existing lighting setups. So many brides and grooms forget to ask about lighting possibilities when they're checking out party rooms! Ask to see the room dimmed, with special spotlights, and how they light the dance floor to be able to tell if you won't need to spend a dime on extra lighting rentals.

591. Ask the site manager if they have additional lighting fixtures they can bring into the room. For business presentations and formal charity balls, some hotels and restaurants do have their own special lighting racks and special effect spotlights. See if you can commandeer them for the night, at no extra charge, promising to tip the setup staff well. Also ask the site manager if you can have special spotlights set up on the cake table and the main table. Some site managers will do so at your request, and they can also easily set up special track lighting or pin lighting to highlight guest tables.

592. Ask if the site will light up their outside fountains or pool area for effect. Some sites won't do so unless you ask.

593. If you're not dealing with an existing site, but rather transforming a plain space, a tent, or a unique location, you'll need to get an expert to help with lighting. Your coordinator or a professional you hire can help. If it's going to be you in charge, see which kinds of accent lighting you can arrange with inexpensive spotlights that you can find at office supply stores or specialty lights from party supply stores.

594. Buy tinted bulbs, such as those with a pink hue or an amber glow, on sale at home supply stores and home décor places like Target or Bed Bath and Beyond.

595. Use strings of tiny white lights (such as those you put up at Christmas—also called fairy lights) to decorate your room, tent, or the trees around your site. Using your own stash, your family's collective stash, or strings borrowed from relatives (label them well so you can return them later), you can create—for free—the same kind of very bridal look that other couples pay a lot to achieve.

596. Buy dozens of boxes of white fairy lights at post-holiday sales for more than 50 percent off.

597.

Check party-supply stores for on-sale selections of specialty lights, such as Asian globe lanterns or those strings of tropical fish that would make a cute, inexpensive accent to your bar area at your laid-back wedding.

598.

Ask friends and relatives if they have any theme lights tucked away in their garages or attics, used only once at a family party. You might be surprised to find your contacts are perfectly willing to lend out these novelty items, and they might even let you have them to keep. A couple in Minnesota tells me that their friend lent them ten strings of tropical fish lights that he had left over from his college days. They once decorated his dorm room, and now they decorated the cocktail area for the couple's wedding—for free. No one remembered they'd been a part of the friend's dorm décor.

599.

If you remember that your friend hosted a backyard pool party last summer with tiki torches lining her property, see if she'll let you use them at your beach wedding. Shop for inexpensive tiki torches at party supply stores, where you'll find them and their fuel for a surprisingly low cost. (Be sure to practice safe usage of them, especially if children will be present at the party.)

600. If you can have a site light its fireplaces in their bar, in the ballroom, in the library, or in the sitting room, that's a great lighting effect that's free for the asking.

USE WHAT THE SITE OFFERS

I always love hearing about how ingenious couples manage to get extras and accents from their chosen reception sites for free. Here are just a few examples of what other couples have asked for and gotten, and you can follow their lead with the same requests.

601. If the hotel or restaurant has a grand or baby grand piano on site, such as in the room where their Sunday brunches are held, ask if the staff can wheel it into your reception room. No one has to play it. It just makes for an elegant décor statement, especially if you top it with a great floral arrangement.

602. Ask to have the site's great leather couches moved from a separate lounge into your cocktail hour room, if that separate lounge will not be used on the night of your wedding. Most site managers will be happy to arrange such luxurious seating for your guests.

603. Ask to use the hotel's pool area or atrium roped off for your cocktail party. After hours, the pool is often closed, so they'll probably have no problem with you making great use of their grounds. They might even have a photographer show up to take pictures of your poolside party to use in their marketing campaign or on their website. You've inspired them!

604. Ask the site if you can use their poolside, ornate, metal bistro tables in your cocktail room (a switch on the previous idea). If it's not the summer season and they have those bistro tables packed away for the winter, they might be happy to pull them out for your use. Thus, you get unique seating without extra rentals.

A FEW DÉCOR EXTRAS

605. Use smart décor tricks to make a buffet table or food station appear to be more lavish and packed. Fill the spaces between serving platters with plants, flowers, greenery, sauces in silver bowls, and other effects to fill out the spread. Some caterers do this with crushed ice as well.

606. Add visual flair to your buffet table by choosing a colorful tablecloth and co-ordinating platters, such as deep blue serving platters on top of a baby blue tablecloth, or the other way around. Color contrasting gives depth to the table.

607. No need to rent serving platters and trays for the buffet table—especially when you're hosting yourself (for the reception, the rehearsal dinner, and any other wedding weekend activity). Ask a number of friends and family to bring their own glass pedestal cake plates, silver platters, and decorative serving dishes and platters for your use. (Label these platters underneath with the donor's name for easy return after the party.)

608. Skip the big ice sculpture on the buffet table. It's not necessary, and it turns into one of those "invisible" items that guests only notice when they first enter the room, say "how nice," and then focus on the food. It's not worth the money.

609. Spotlight the wedding cake, making it the focal point of the room and making it look more dramatic than it looked on a counter back in the kitchen. This is the #1 décor tip for making an impact in the room. (I saved the best for last.)

The Menu

Here's a special treat for you: the tips in this chapter can work triple time for you, if not more! Just use them for every wedding weekend event where food and drink will be served—the cocktail party, the reception dinner, the rehearsal dinner, the after-party, various wine and cheese parties or showers, the bridal brunch, the wedding day breakfast, barbecues, clambakes, breakfasts, and quiet dinners at home. These tips can be used many times over, saving thousands from your entire entertaining budget!

As already mentioned, it's the wonderful menu at your wedding that guests remember most. A great spread can make your wedding a success they'll talk about for years—making your wedding the one your competitive cousins and friends will need to compete with for their own weddings—while a skimpy or obviously cost-cut menu can

ruin the entire thing. Freezer-burned appetizers mean failure. You don't want guests walking away from your party wiping their tongues with napkins and trying to get the taste out of their mouths, saying, "I've had better food on airplanes...in coach." Going too far to save money reaches the opposite extreme.

So, hire a great caterer—never hire the cheapest one out there. That's courting disaster and not a savings at all. A slightly more expensive caterer can save you money in the long run. Check with friends for their recommendations (especially friends who planned budget weddings), and interview all of your candidates well to find the best match and talent possible.

Go unique and original to make your menu stand out, and make it seem like you spent more. Done right, your guests will never know that you spent half on it. Personalize your dishes with sentimental choices like the Asian fare you shared on your first date. Let Grandma make her German iced strudel as an addition to your dessert bar for that extra touch baked with love. Hungry for the money-saving menu tips that will save your wedding events? Lets get started...

HERE'S WHERE YOUR HEADCOUNT COUNTS

Brides and grooms devote up to 60 percent of their wedding budget to their receptions, the bulk of which goes to the menu. As you know, caterers and reception sites charge you per guest to figure out your final bill. See where you fit into the national averages from WeddingBells magazine's recent survey that found:

- Eighty-one percent of brides and grooms will have over one hundred guests at their wedding receptions
- The average number of guests at a reception today: 181

That's a lot of mouths to feed, and quite a challenge when it comes to creating a delicious menu for all—but don't despair! You and your caterer can triumph over this challenge, beat the numbers, and create a fabulous, unforgettable menu for less. If your guest list is under one hundred, you have a slight advantage. No matter what, you'll still get great use from the tips in this section.

LET ME COOK FOR YOU!

The first thing you might think in terms of saving money is preparing the food yourselves, or having relatives do it. That's fine for small parties and informal gatherings, even rehearsal dinners or bridal brunches. However, for larger reception parties, you don't want to slave over a stove (or have Grandma risking a coronary as she tries to

heat appetizers for fifty people). Professional caterers are very experienced in prepping for large numbers of people, and they have a system in place. Freeing you up to enjoy your party is one major, priceless perk of hiring a caterer and his or her assistants.

610. Of course, you can ask or allow relatives and friends to contribute menu items for select events. Grandma can make that strudel, your mom can make her lasagna for the rehearsal dinner, and you bring the salad. A friend can contribute her lobster bisque at your clambake as her gift to you. It's a great idea to allow guests to contribute, as that brings something special to your menu—just be wise about obligations in time and money for them.

611. Hire a caterer for the appetizers and meal, and then provide desserts on your own. You can serve desserts such as pastries, chocolate mousse pies, and petit fours you can buy inexpensively from a supermarket bakery, your own favorite bakery, or from a quality warehouse supply store like Costco that has a great, impressive bakery on the premises. You can then transfer these desserts from their plastic or cardboard containers onto serving trays and pedestal cake platters of your own.

612. For very small parties, brides and grooms are reporting in that they hired personal chefs rather than wedding caterers. These chefs whipped up unique meals, even specially requested healthy meals, at a price that was worth it for the couple. It all depends on if your comparison shop deems this professional as the best buy. To find experts near you for your interviewing list, check out www.personalchef.com.

613. Check with your ethnic or heritage association to see if their chefs or member cooking circles can make their specialties for your wedding. I've found that these associations are great resources for ethnic menu items at a discount, depending on what a standard caterer can do with his or her choice lists. It's a comparison shop thing and a tasting thing. See if association members' pierogies or gyoza taste more authentic than a chef's does.

COCKTAIL PARTY AND
HORS D'OEUVRES CHOICES

614. Choose passed hors d'oeuvres, where tuxedoed servers present appetizers on platters, rather than setting up a full buffet. Caterers tell me that choosing this kind of serving style impresses guests, yet still has them eating less than they would from a buffet, saving 20 to 25 percent off your catering bill.

615. Use passed hors d'oeuvres style only for your more expensive menu options, like shrimp cocktail, crab legs, stuffed clams, and other more pricey dishes you want to have at your wedding for less.

616. Skip the seafood bar, which is among the priciest cocktail party options. You can ask to have seafood elements worked into other dishes, as toppers at the pasta station, or fillers at the crepe station.

617. Choose fewer passed hors d'oeuvres options. Rather than having twelve different offerings on those silver platters, select eight. Have servers arrange their platters so that each has two different choices on it. Guests won't have to crane their necks, then, to see where the shrimp cocktail server is.

618. Talk to your caterer about how he or she can make "the usual" appetizer options more interesting, such as adding a tartar sauce or spiced curry sauce in addition to cocktail sauce for seafood items, or choosing more unique fillings for those pastry squares. Going unique adds the appearance of more value to your menu.

619. Rather than choosing all in-expensive appetizer options, choose two or three of the pricier ones as treats, and then fill out the rest of your menu with the more inexpensive choices.

620. Skip the cheese tray. That enormous display filled with tiny squares of white and yellow cheddar, Swiss, and Monterey jack is done at every wedding, and it's the one choice that remains mostly untouched. Either skip the cheese tray entirely, sending guests toward your more enticing menu choices, or just do one smaller platter with a tenth of the amount of cheese squares usually offered, plus something delectable like a warm Brie spread.

621. Skip the big fruit platter in favor of a moderately sized bowl of strawberries. Have strawberries and fruit garnishes placed on your passed hors d'oeuvres serving trays or as accents to buffet dishes like puff-pastry squares.

622. Select fruit platters as healthier options for your buffet table than those creamy- and cheesy-topped appetizers. Your guests on diets will appreciate the offerings, especially if you choose unique fruits and fruit dipping sauces (e.g., caramel, berry, and chocolate sauces), which can be a bargain choice to replace other more expensive platters (like smoked salmon) on your buffet table.

623. Choose more meatless options for your cocktail party menu. If you'll serve a beef, pork, or chicken entrée at your dinner, then you won't need extra meat dishes at this gathering. That means no carving station at the cocktail hour where guests can get a slice of beef or ham. Meat accents can be added at the pasta or crepe stations or as garnishes for your other dishes.

624. Don't overdo your cocktail party! Couples who are trying to compete with other relatives and friends really go too far when it comes to their cocktail party menus. Less is more and too much is overkill. Ask your caterer to limit the number of hot serving plates, stations, and platters to a more reasonable number, and leave guests able to eat the entrées and desserts you've selected!

625.

Choose fewer specialty food stations. A great cocktail hour needs only two or three truly great, unique stations, rather than the four or five stations most sites will offer you. Save 20 percent off your cocktail hour by arranging for a fewer number of truly different choices. What's out for budget weddings: sushi stations, meat carving stations, and raw seafood bars. What's in: pasta stations with great, unique sauces like vodka sauces, seafood sauces, and meat sauces; tapas and other Latin-inspired stations; Asian spring roll stations; other ethnic stations like pierogies—things guests can't get every day and are not likely to experience at other weddings.

626.

Very hot right now (and very inexpensive): the mashed potato bar. Scoops of mashed potatoes are served in martini glasses, and guests choose from a variety of toppings: mushroom sauce, beefy onion sauce, ginger and teriyaki sauce, and a thick corn chowder sauce, in addition to regular sour cream. All of your guests who have allowed themselves a break from their low-carb diets for your wedding day will thank you later!

627. Offer other, inexpensive appetizers in martini glasses or on unique little square plates. Presentation is key for making moderately priced hors d'oeuvres look like you spent more on them.

628. If you will have a pasta serving station, as is always the brightest budget way to go, choose a unique shape or style of pasta like bow ties, mostaccioli, or orecchiette (which looks like tiny oyster shells). Add in unique sauce and topping options to make this inexpensive option more crowd pleasing.

629. Also on the pasta front, go with unstuffed pasta over stuffed pasta (such as manicotti and stuffed shells). Less effort can mean lower prices.

630. Remember that cocktail party food needs to be easy to eat when guests are standing, mingling, and holding their wine glasses. So for ease of consumption as well as a price break, avoid foods that need to be cut with a knife and fork—that means your meat carving station. Finger foods are ideal.

631. Consider a soup bar. Also inexpensive by virtue of its ease of preparation—often priced at just a few dollars per serving—you can offer your guests something they probably haven't had at other weddings and events. Choose from onion soup, clam or corn chowders, crab or lobster bisque (notice the seafood opportunities here), or theme- and cultural-appropriate soup choices like miso soup. Especially for winter weddings, these small cupfuls of soup are often a big hit!

YOU CAN HAVE CAVIAR!

632. Turn the most expensive appetizer toppers into more affordable options. Rather than pure caviar, your caterer can make caviar-infused spreads. I've found countless flavors of caviar spreads at gourmet stores and marvel at their low price. A simple cream cheese caviar spread can be mixed with herbs, tomatoes, and even hot red peppers. Ask your caterer for more options to allow you that caviar touch you've always wanted at up to 75 percent off the pure caviar price!

633. A hot option for informal cocktail hours: fondue stations. With cheesy sauces or melted chocolate, your guests can spear and dip a selection of fruits or pound cake cubes. It's an activity as well as part of your menu, and it facilitates mingling.

634. For traveling cocktail parties, each "stop" along the way doesn't have to be overflowing with foods. Trying to do so will kill your budget. So choose smaller display tables or fill out each area with fruit or floral décor and plenty of candles.

635. Go seasonal with menu choices for your cocktail hour. At certain times of the year, certain foods are in stock and priced well, such as seafood, certain fruits, and specialty meats. Talk to your caterer about taking advantage of the great seasonal offerings to make more from your menu budget. Conversely, skip the pricier out-of-season foods that will cost more to import.

YOUR DINNER MENU

636. Skip the salad course, especially if you had a salad offering at your cocktail party.

637. Skip the soup course. Not only is it unnecessary, but you might have chosen to provide a soup bar at your cocktail party.

638. Replace the first course with something simple and elegant—like a dish with two different kinds of melon slices, berries, and a slice of prosciutto or smoked salmon.

639. If you do wish for a salad course, comparison shop between salads made with mixed greens or slightly pricier greens like mesclun. Caesar salad choices are a bit pricier, and some guests object to eating salads made with raw eggs, so that's one option you can skip.

640. An intermezzo course is often served before the entrée, as a palate cleanser for guests. The most common choice for this very inexpensive and classy "break" in the meal is sorbet: choose from small scoops of lemon, lime, orange, passion fruit, berry flavors, or a combination of two different flavors to match your color scheme (such as lemon and lime). Ask for intermezzos to be served in martini glasses or some other eye-catching presentation manner. Some ballrooms use specially designed glass plates shaped like flowers just for this course. See if you can use them for free, which will most often be the case, rather than renting them.

641. Take a look at size portions and see if they're way too big. Some caterers will understand that you're on a budget, and will agree to serve smaller portions to your guests for two-thirds the price.

642. For children's meals, ask for special menus and pricing. Most caterers have specially priced, kid-friendly meal options, so be sure to ask for them. Believe it or not, many couples forget this opportunity, naively figuring that kids will just eat what they like from the buffet and enjoy the same chicken entrée the adults are having. Choosing kid-priced entrées can save up to 50 percent off the price of a regular meal.

643. Rather than serving pricier meat entrées, such as filet mignon or London broil dishes, ask your caterer about alternative preparations of beef, such as flank steak with a great mushroom sauce. Explore the many possibilities in the caterer's beef repertoire to find something unusual and tasty that, with great presentation, will still thrill your guests.

644. You probably know that chicken is most often a less expensive meat entrée than beef, so again ask your caterer about delicious, distinctive preparations for chicken, such as Kiev style, with Marsala sauce, with ginger and teriyaki flavor, and so on.

645. Ask about different meats and their comparison prices. Pork dishes are growing in popularity, for instance. The "other white meat" can be prepared in a variety of different and tasty ways, so ask about the many things your caterer can do with this dish.

646. Australian lamb is a growing trend for its high quality, competitive prices, and the fact that guests consider it a treat they don't get every day. Inquire about this meat dish to find out the creativity possible in its preparation.

647. When you're looking at specialty game meats such as venison and quail, which may be the perfect dishes for your seasonal wedding, be sure your caterer can find such meats in season and from a reputable source. Preparation is key as well, since some game meats can be tougher or are an acquired taste.

648. If you're looking at seafood, obviously those lobsters and lobster tails are going to catapult you into the upper stratosphere of your wedding menu budget. So talk to your caterer about how he or she can use lobster meat as a garnish to menu options, rather than serve guests the full, shelled originals.

649. For all seafood dishes, you'll need to know what's going to be in season and what the market price is likely to be. These factors will fluctuate, depending on how the fishing has been during the season of your wedding. Bad weather and environmental concerns can change the prices of fish and shellfish dramatically as close to your wedding as the week before. So, it's best to talk with your caterer to let him or her know that you're going to be open to using the type of fish that's best-priced on the market at that time. Being flexible can save you thousands of dollars.

650. Talk to your caterer about unique fish options. Cod, tilapia, and catfish, specially prepared, are popping up on wedding menus more and more these days—challenging salmon as the catch of the day. A great caterer can work magic with fish, so be open to suggestions that can lead you in a more budget-friendly direction.

651. The same goes for shellfish options. Comparison shop for the prices of shellfish preparations, such as oysters Rockefeller, fried calamari, clams casino, and the like. A good comparison shop with your caterer can turn up the most attractively priced option for you.

652. Caterers themselves have told me that this is the smartest budget move possible when you really want an upscale meal but your budget restrains you: choose a surf and turf combination platter with four grilled shrimp and several beef medallions with a great sauce. This is a dish that entices guests into thinking you spent a lot on your entrées, when, in fact, you're spending less than the price of a filet mignon entrée.

653. Play with the combination platter concept, knowing you get more for your menu budget when you give guests two features on their plates. Think about pairing variations on meat and seafood to create a unique combination (such as glazed salmon with a creamy seafood stuffed crepe or beef medallions with calamari).

654. Offer only one meat option for the entrée, rather than beef and chicken in addition to a fish or pasta entrée choice. Give great meatless options and your price per head could go down as much as 30 percent.

655. Look at delicious and visually colorful dishes like paella and jambalaya that feature meat and seafood, but by virtue of their additional ingredients are far less expensive.

SPECTACULAR SIDE DISHES

656. It's not just a spoonful of rice and a few broccoli shoots on the side of the plate. Your caterer's artistry with side dishes can make even a moderately priced entrée really stand out. When you pay attention to the sides on guests' dinner plates, you're making use of an insider secret: side dishes are inexpensive and they can wow your guests. Consider the following:

- Wild rice with cranberries
- Chive-wrapped asparagus
- Scalloped potatoes with sausage or bacon and chives
- Creamy garlic mashed potatoes piped onto the plate in star burst shapes, drizzled with mushroom sauce and mushroom slivers

- Creamy sweet potatoes with brown sugar and molten marshmallow sauce
- Fried potato "straws," either regular potatoes or sweet potatoes—a staple at many trendy Hollywood and New York City eateries
- Baked potatoes stuffed with mashed potato, goat cheese, crabmeat, bacon, and cheddar
- Garlic spinach with pumpkin or sunflower seeds

With any of these choices, you add color and flash to the plate, give guests a unique gourmet treat, and use this low-budget trick to make a rather simplified cut of beef, chicken, or salmon with sauce turn into a work of art on the plate.

657. Ask your caterer to garnish your entrée in the shape of your monogram. He or she can do so with a swirl of sauce or a stenciled sprinkling of colorful spice like paprika.

658. Remember that taste makes a dish truly valuable. Always choose dishes with incredible flavor, perhaps a bit of spicy kick, and great texture to make it interesting.

INFORMAL MEAL MENU POSSIBILITIES

It could be your reception that's going to be informal, your rehearsal dinner, or a wedding weekend activity. Whatever the occasion, it calls for a more casual menu with no caviar or monogrammed sauce designs in sight. Choose from the following tips to plan your informal menus on a deceptively low budget.

659.

Check the catering menus at your favorite delis, pizza places, Asian food places, and other establishments you frequent to comparison shop for their party platters. They are often less expensive than hiring a caterer, since they do these platters in bulk. For instance, I self-catered a party of my own recently by ordering finger sandwich party platters from my favorite deli, a tray of sushi from my favorite sushi place, and a bagged salad I bought at the grocery store. When I compared my picks to that of a professional caterer, I saved 20 percent.

660. Check out the selections for your barbecue party at several different sources. For example, check out your supermarket if you plan to cook yourself and check out takeout places that do barbecue and chicken platters. I found a great New Orleans style takeout place that did pulled pork sandwich platters for a competitive price. Many couples planning barbecue parties go to their nearest discount bulk warehouse stores (like Costco and Sam's Club) to load up on chicken breasts and legs, ribs, even seafood like clams on the half shell, shrimp by the bag, and king crab legs—all for a discounted price. For them, cooking for the party was fun in and of itself.

661. Check bulk warehouse stores like Costco to comparison shop for trays of frozen or fresh appetizers. Taste test to find your favorites, and you could save a fortune on bulk buys of sushi, finger sandwiches, shrimp or fruit platters, taquitos, mini pizzas, buffalo wings, mini quiches, stuffed puff pastry appetizer samplers, mini meatballs, and so on. If the price is right, you're in the right place.

662. Set out a selection of great, unique salsas (red hot, green chili, mild, etc.) along with a variety of chips or crackers. Also great party treats at low prices: bean dips, hummus, cheese spreads, and homemade dips using soup mix and spinach.

663. Make your own bruschetta by buying a loaf of French or Italian bread, cutting thin slices, toasting them, and spooning on diced tomato bruschetta mix from the supermarket. Top with sprigs of parsley and serve on a silver platter.

664. Serve family-style dinners of either purchased or homemade lasagna, stuffed shells, meatballs, and salad.

665. Go family style with help-yourself vats of chili (one with beans, one without) or jambalaya.

666. Make your own antipasto with a layer of lettuce or bagged salad, topped with rolls of cold cuts like ham, salami, turkey, pepperoni; cubes of cheese; hard boiled egg slices; and roasted peppers. Homemade costs far less than catered or ordered.

667. Use your own slow cooker to make (and keep warm) Swedish meatballs or mini hot dogs in barbecue sauce. (I love the slow cooker for parties since it's easy to add the ingredients, turn on, and serve in six hours when everything's ready!)

668. Check out the recipes on www.foodtv.com to discover thousands of recipes you can make yourself—everything from dips to salads to slow cooker recipes, even specially collected recipes for theme parties.

BRUNCHES

669. Brunches at a hotel or restaurant can be the best buy possible! Often, you'll find prices set at $15 to $25 per person for a site's regular Sunday brunch, and you'll all get full access to a lavish buffet with an enormous range of menu items, plus free champagne! Just ask for a private room for your party.

670. A brunch at your home can be catered, of course, but with so many do-it-yourself options, why would you want someone else to cook for you? Pick up bags of bagels at the bagel shop, and line up spreads and meat or cheese fillings for guests to make their own specialty bagel sandwiches. At one party, the guests loved using the couple's panini machine (which works as a sandwich press) to make "smashed bagels" filled with ham and provolone or Taylor ham and cheese. Supply eggs, bacon, sausage, lox, and other brunch treats, and you have yourself a very inexpensive party!

671. Make or buy quiches, delighting your guests with a range of flavors like three cheese, spinach and mushroom, sausage and cheddar, or any mixture you desire.

672. Also popular at brunches is the cheese and vegetable lasagna for a morning twist on a family favorite recipe. Make one with cheese and bacon or ham for your meat-loving guests.

673. Waffles can be the centerpiece of your brunch when you supply a wide range of delicious toppings—warm strawberry sauce, fresh whipped cream, baked apples with cinnamon, pecan sauce with brown sugar, and so on.

674. Breakfast crepes are easy to make—just buy or make crepes and provide a "fillings bar" where guests can choose from a variety of berries, baked apple filling, ricotta cheese and fruit, even seafood.

675. Of course, don't forget dessert at your brunch! You can spend a little more and get all the cakes and pastries you could want at a bakery or supermarket, or make the desserts yourself. At one formal brunch, the parents of the bride went out and bought Entenmann's cakes and pastry rings, then just transferred them onto silver platters and glass pedestal cake servers. They spent under $25, and their guests loved the selection.

TEA OR LUNCHEON

676. Serve inexpensive finger sandwiches that you order from a deli or make yourself. Again, visit www.foodtv.com for great recipes in their tea or lunch recipe roundups.

677 Make a selection of light salads like cucumber salad, a carrot and raisin salad, an antipasto, or a wild rice salad as side dishes for the mini sandwiches.

678. No afternoon tea would be complete without scones, muffins, and unique breads (like cinnamon raisin). See if your nearby supermarket's bakery can beat the prices of your favorite bakery, and taste test for quality. At the party, warm the breads and serve with softened butter and spreads.

679. Consider light soups, which you can buy in bulk from your supermarket. Often, supermarkets pack their homemade soups into containers and mark them way down.

680. Create a tray of cold appetizers, including salmon mousse tartlets, fruits, veggies, and the very upscale looking (but inexpensive) endive leaves stuffed with a cream cheese mixture and even topped with a dot of caviar.

681. Very big on the tea and luncheon "most wanted" menu list: artichokes. This is an easy one to make yourself. You can even add a breadcrumb, garlic, and Parmesan stuffing into the artichokes and drizzle with a little bit of olive oil.

BEACH OR BACKYARD CLAMBAKE

682. Buy seafood that is in season and plentiful (see the earlier seafood options in this chapter for additional ideas), from a great wholesaler or competitively priced source.

683. Couples in New England tell me that they can go down to the docks and buy lobsters right off the boats for a fraction of market value. If you have access to such a great budget move, check it out.

684.

Invest well in the pricier options of lobster, clams, and king crab legs, and then fill in the rest of your menu with much less expensive items like baked potatoes, corn on the cob, and corn bread or corn fritters.

685.

How could a seafood menu be less expensive? The informal nature of a clambake means you're not spending a fortune on décor and desserts, and your liquor bill will likely be lower due to the popularity of great beers over champagne. It evens out to allow you more financial freedom for your seafood.

PRIX FIXE MENUS

Don't forget that caterers offer Prix Fixe menus in addition to their standard wedding menus! Priced per person, consider these offers to be all-inclusive, as you'll see in the example that follows, provided by Lifestyle Catering's Kaye Lyssy and chef Keith Falco (www.lifestylescatering.com).

Sample Prix Fixe Menu

(Price includes salad, rolls and butter, entrée, starch and vegetables, china dinner service, labor, and service charge.)

Salad Selections (choose one)

Chopped salad—*red and green cabbage, romaine lettuce, crisp bacon bits, blue cheese crumbles and diced apples, tossed with light basil vinaigrette*

Spring mix salad—*spring mix, diced tomatoes, red onions, and home-style croutons, served with your choice of Italian, Oriental or raspberry vinaigrette, ranch, or blue cheese dressing*

Spinach salad—*baby spinach leaves with bacon bits, red onion rings, diced tomatoes, crumbled feta cheese, and home-style croutons tossed with balsamic vinaigrette*

Caesar—*crisp romaine lettuce, parmesan cheese chips, and garlic croutons tossed with house-made Caesar dressing*

Vegetarian Entrées ($25.00 per guest)

Wild mushroom strudel—*sautéed mushrooms and onions with a Gorgonzola cream sauce*

Vegetarian lasagna—*grilled vegetables layered with two cheeses and Alfredo cream*

Eggplant roletini—*thinly sliced eggplant rolled with provolone and ricotta cheeses then topped with a fresh basil and tomato ragu*

Vegetable cannelloni—*pasta filled with summer vegetables and covered with a spicy marinara sauce*

Bow tie pasta al fresco—*with tomatoes and fresh basil finished with extra virgin olive oil*

(Vegetarian Entrées are accompanied with two Vegetable Selections in place of a starch.)

Chicken Entrées ($28.00 per guest)
Chicken Marsala—*sautéed breast of chicken with mushrooms and Marsala wine sauce*
Herb grilled chicken—*chicken quarters marinated in lemon and fresh herbs then grilled*
Colorado chili rubbed chicken—*with mango red onion salsa*
Oriental style chicken—*breast of chicken marinated in soy, ginger, garlic, and sesame oil then grilled to perfection*
Mediterranean chicken—*breast of chicken, stuffed with sun-dried tomatoes, spinach, and feta cheese, finished with a light wine sauce*

Starch Selections (choose one)
Basil mashed potatoes
Classic rice pilaf

Beef Entrées ($29.50 per guest)
Braised beef tips—*slow cooked in beef stock and Merlot wine, finished with pearl onions and mushrooms*
Grilled flank steak—*marinated in Italian herbs, offered with tomato basil marmalade*
Braciola—*beef stuffed with pine nuts, Parmesan cheese, and fresh herbs, then braised in it's own juices*

Asian style beef kabobs—*marinated beef cubes skewered with crisp vegetables and finished with a rich teriyaki glaze*

Starch Selections (choose one)
Herb roasted baby red potatoes
Garlic mashed potatoes
Buttered and herbed noodles
Basil pesto rice

Pork Entrées ($29.00 per guest)
Citrus & rosemary grilled pork loin—*grilled and finished with a citrus glaze*
Tuscan-style filet of pork—*roasted with rosemary, garlic, and parsley, finished with Chianti reduction*
Maple glazed pork chop—*pan seared and finished with a pecan-maple glaze*
Red-hot chili rubbed pork skewers—*grilled pork marinated with chilies, oregano, garlic, and citrus juices*
Old-fashioned, pan-fried pork chops—*dusted with seasoned flour and pan-fried until golden brown, served with Dijon mustard gravy*

Starch Selections (choose one)
Garlic mashed potatoes
Herb roasted baby red potatoes
Wild rice with toasted almonds
Grilled polenta with herbs

Seafood and Fish Entrées
($29.75 per guest)
Pan seared orange roughy—*topped with pineapple salsa*
Stuffed sole—*fillet of sole, stuffed with spinach and seafood filling, topped with spinach cream sauce*
Grilled salmon—*with lemon caper beurre blanc*
Shrimp scampi—*Gulf shrimp sautéed in garlic butter and fresh herbs*

Starch Selections (choose one)
Orecchiette pasta with fresh herbs and olive oil
Chive mashed potatoes
Sun-dried tomato rice pilaf
New potatoes served with fresh parsley and butter
Toasted orzo with fresh herbs

The Cake

There's a great line in the Steve Martin version of the movie *Father of the Bride*. When told that the elaborate wedding cake his daughter fell in love with at first sight cost $1,500, Steve's character deadpans, "A cake, Franck, is flour and water!" How could a wedding cake cost $1,500? Easy. It's all about the labor and the time it takes to create a cake masterpiece like the one shown in that movie. That's an important concept for you to know, since all of the cakes you'll look at will be priced not just for their ingredients, but for the amount of work it takes to create them. That's the foundation for your decisions.

686.
Choose a great cake baker, one with a great reputation and referrals from friends who can tell you that this baker worked miracles on their low budget.

687.
Look at simpler styles of wedding cakes, such as layers placed directly on top of one another, rather than balancing on pedestals. When you add extra details like these, the price goes up.

688.
Choose frosting for the cake, rather than a rolled fondant covering (the type that looks like your cake has been dipped in plastic for a smooth finish). This style of décor is more labor-intensive, and some people aren't wild about the way fondant layers taste. Choose the sugar or buttercream icing that's more traditional and less expensive.

689. Choose a décor style that's less labor intensive. Sure, you could go high style and have the cake artist recreate in icing a replica of the lace on your wedding gown (as some celebrities and high society types have done), but you're far better off choosing a less elaborate icing style. One such option is the addition of icing "pearls" to give your cake that bridal look. It doesn't take long, and it looks gorgeous.

690. For a simpler, elegant, and classic look, have the baker frost your cake simply, and then have fresh flowers arranged to cascade over the top and sides of your cake. This popular style is among the least expensive and most impressive.

691. Pass on the sugar-paste flowers or marzipan doves, fruits and other expertly sculpted décor. Even though they are lovely, these extras aren't necessary and it's a lot of labor time to pay for.

692. Ask your baker to monogram your cake using colored icing. Imagine an ornate Tiffany blue initial on the front layers of your cake. Monogramming is a great way to personalize your cake, and it's low on the labor scale.

693. Comparison shop through the baker's list of available cake flavors and fillings. The standards (yellow cake and strawberry frosting) may be the least expensive, while more elaborate fillings (such as cannoli cream) will be higher. This tip is not to advise you to choose the least expensive flavor and filling! Your cake is important and the finishing touch of your wedding day, so invest well. Arrange your budget so that you can get a great chocolate cake with a chocolate mousse filling.

694. Use texture to make a plain cake layer filling something special. For instance, you can turn a plain chocolate filling into something more impressive by asking the baker to mix in chocolate chips, tiny M&Ms, or even white chocolate chips. Texture is one of those things that magnifies the taste and perceived value of your cake. So ask about the different texture possibilities for whatever type of cake and filling you choose.

695. Forget about having different flavors in each layer of your cake. Bakers hate it when brides and grooms request this, since it's a lot more work for them, and that makes the price go up. Just choose one flavor and filling for your entire cake.

696. Choose a smaller wedding cake instead of a five-tier monster. You can display a lovely, three-tier cake with an elegant décor, cut it in front of your guests, and then have the guests' slices taken not just from that cake, but from a regular sheet cake that's waiting back in the kitchen. This "ploy" has been used for years and it still works.

697. A smaller cake can look more visually enticing if you choose a unique appearance for it. Chocolate frosted cakes are a growing trend, and they just look better when they're smaller. Call it a "too much of a good thing" thing. If you opt for a mouth-watering chocolate cake, decorate it with chocolate curls for added visuals.

698. Another option for making a smaller cake stand out: decorate the base of each layer by wrapping a length of colored ribbon around it. At a wedding I recently attended, the couple's chocolate cake boasted thin strips of beautiful burgundy ribbon around each cake layer that added just the right amount of color and contrast to make an impression. Plus, it was the best wedding cake I've ever had (thanks, Mark and Rachel!).

699. Use the ribbon trick and top the cake with a spray of flowers that match the ribbon's color. That gives color and the allure of a smaller amount of fresh flowers. It's budget perfection.

700. Purchase a plain, unadorned wedding cake, or a sheet cake if that works for you, and decorate it yourself! You can buy incredibly inexpensive but still ornate chocolate cake accents in the baking aisle at your supermarket. These pop-out chocolate leaves and swirls are perfect for adding your own personal touch to your cake. Even kids can help!

701. Purchase a cake décor kit from renowned cake specialist Gail Watson at www.gailwatsoncake.com, where you can order sugar paste flowers and other expert-made cake accents.

702. Decorate your cake with fresh fruit, such as strawberries. The same goes if your cake is chocolate: decorate each layer's base with chocolate-dipped strawberries.

703. Use simpler floral accents to decorate your cake. For instance, press daisy heads in a circle around the base of the cake or around alternating layers (i.e., leave the middle layer unadorned to avoid overkill). This fresh look is surprisingly inexpensive, and far less than doing a more dramatic cascade of flowers as your cake's décor.

704. Top your cake with something nonfloral: starfish or seashells are the top choices for beach weddings and summertime formal weddings, even if the event is not at the beach.

705. Top your cake with a family heirloom, such as the cake topper from your parents' wedding.

706. Top your cake with a sparkly faux-stone tiara, which is an easy purchase under $20 at accessory shops. If your wedding will be a princess fantasy come true, the tiara especially fits the theme. You can even attach an inexpensive length of veiling to drape behind the cake.

707. The groom's cake can be homemade, such as the groom's favorite chocolate chip cake, or you can order a specially designed, theme shape cake from a professional baker. Some grooms on a budget are choosing to have a pie instead, or they're skipping the groom's cake option altogether in favor of the diverse desserts they're already placing out.

708. Negotiate to have the cake cutting fees taken out of your contract. Some sites charge $1.50 for each slice of cake their staff cuts for your guests! Try to get this fee waived.

709. For informal or smaller weddings, the wedding cake can be homemade. You can also do what many celebrity couples are doing at their informal weddings: have frosted cupcakes arranged in the shape of a wedding cake, and let guests just help themselves! Total savings: up to 75 percent off the cost of a formal wedding cake!

ADDITIONAL DESSERTS

Sometimes a Viennese desserts table can be way too big, with more pies, cakes, tarts, and treats than your guests could even begin to dig into after they've eaten all that great food at the cocktail

hour and during the meal. Even though you're on a bargain hunt, you can give your guests another indulgence in addition to the wedding cake as the finale to your wedding event. Consider the following budget-friendly tips.

710. In addition to the cake, have chocolate mousse, truffles, and chocolate-covered strawberries in platters as the other choices.

711. Go with chocolate-covered goodies: fruits and cookies dipped in white or dark chocolate may be all you need.

712. Chocolate fondue could be the perfect do-it-yourself attraction for your guests. Just provide white and dark fondues, along with sponge cakes, brownie squares, and fruits for their own spearing and dunking.

713. Skip anything flambéed. If you need liquor and fire to light it up, chances are it will be an extra expense you don't need.

714. Consider an ice cream bar, which is a fun treat even at formal weddings. Guests can choose from three ice cream flavors, then top to their hearts' content with sprinkles, chocolate chips, whipped cream, and a cherry on top.

715. Desserts for kids include the ice cream bar, brownies, frosted cookies, or brownies covered with ice cream.

716. Kids' desserts for adult guests are the hot dessert choice right now, with a trend toward choosing childhood favorites at many couples' weddings. So hit the bulk warehouse store to get cases of Twinkies, Yodels, Ring Dings, and Moon Pies that guests will flip over. If you can work a childhood favorite dessert into your theme—such as SnoBalls cakes for your winter wedding—that's priceless.

717. The same goes for childhood favorite ice cream and Popsicles. Some favorites include those Good Humor ice cream bars in the strawberry shortcake and chocolate éclair flavors you'll find at the supermarket. Guests love this surprise, and they get it without chasing the ice cream truck!

718. Petit fours are very bridal, and you can get them from the supermarket bakery often for less than from a standard baker.

719. Bring in homemade desserts, such as Mom's apple pie, brownies, peach cobbler, and, yes, here's where Grandma's strudel comes in.

720. Frosted cookies are a hot choice for the dessert bar, since you can find them now frosted in theme designs and colors to match your wedding's décor. Check out www.cheryl andco.com to see their frosted cookies (my favorites!) in pastel shades of yellow, orange, green, and other colors for inspiration.

721. Fruit tartlets with Chantilly cream add some extra color to the table, and they're a great addition to all those chocolate desserts you may have in mind.

722.

Use seasonal or exotic fruits as another chocolate alternative, and an inexpensive one at that.

IT'S ALL IN THE PRESENTATION

723.

For any desserts you choose, make it special in its presentation. Especially with more budget-friendly foods, a little bit of creativity in how it's served can make a big impression and hide the fact that it's a budget choice. Here are some suggestions:

- Lined up on silver platters
- Served in martini glasses
- Decorated with chocolate and berry sauce swirls, crisscrosses, or even heart shapes (dot red berry sauce and then drag a knife through the centers in one direction—so easy!)
- Decorated with chocolate shavings or curls
- Sprinkled with fresh berries
- In dark chocolate cups (looks like the base of a Reese's peanut butter cup)
- In footed glass dessert bowls
- With initial-shaped chocolate pieces sprinkled on top
- With candies sprinkled on top
- Dusted with powdered sugar or cocoa powder, either straight sifted or sifted through a creative and inexpensive stencil found at the craft store

The Bar Tab

The liquor bill for all of your wedding events can add up to a lot, so use the following budget saving tips to get great drinks for your guests without wasting money.

WINE AND CHAMPAGNE

724. Start off by researching wines and champagnes on www.winespectator.com. On this site you'll learn all about pairing certain foods with the right wines, and you'll also find great suggestions like "the best wines under $15 a bottle" and in other price ranges. This site is absolutely priceless, since it can lead you to terrific vintages that don't cost a fortune. Being an educated consumer in this realm can save you thousands of dollars.

725. Find a great liquor store where the selections are terrific and the prices are mild. Ask around for referrals if you don't already have a great source.

726. See if you can join a liquor store's members' club for extra discounts.

727. See if you can join a wine taster's club for 15 to 20 percent discounts on every bottle of wine you buy. The Tasters Guild is just one that you'll find online, so ask at your liquor store for referrals to the nearest club. For just a nominal joining fee (often under $75), you could earn great savings, freebies, and extras as a member.

728. Get a high quality (and more expensive brand) of champagne for just the first toast of the night. For later consumption, and for champagne cocktails with mixers and juices, you can use more moderately priced champagne.

729. Dress up your champagne cocktails—and make your champagne supply last longer—by adding in fruit juices and accent fruits. Fruits such as strawberry, peach, and pomegranate not only create pretty drinks, but can also match your color scheme.

730. For brunches and breakfasts, make mimosas with moderately priced champagne rather than the top-priced names.

731. Try out different champagnes and wines at a party just for yourselves and your bridal party. This wine tasting party could help you decide which of the vintages you'll serve at your wedding. Ask your friends for feedback on each bottle, and make your selections from your own tasting session.

732. Find bargain-priced top quality wines. You can find a terrific vintage for under $20 a bottle—even less when you buy by the case! Ask wine experts, or check at www.winespec tator.com, for the latest award-winning and best-rated wines both domestic and imported. Wine lovers are raving about Australian, New Zealand, and Argentinean wines, so look into these moderately priced selections of the best imports to judge price value and taste.

733. Look at dessert wines, which are sweeter with unique blends of berries and fruits, for your dessert parties. Dessert wines are available in a range of surprisingly affordable prices. Once again, check www.winespectator.com for their terrific breakdowns of wine by price range.

734. Go to a local winery to taste their vintages. Often, local wineries hold special sales and clearance specials to make way for their new stock. Without the added costs of shipping, their prices can be lower. Just go for tastings and see if their wines stand up to the competition.

735. Ask your hotel, restaurant, banquet hall, or liquor store about their "dead stock." These are wines and liquors that they have removed from their menus to make way for newer or fresher vintages and brands. They're often just sitting in the basement waiting to be returned to the distributor. Very often, especially if you're having a smaller party, the site might agree to let you use this stock for a deep discount.

736. Negotiate to have "corkage fees" waived from your bill. Some sites charge $1 to $2 just for the bartender's efforts at uncorking a bottle! Wipe this wasted charge if you can!

737. Arrange to have bartenders stop uncorking new bottles of wine at a certain time of the night, such as two hours before the reception ends. They can offer guests the already open bottles they have sitting behind the bar. Be smart and ask a friend or relative to keep an eye on stealth uncorking. You pay for the number of bottles that are open at the end of the night, and many couples have reported that they were charged for as many as a dozen open but untouched bottles of wine!

738. If you're staying at the hotel where your reception takes place, prearrange to have opened bottles of wine brought to your hotel room for the after-party. Without a plan for using your own leftovers, the hotel staff would get to keep the bottles you paid for! (Just be aware that you can't drive home with open bottles of liquor in your car. No use risking being pulled over by the police.)

MIXED DRINKS

739. Limit your bar menu. Instead of offering a fully open bar where guests can have any drink made (and thus, every type of liquor must be stocked), offer only a select number of mixed drinks. Some possibilities are martinis, gin and tonics, Jack and Cokes, cosmopolitans, and wine and champagne. Limiting the possibilities— and printing the drink menu on a bar card—saves you a fortune in liquor supply.

740. Avoid drinks that are made with many different kinds of liquors, like Long Island Iced Teas.

741. Eliminate the option of shots from your bar menu. These quickly downed drinks add up to a greater consumption of liquor, and your guests might get a bit more out of control when the shots start coming out on trays. Mixed drinks last longer in guests' hands.

742. Ask your bar manager how he or she can dress up regular drinks with great presentation. Examples include colored salt on the rims of margaritas, fruit slices added to drinks, popping unique drink mixing sticks into each glass, or serving martinis in unique glasses. Just an extra touch can make standard drinks stand out.

743. Check party supply stores for inexpensive drink stirring sticks (you'll find sleek designs in blue, red, or sticks with theme baubles at the tops) rather than shopping on bridal supply websites. Higher prices for packs of twelve plus shipping costs is a waste of money when you can get them for so much less on your own.

744. See if the site provides simple mini straw stirrers for free, and ask if you can get those in a color that matches your scheme, like red or blue. Know that you can ask for this particular selection.

DRESS UP YOUR ICE CUBES

745. For smaller parties, brunches, or teas, you might wish to get crafty by placing a single raspberry or mint leaf in your ice cube trays before freezing the water. This is such an easy task that it's dumbfounding to me when I hear that some couples pay for dressed-up ice cubes!

746. Use this trick from more upscale restaurants and banquet halls: remove barstools so guests can't plant themselves there all night to take advantage of an open bar. Clearing the chairs gives your guests easier access to the bar and keeps the line moving.

747. Look at microbrew beers to see if they're priced competitively. Supplying unique beers in addition to standards can give guests a new discovery and perhaps save you money at the same time.

748.

Buy Bloody Mary mix in bulk from a discount warehouse store or on sale at a liquor store.

NONALCOHOLIC DRINKS

749.

Provide a great supply of nonalcoholic drinks such as exotic fruit juices, diet sodas, orange sodas, crème sodas, flavored seltzers, and sparkling ciders that you can buy in bulk from warehouse food stores like Costco.

750.

Check supermarkets for their two-for-one sales on tonic water, seltzers, and soft drinks, or their discounted case prices.

751.

Check www.foodtv.com for delicious punch recipes that you can make yourself.

752. For winter weddings, ask for hot chocolate to be served in addition to coffees. In bulk, this is a great buy.

753. Provide plenty of water! Ask your site manager if water can be served in great big pitchers with an array of lemon, lime, or orange slices. Make the accented fruit work with your color scheme for an added bonus.

LAST CALL!

754. Close your bar earlier in the night, perhaps an hour before the party is scheduled to end. This saves money by limiting consumption, and it sobers up guests who are then offered coffee.

AFTER DINNER DRINKS

755. Limit the selection of international coffees. Choose just regular coffee, espresso, and cappuccino, rather than Irish coffee, Jamaican coffee, and other liquor-infused drinks.

756. Limit the selection of after dinner drinks, choosing three or four options such as Cognac, brandy, and Chambord served in smaller snifters.

757 For smaller parties, see if you can bring your own bottle of Cognac from home.

758. Offer a supply of exotic teas, such as chai and flavored tea to give noncoffee drinkers a great selection.

ITEMS TO SKIP

759. Items to skip: custom-printed matchbooks, napkins, and coasters.

760. Skip the dishes of salty snacks that are often placed on the bar. The salt tempts guests to drink even more.

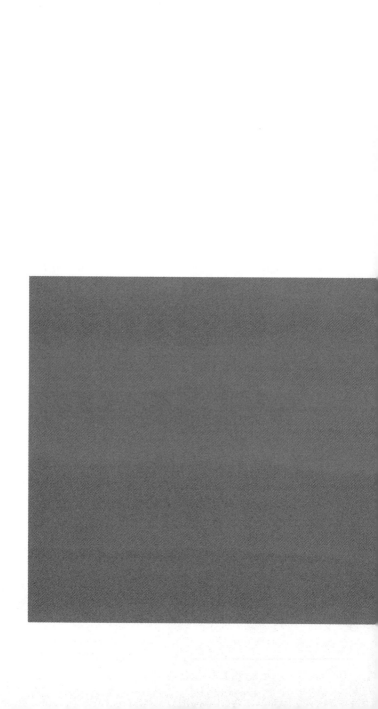

Entertainment

Second to the food, it's the entertainment your guests will enjoy most at your wedding. If you've already started to check out bands and deejays, you know that their wedding packages are expensive. Think about all that equipment they need to maintain, their stock of CDs or MP3s, and the time and labor of the musicians or performers. It's money well spent when you find the perfect entertainers to lead your party—ones who keep the dance floor packed and bring a great sense of energy and excitement to the room. Research well and ask for referrals to find the ideal kind of entertainers you have in mind, interview and audition them, and see if you can arrange to see them playing at a live party or club near you. That's an important factor, as you'll want to see how they command the stage and how their audience is reacting to them. You don't

get that off an audition videotape that they'll send to you, and even those can be edited to make them look and sound better than they do in real life.

This is an important investment, so shop well (you get what you pay for, so don't go for the cheapest act in town), and know that you can find many ways to get more value for less money using the following tips.

761. When you're trying to decide between having a deejay or having a full band, comparison shop between their package prices. You may find that deejays are priced lower since it's the time and effort of only one professional you're hiring, rather than eight.

762. You'll need to feed your entertainers, so factor in the price of one meal for a deejay versus eight meals for the band (plus perhaps a few extra ones for their manager, sound technician, and even their wives in some cases).

763. Know that you can arrange with the caterer to have a different meal served to the entertainment. They won't get the shrimp and beef medallions with the portabella sauce, but they'll get chicken parmigiana and a salad. Don't worry about offending them. Expert entertainers tell me they're happy to get the simpler meal. They can't possibly eat rich wedding fare every night throughout every weekend, so they don't expect the elaborate meal. Save 40 percent and cater them more moderately.

764. If you love the sound and energy of a live band, choose a band with fewer performers. Eight is less expensive than twelve, for instance.

A DEEJAY _AND_ A BAND?

765. Here's the answer to your prayers if you really want a live band, but your budget doesn't allow it. You can now hire a deejay, with special performances by a live singer, musician, or ensemble band as a featurette for half an hour during your reception. Professional wedding music companies now give you this option, which can be a great budget saver. You get the best of both worlds for less!

766. Hire your entertainers for fewer hours. Rather than the five-hour package, choose the three-hour package. Shaving those two hours off their on-the-clock expenses can save you hundreds of dollars.

767. The band can be hired to perform only during the after-dinner hours, while a pianist or recorded music plays during the meal itself.

768. Hire a band made up of entertainers who play several instruments each. When you specifically request multitalented artists, you might get a great trumpeter, pianist, and solo guitar player in one! That band of four members can seem more like a band of ten, and give you specialty performances that your guests will love!

769. Don't pay for a band's optional extras, like specialty lighting and props.

NONWEDDING MUSICAL ACTS

770. Check out the going rates for nonwedding musical performers, like musicians, soloists, vocalists, or jazz bands. Without the label and marketing as "wedding performers," these very professional artists might be charging less per hour just by being outside the bridal loop.

771. Find nonwedding performers at local clubs, community events, hotel brunches, and even at bookstores and cafes where many great and talented performers have been "discovered" by brides and grooms on a budget mission. Chicago couple Beth and Ryan tell me they found a marvelous Frank Sinatra sound-alike singer at their favorite coffeehouse and booked him on the spot for their cocktail hour. Since he was just starting out, and also a music student, he charged about half of what the couple found quoted by other performers—and he was great!

772. Go to a university or musical university to put out a call for talented pianists, trumpeters, vocalists, guitarists, and even ethnic musical performers who you can audition. Their prices may be less than on the professional circuit. Just audition them well to be sure they have a varied repertoire for your event.

773. See if you can arrange for free or discounted entertainment through your ethnic or cultural association. At the very least, they might be a great source to lead you to professionals to audition.

774. See if your professional association or alumni status can net you great referrals or even discounts on entertainers found through your networks.

775. Check out a professional musician association (such as www.musicintheair.com if you're in the New York City area) that can assist you in finding an accredited professional musician or specialty musical act that is a great fit for your budget.

Free Music!

776. Mix your own CDs to create your own soundtrack for cocktail parties, the rehearsal dinner, or even your reception if you wish. Loading your own mixes into a CD player means your entertainment is free.

777. At brunches, lounges, and even at hotels, they may already have their own musicians on site. For instance, if you'll book your reception or party at a hotel's brunch, you'll be able to listen to their own pianist or their piped-in music. The cost to you? It's included in your per-person package, so that means zero from your wallet for entertainment.

778. Your hotel or ballroom can pipe in easy listening or jazz music throughout the entirety of your reception. Especially for weddings where there will be no dancing—as might be a family or religious choice—this option can give you great, original music renditions for free.

779. If you're looking for party style music, theme style music, or steel drum band music, visit your library to borrow discs for free or check out the party supply store for inexpensive CDs.

780. Find out if the restaurant or hotel where your party will be held regularly features strolling violinists or vocalists in their dining room during their dinner hours and ask if you can arrange to borrow them. These performers can make a drop-in or walk-through appearance at your wedding for a nominal fee—or for free—as a special treat during your event.

781. Ask a friend to perform at your smaller wedding events, such as playing a few songs on the piano during your wine and cheese party, or a trio of friends singing by the fireplace at your winter wedding weekend event. These performances add something special to your party, and at no price.

782. You will be the ultimate entertainment at your reception when you as a couple take to the dance floor for your first dance. Make sure you're entertaining in a good way by taking ballroom dance lessons and perfecting your choreographed routine before the big day. You can sign up for expert lessons at a dance school or an adult education center's night classes, or you can take advantage of a free resource that's going to mean far more to you and to your teachers: ask your parents or grandparents to give you lessons. You've always marveled at how expertly they dance together, so your request for lessons can be an unforgettable memory for all of you, not to mention a fun night of practice and a great dinner afterwards to say thank you.

783. It costs nothing (except your pride if you're easily embarrassed) for you to sing a song to your groom at the reception or to have him sing to you. So consider taking center stage for a priceless moment.

784.

The toasts of the night will be entertaining as well. Everyone can get involved—it's not just the best man making a toast at the wedding anymore, so prepare to take the microphone yourself. A funny friend can bring down the house, your siblings can share great stories about you, and your best friend can bring tears to everyone's eyes. Often, it's the personal, sentimental words spoken at a wedding that are the best entertainment of all. (Pick up my book *Your Special Wedding Toasts* to perfect your speech and find the perfect quotes, poetry, and song lyrics you might want to borrow for it.)

785.

A growing trend at weddings today borrows from the Oscars, believe it or not. It's a specially edited video presentation including messages from your closest relatives and friends, a montage of childhood photos of the two of you, some snapshots from your courting days and when you got engaged, and whatever other footage you desire. You can make this video yourself using your home computer's video editing tools, or ask a friend to make this video or DVD for you as your wedding gift. Arrange for viewing or projection equipment to be set up at the site and roll the videotape! This short video can start your party off in grand style and your guests will never forget it.

The After-Party

After the reception, you might not want the party to end. You and your families, plus the bridal party and a few special guests, might opt to head out for an after-party. This post-reception bash doesn't have to be elaborate (in fact, it really should be more laid back as a wind-down to your big day), and you don't have to spend a lot. It's all about spending some quality, quiet time with your guests, maybe having a snack or some late-night cocktails, and reflecting back on the amazing moments of the day. You could look at digital pictures your friends took on their cameras, and you'll probably hear a great story or two about things that happened during the ceremony or reception that you didn't notice. Whatever your itinerary, here are the most popular, inexpensive plans and tips for today's great after-parties.

786. While some couples go all out and cater the after-party just as elaborately as they did the rehearsal dinner, you don't need to go to such expense. Round up your inner circle of friends and family (make it a VIP party, not a second event for all of your wedding guests) and head out to a nearby lounge for drinks and snacks. You might wish to change into more casual clothes first for this or any of the following options.

787. Invite everyone home to your place for drinks and snacks. Calling for pizza delivery could be ideal, especially if your pizza place has a two-for-one deal going on.

788. Your parents might wish to host the after-party at their place, in which case they might be the ones to call for the pizza, or they might self-cater with a tray of sandwiches or leftover hors d'oeuvres from the rehearsal dinner.

789. Invite your guests up to your suite, where you can enjoy some of the leftovers from the wedding that you've arranged to have delivered up to your room. This could be the perfect way to finish off that cheese platter, fruit plate, or cold canapés.

790. Go out for coffee and dessert at a great coffeehouse, especially if they already have live music scheduled.

791. Head out to a sports bar for pitchers of beer and bar food. Shoot pool and play darts for the ultimate relaxed after-party.

792. If it's late at night, go as a group to a diner for coffee and snacks like cheeseburgers and French fries—reminiscent of your "diner runs" after late-night partying in your younger days.

793. Pile in the limousine and drive through a fast food takeout window, passing the burgers, chicken sandwiches, fries, and sodas while your driver wheels you around town. Hey, you're paid up until midnight for the chauffeured car, so you might as well get your money's worth and have a party on wheels.

794. Have a late-night pool or hot tub party back at your place, or at a friend's place if they'd like to host. Just be sure everyone is sober before you go anywhere near bodies of water.

795. Hold your after-party on your own poolside terrace, with lit torches or candles helping out the ambiance. Heat up leftovers, or fire up the grill for fresh burgers and chicken.

796. If the wedding will end earlier in the evening, you might opt to host a movie night at your place. Once everyone has changed into casual clothes, pop in a videotape to catch a group favorite. At one winter wedding, the hosts pulled out their already-owned collection of holiday specials on tape—those animated movies everyone loves before Christmas. Light the fireplace, make some great coffee, and serve desserts or make popcorn for a cheap and relaxing post-party.

797. If there's snow on the ground, go out and play! Make snowmen, go sledding, have a snowball fight, and then warm up by the fire with hot chocolate or spiked mulled cider.

798. Pick up the kids and have a sundae-making party at your place.

799. Go to an ice cream parlor instead of a bar.

800.

If it's late at night and you're right nearby, go to the beach and wait for the sunrise.

801.

Use up the remaining exposures on all of those throwaway cameras from the guests' tables by taking fun end-of-the-night pictures with your closest friends.

802.

Consider making the afterparty just for the two of you. Have the hotel bring up a remaining bottle of champagne or wine from your reception, the fruit and cheese platters, and the remaining chocolate-covered strawberries and enjoy some time alone. Tim and Maria from Portland recommend that you hold your own private after-party for just the two of you—in a bubble bath.

Part Six:

A Token of Affection

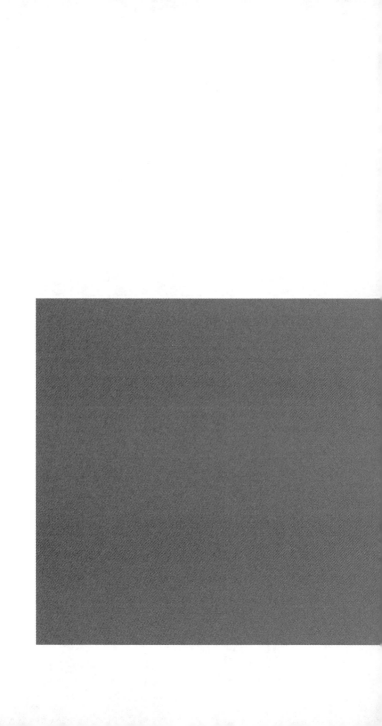

Wedding Favors That Don't Cost a Fortune

As a gracious and generous host, you'll send your guests home with a little something to remember your day by. The subject of wedding favors is a hot topic, with more and more couples wondering if it's something they can skip to save money. The answer? No way! Favors are a must-have, and guests deserve—after taking the time, trouble, travel, and expense to be with you—something a little bit more than just great memories to take home with them.

Your choice of favor should resonate with the theme and style of your wedding, perhaps the season, and it should definitely be you. There are countless ways to personalize your favors, and you have a world of inexpensive options open to you. I'll start you off here with a collection of the most popular favor ideas out there,

and I encourage you to comparison shop while you're looking for "the one."

803.

Let's start with the gold standard of wedding favors: Godiva chocolates (www.godiva.com). There's something very elegant about that little gold box of chocolates with its colored ribbon in velvet or satin that gives guests a taste of the good life. You'll be surprised to find out (if you don't know already) that the two- and four-piece boxes of Godiva chocolates are very affordable. That makes them perhaps the best choice for favors.

804.

Another great choice: other brands of filled chocolates or truffles, also in their own attractive boxes.

805. Fill small tulle bags or gift boxes with a few handfuls of your favorite candies, like M&Ms, Skittles, miniature peanut butter cups, jellybeans, or nonpareils. Now you can get custom M&Ms, including personalized colors and even custom words printed on M&Ms (with your names, perhaps) at www.m-ms.com. Choose from over twenty colors, plus perfect-for-weddings color blends in all white; black and white; all cream; purple and white; and pink, cream, and white. The website features a wide range of additional color blends, so take your pick.

806. Very popular now: oversized peanut butter cups that have been iced with a petite rosebud design.

807. Chocolate-covered Oreos or other childhood favorite cookies. (Notice the theme of childhood favorite snacks within the favors list and menu suggestions! It's a trend for a reason.)

808. Fill a decorative gift box with a selection of iced sugar cookies, like the ones you'll find in your wedding's theme colors at www.cherylandco.com.

809. Fill a box with great chocolate chip cookies.

810. Brownies are a delicious treat for your guests.

811. Fill a bag with chocolate-covered coffee beans.

812. A bag full of pistachios or a mixed peanut collection also makes a great favor.

813. Go traditional with sugared almonds (sometimes called "confetti"), which has been a staple in wedding favors for decades. These treats are symbolic of sweetness and prosperity. Shop for these in bulk at candy stores and even at craft stores that stock them at a discount. If you go to a bakery for them, you'll pay top dollar.

814. Hand out great big tufts of cotton candy in your wedding's colors. You can buy them pre-made for less at bulk candy stores and party supply stores rather than renting a machine (and getting all sticky as you try to make them).

815. Choose jars of great, unique salsas and place them in baskets together with mini bags of tortilla chips.

816. Gourmet-loving couples are handing out small bottles of infused olive oils—with lemon, rosemary, or hot pepper flavoring to suit their guests' future cooking needs. Get small cork-stop bottles, fill them from economy-sized jugs of quality olive oil, place in your flavor of choice, cork up, and seal with wax. Voila!

817. Hand out regional specialties for your mountain wedding, such as jars of honey or maple syrup. At a wedding on Hunter Mountain in New York, the bride and groom handed out honey in squeezable jars shaped like bears. All of the bride's cousins remembered how their grandmother always used to bring them home honey bear jars from her trips to the mountains, which made it a touching and sweet treat.

818. As per tradition, guests can take home slices of the wedding cake or groom's cake set in specially shaped boxes for this purpose (see www.bayleysboxes.com for examples of cake slice boxes).

819. Hand out chocolate bars, which are always a favorite. Take a twist on those specially designed candy bars you've seen online at bridal websites where they'll custom-print labels with your names on them. Skip the expense by making your own labels on your computer using colored paper and a great design print. Remove the original outer wrappings and affix your own. When you buy candy bars in bulk from a warehouse store like Costco, it's a great buy.

820. Take advantage of post-Halloween candy sales and stock up on miniature versions of everything from silver Peppermint Patties to Hershey's Kisses.

821.

Mint tins are another growing trend in the world of wedding favors. You can order these online in specialty tin shapes with customized labels, or you can make this an easy do-it-yourself job by buying miniature tins (shaped as hearts, moons, ovals, etc.) and big bags of mints at the craft store. Then print out your own custom labels to affix on top.

FROM THE GARDEN

822.

Single roses for the women and a cigar for the men are a classic choice for favors.

823.

Bunches of cellophane-wrapped tulips or daisies in great, bright colors are great for a spring wedding.

824.

Give guests flowering plants like miniature roses or daisies, wrapped with a colored foil at the base to work with your wedding's theme hues.

825.

Tree or plant seedlings are a gift your guests will enjoy for years.

826. For a functional living favor, try herb plants, like great rosemary plants in a colored foil-wrapped base.

827 Instead of just one herb, select a kitchen garden seedling trio (parsley, rosemary, chives, tarragon, and so on).

828. Give guests packets of flower seeds with a personalized label (not covering the planting directions, of course).

829 Garden rocks with words engraved on them are a great gift and table decoration. (You've seen these at florist shops, those pretty smooth little rocks with the words love, trust, wisdom, hope, heart, peace, dream, and more. Check at craft stores to compare prices as well.)

FROM THE BOOKSTORE

830. Small gift books with poetry, quotations, or great pictures are a keeper for your guests, and most can be found in the $3 to $8 range. Choose them to work with your theme (such as a lighthouses book for your beach wedding) or look for great love books like *Perfect Pairs* by Hulton Getty or *What Love Is*, photographed by Laura Straus.

831. Bookmarks cost just a few dollars each, and you have plenty of theme-appropriate choices. Look for great, graphic bookmarks in either laminated paper or even quote-engraved, thin brass designs.

832. Purchase gift books filled with tear-out postcards, such as theme collections of classic artwork, angels, flowers—whatever works with your wedding's style.

833. Find card decks with theme ideas on them, such as a collection of ways to spend a rainy day, simplify your life, rekindle romance, etc. These are usually in the gift book section of your bookstore.

834. Boxed note card sets with terrific graphic designs and blank insides are a functional gift

835. Give your guests framed or matted artwork of your favorite artists or of a picture that matches your wedding's theme. (Check bookstores, home décor superstores like Bed Bath and Beyond or www.art.com for great bargain selections.)

836. Bumper stickers with great sayings on them, like "Follow Your Bliss," are a fun gift.

837. Look for magnets with great poems or quotes on them, such as Helen Keller's "Life is either a daring adventure or nothing at all."

838. Great, graphic journals or blank books with fabulous covers and inspirational quotes within their pages are another functional gift that guests will love.

839. Music CDs are gifts that will bring back memories of your magical day each time that your guests listen to them. You can include movie soundtracks, classical collections, favorite artists' greatest hits, or compilations you make yourself using your favorite songs. Print out your own labels to personalize custom mixes.

FAVOR FAVORITES

840. Create photo calendars with your own personalized shots (see www.ofoto.com and other custom photo creation sites to make these for less).

841. Personalized mugs are a fun choice for favors.

842. Coffee lovers can give travel coffee containers. (Check out Starbucks' sleek choices, or look at the new range of coffee containers where you can slip a photo into the outer plastic holder.)

843. Candles and candleholders (found at the craft shop or stores like Target, Bed Bath and Beyond, or Pier 1) are a classic and inexpensive favor.

844. Purchase potpourri holders and bulk bags of potpourri from the craft shop for a do-it-yourself favor creation.

845. Silver frames are a great favor idea and can double as place card holders by slipping a piece of paper with the guest's name inside. (Get these from the craft shop, where you can find great little frames with butterfly accents, stars and moons, and a range of other specialty designs.)

846. Cigars and cigar accessories, like cutters, are also popular favors. One couple gave out cigars with clips that guests could use to attach their cigars to their golf carts—great idea, especially for being under $10 each.

847 Look for key chains with theme décor or novelty pictures.

848 Wine charms are a very hot trend right now and make great wedding favors.

849 Charm bracelets for women can be found for under $10 at accessory stores.

FORGET ENGRAVING

850 Skip the engraving on silver or crystal favors. It's just not necessary.

851 Playful couples love to give out great, nostalgic toys for under $10 each (some under $5!). Choose from classics like Etch a Sketch, Magic 8 Ball or the new pink version called the Magic Date Ball (to be used for all those romantic questions), Slinky, and Super Soakers (a great favor for an informal outdoor or backyard wedding).

852. Believe it or not, playful socks in holiday print themes for Christmas or Valentine's Day is a big hit. One couple from San Francisco went into a dollar store on a rainy day and rounded up 75 pairs of novelty socks for just a dollar each. Their guests loved them!

853. Also trendy are wintertime scarves in great pastel colors for the women, with matching gloves or mittens. The men's collection came in blue or black.

854. Purchase bath salts in pretty colors, put them in great glass containers, and wrap them in tulle for a great do-it-yourself project!

855. In winter, a s'mores-making collection with graham crackers, marshmallows, and a few chocolate bars is a delicious treat.

FAVORS WITH A PURPOSE

Look at favors that serve a greater purpose, such as the pink pins at Avon, where a percentage of each purchase goes to fight breast cancer. You can find a wealth of great charities with gift tie-ins to raise money for a cause at www.give.org.

If you're among the couples who wish to donate to charity in your guests' names instead of giving out gifts, be sure to print out the announcement on a great card with color print, and attach a token for guests to take home. Attach candies or a printed poem on a laminated card from the book-store or card shop—something tangible and not just an announcement.

PACKAGING FOR PRESENTATION

856. Package your favors with great presentation to give even the most inexpensive choice a little bit of extra flair. Check the craft shop for colored miniature gift boxes in bulk, or go to www.bayleysboxes.com to find creative designer-style boxes and containers for low prices. (I love their shiny silver pyramid boxes and the one that folds into a rosette on the top!)

857. Buy plain white, miniature gift boxes and decorate them yourself by affixing bows to the top or wrapping them with great vel-vet ribbon (discount priced from a fabric store).

858. Check out the offerings in velvet ribbon. It's available in a rainbow of colors from cranberry to royal blue to hunter green, with gold edges, and perhaps even in a scalloped design. The fabric or craft store is your destination on this one, and you can buy rolls in bulk at discount or negotiate to get remainder rolls for a lower price.

859. Print out your own favor labels using great theme labels from the office supply store. Choose between romantic pastel prints with rosebuds, light blue labels with silver snowflakes, jalapeño prints for a fiesta, and a world of other possibilities. Use a color print and a great font that you design yourself, and save up to $30 on this task alone.

860. Buy inexpensive gold, silver, or colored monogram labels at the craft store to affix to your gift boxes.

861. The craft store is your source for a wax seal kit. It's very inexpensive and, if you use a monogram stamp with gold or red wax, it gives a favor that upscale look.

862. If you're looking for baskets, visit the craft store or dollar store for a wide range of possibilities and bulk buy discounts.

863. For colored cellophane bags, you can't beat the prices at the craft shop. Cellophane bags come in pastels, clear, brights, and theme graphics like flowers, stars, moons, hearts, Cupids, stripes, snowflakes, and more.

864. For gift certificates and other flat objects, choose colored or graphic imprinted envelopes from the office supply store.

865. As accents to wrapped, bagged, or boxed favors, glue on tiny silk flowers, silver-colored charms, seashells, ribbon bows, or any other great little items you find at the craft store. One couple from Memphis tells me they went to a shop that specializes in miniatures to find the perfect items to glue onto their favor boxes.

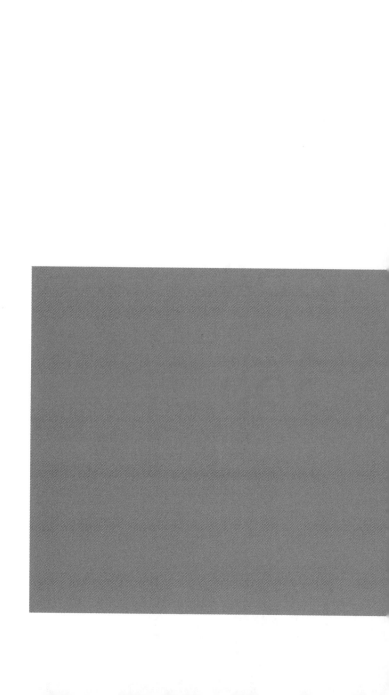

Gifts for Others

You have so many people to thank for being an important part of your day, and they deserve something more than just one of your wedding favors. Especially if your parents, relatives, and friends have devoted their time and skills (by crafting or cooking or hooking you up with their great contacts for a friendly discount) to help you get more wedding for less money, it's a must to show them your appreciation with a great gift.

This is not an area where I'll encourage you to cut your expenses way down low. A Magic 8 Ball or a baggie of chocolate-dipped Oreos is not going to cut it in this section. Prepare to spend more to give this important gesture its due. Some couples wisely scale down other areas of their wedding budget so that they can give better gifts to their families and bridal parties. They're worth it!

So read on for some ideas, and devote yourself to finding great values at reputable sources, finding discounts where you can, and remembering that great meaning and sentiment in your choices always adds up to great value in the recipient's eyes.

GIFTS FOR PARENTS

866. Get flowers for Mom and cigars for Dad.

867. Give them a portrait of your family in a great frame.

868. Put together a special photo album filled with great pictures of them and of your family.

869. Give your parents a tree seedling to plant in their yard.

870. Create an edited video of footage of them throughout the years. (You can make this on your home computer, or bring it to a video editor friend.)

871. Purchase a great bottle of champagne or wine (check www.winespectator.com for ideas in your budget range).

872. Mom will love a beautiful piece of jewelry or a mother's ring. Buy it during a jewelry store's holiday sales.

873. Give your parents a gift certificate to a great brunch and a note saying you'd love to join them some time after the wedding.

GIFTS FOR USHERS AND GROOMSMEN

874. Engrave beer mugs with each groomsman's initials or the bride and groom's initials and wedding date.

875. For a very useful gift, give the ushers or groomsmen engraved key chains or money clips (check www.thingsremembered.com).

876. An engraved silver business card case is a great gift that will last for years to come.

877. Cufflinks are a double-duty gift since the ushers and groomsmen can wear them during the wedding.

878. Cigars and cigar cutters are a popular gift right now.

879. Theme-printed ties are a fun gift, especially around the holidays.

880. Playful couples might choose theme-printed T-shirts (such as funny golf sayings).

881. Sports accessories, such as a handy cigar holder that clips on to a golf cart (I found these at a cigar store for under $5 each!), are always appreciated.

882. Colorful or personalized luggage tags can be used for all of their travels.

883. Give them a great bottle of wine, champagne, port, brandy, or cognac (see www.winespectator.com) to be used at a special occasion of their own.

884. A personalized travel coffee decanter with miniature bags of their favorite coffee blends is a great idea for coffee lovers.

885. Purchase cologne or items from a men's line of pampering products.

886. Find music CDs (or create your own music mix CD) with all of your shared favorite songs—the soundtrack of the best times of your friendship.

887. Purchase a DVD of your shared all-time favorite movie.

GIFTS FOR THE MAID OF HONOR AND BRIDESMAIDS

888. Your gift could be the jewelry for them to wear on the wedding day.

889. An initial necklace or bracelet is a great personalized gift.

890. Purchase a charm bracelet and charms that match each bridesmaid's personality and interests.

891 A heart locket is a sweet gift, especially if you add pictures of you and the bridesmaids inside.

892. Engrave a silver compact case with each bridesmaid's initials (see www.things remembered.com).

893. Give each bridesmaid a silver business card holder. Have it personalized by engraving each bridesmaid's initials, the bride and groom's initials, and/or the wedding date.

894. Put together an album filled with photos of the two of you and your group of friends.

895. Give each bridesmaid a framed photo of your group of friends.

896. Find a great bottle of wine, champagne, port, brandy, or cognac (see www.wine spectator.com) for the next special occasion in her life.

897
A basket of great pampering products is a much-deserved gift for all of your hardworking bridesmaids.

898
Purchase framed artwork (check www.art.com for a great selection of prints).

899
Frame a great saying or poem, such as the "Desiderata."

900
Promise that you'll always keep in touch and give your bridesmaids a collection of stationery and a packet of pre-paid phone cards. This is especially great for bridesmaids who live far away or are moving for work or love.

901
Give each bridesmaid a bottle of her favorite perfume or pick one that you think she'd like.

902
A novelty T-shirt with funny or trendy sayings on it is a fun gift idea.

903. Select a wonderful item from the Maya Angelou line of gift products, such as her "Only equals can be friends" mug.

904. Look for a great card (perhaps from the Maya Angelou line) and write a wonderful, personalized note.

905. A personalized travel coffee decanter with miniature bags of their favorite coffee blends is a great gift for coffee lovers.

906. Look for or create colorful or personalized luggage tags your bridesmaids can use for all of their travels.

907. Either purchase music CDs or create your own music mix CDs to give your bridesmaids the soundtrack of your friendship and favorite times.

908. Give bridesmaids a DVD of your shared favorite movie.

GIFTS FOR KIDS

909. Little girls love to get jewelry such as silver heart lockets, initial necklaces or bracelets, or a birth stone ring.

910. Ask their parents to suggest a great toy they've been wanting.

911. Kids will love adorable stuffed toys—try finding ones dressed as a bride or groom.

912. A gift certificate to a toy shop or music store lets older kids pick out exactly what they want.

913. Purchase DVDs, CDs, or computer games that they've been asking for.

914. Give the kids a hat or T-shirt with their favorite professional sports team's logo.

915. For athletic kids, give them a personalized water bottle for use during their sporting events and practices (you can make these using kits from the craft store).

916. Look for a much-wanted poster for their bedroom, such as one featuring the child's favorite singer or movie, or a sports hero (personalize your poster choices to each child's tastes, of course).

917. An inexpensive camera and film would be great for the budding photographer's new hobby.

918. Purchase art supplies like an easel, paints, and canvases for the child who is interested in art.

919. Purchase a gift certificate to a favorite clothing store.

920. Snow globes are a great gift idea. If you're having a destination wedding, purchase snow globes that depict the location of your wedding.

921. Music boxes can be personalized by picking a meaningful song or have them engraved with the child's initials.

922. Purchase gift certificates for movie rentals.

GIFTS FOR HELPERS AND THOSE WHO WILL DO READINGS OR PERFORM AT THE WEDDING

923. Purchase a gift certificate for brunch.

924. Give each person a gift certificate to a bookstore with a café.

925. Purchase tickets to a comedy club.

926. A lovely scarf is a great gift for the women.

927. A great pair of gloves can be given to men and women helpers.

928. Give each helper a book of gratitude quotes.

929. Purchase framed artwork prints.

930. Give the women a necklace, such as a heart locket.

931. Give the men cigars.

932. Purchase a gift certificate to a coffee shop, together with a great travel coffee mug or container.

FOR YOU AND YOUR GROOM TO GIVE EACH OTHER

933. Your wedding rings can count as your gifts to one another.

934. Your honeymoon can count at your gifts to one another.

935. Your wedding day jewelry can count as the groom's gift to you.

936. Tree seedlings that you will plant together in your yard will grow as your marriage grows.

937. A bottle of great champagne can be shared on your first night as husband and wife.

938. Create a special photo album of the two of you. (For extra romance points, label it Volume I, and then get another unfilled photo album labeled Volume II for all of your captured moments in the future.)

939. Enlarge your favorite picture of the two of you (such as when you got engaged). Frame it and hang it in your home with a spotlight on it.

940. Frame your greatest accomplishments (such as your diplomas, articles you've had published, your (as-yet-undiscovered) artwork) and hang them in your home.

941. Give items to support your goals, such as a new leather portfolio or briefcase.

942. Purchase framed artwork featuring your favorite artist or scenery.

943. Playful, romantic gift certificates for massages, breakfasts in bed, dinners cooked for you at home, dessert in bed, etc., are always a great idea.

944. Create a book of gift certificates to be cashed in on each of your future wedding anniversaries. For example, "First Anniversary—this certificate entitles you to one breakfast in bed, menu of your choice." Print these out yourself on colored paper with fun graphics or stickers from the craft shop and enclose each in an envelope that's not to be opened until the date of your anniversaries.

945. Create an original song written for your partner. It can be instrumental and just a melody on the piano or guitar, and it becomes "your song" to play onward into the future.

946. Share the journal you've kept from the beginning of the wedding-planning process, detailing all of your thoughts and memories, future wishes, favorite quotes, and thoughts about your partner to keep for all time.

947. Purchase the first item in a collection you'll keep as a family tradition: holiday ornaments, seashells from each destination you visit together in the future, and so on.

948. The most heart-warming gift—that costs only the paper it's written on—is always going to be your heartfelt expressions of gratitude written in your own hand as a letter from you. Take your time composing these personalized letters, and be sure to include your favorite memories with these loved ones you're writing to, what you've learned from them, what they have brought to your life, and how blessed you are to know them. Parents especially find these letters to be priceless gifts, and they keep them forever.

949. Another twist on this idea: videotape yourself reading the letter and give the video as your gift in addition to the letter itself.

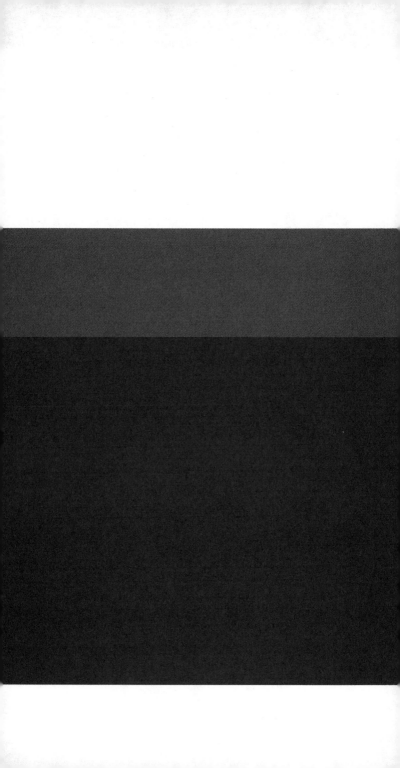

Part Seven:

Last-Minute Expenses

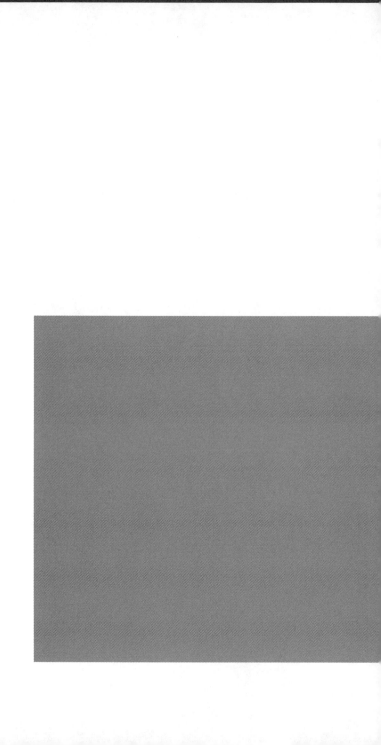

Wedding Weekend Events

You can fill the entire weekend of your wedding with great activities and nights out designed to give you and your guests something priceless: time spent together in a relaxed atmosphere where you can catch up with one another before all the official wedding day formality and activity sets in. This is a time for laughter, fun, adventures, and also interaction with your guests' kids (especially if they won't be at the wedding itself). The rise of action-packed wedding itineraries has come about because countless brides and grooms in the past have found that they had very little time to actually relax and hang out with their friends. This is particularly true if their friends live around the country and this is the first time they're seeing them in a while. Thus started the trend of planning breakfasts and barbecues, softball tournaments and

sailing trips to make the weekend all about togetherness and not just about the wedding.

In this chapter, you'll start thinking about great wedding weekend activities that might be perfect for your plans, and for your guests. As far as price is concerned, these activities are most often low budget, and many of them are free.

950.
Plan a family-style dinner at home, rather than out at a fancy restaurant.

951.
For a laid-back night out, go to a sports bar's happy hour for discounted drinks and even free food at their buffet.

952.
Have a barbecue or picnic out at a park or in your backyard—pool parties included.

953.
Have breakfast or brunch at a restaurant or at your home.

954. Check with your hotel manager for special pricing on a welcome cocktail party for your guests.

955. Go to a pizza parlor for a casual dinner out.

956. Have a wine and cheese party.

957. Have a fondue party.

958. Have an ice cream social.

959. Have a slumber party for kids, and serve pizzas and cake.

SPORTING ACTIVITIES

960. Plan a miniature golf tournament for your guests. It's often under $5 per person to play. Give out gift prizes for accomplishments such as "Best Hole in One" or "Best Comeback in the Back Nine." Get a toy trophy for the winner.

961. Plan a softball tournament, with his side of the family versus her side.

962. Plan a tennis outing.

963. Take your crew out to a family fun center, where you can play arcade games, laser tag, even bumper cars.

964. Go sledding at the park or on your own hills .

TRIPS TO ATTRACTIONS

965. Plan a trip to a nearby boardwalk.

966. Visit a nearby museum, especially children's museums.

967. Visit a nearby aquarium.

968. Go on a free walking tour of your town or go hiking along a county park trail.

969. Tour historic homes.

970. Go to a festival (check www.festivals.com to find out if one will be near your home town) or to a town carnival.

971. Take your group to the beach for a day of volleyball and relaxing time in the sun.

972. Go to a car show, which is often free at car dealerships and often planned during the summer and fall months.

973. Go to a family farm, where you might find apple picking, tractor rides, corn mazes, and pumpkin patch tours.

974. Go to a winery for free wine tastings and tours of the establishment.

975. Go to a minor league baseball game, with a group discount for your block of tickets.

976. Go bowling.

977. Go ice-skating.

978. Plan a trip to the nearby shopping outlets for a day of shopping (and no, you don't pay for your guests' purchases!). You might even be able to take advantage of the hotel's shuttle bus for free transportation to and from the outlets! (Check www.outletbound.com to find outlet shopping centers near you.)

979. Go to haunted houses for tours.

980. Go on a culinary tour where you'll have one course at one restaurant, and the next course at the second stop, and so on.

981. Check out your community calendar for free concerts in the park.

982. Your community calendar might also show you the schedule for movies in the park.

983. Go to the movies during matinee hours.

984. Have a game night at your home.

985. Have a movie night at your home.

986. Go to the playground at the park, where kids can play on the gyms, and adults can walk the paths or play Frisbee golf on a set course. Some parks are all-inclusive, offering in-line roller skating rinks, ice rinks, tennis courts, and obstacle courses. Planning a day at the park could mean activities for everyone.

29

The Rehearsal and Rehearsal Dinner

In the past, the rehearsal dinner—being the main event the parents of the groom got to plan—was almost as formal an event as the wedding itself. Parents spent thousands of dollars to "compete" with the wedding reception the next day. The finest champagne was served and florists were hired to make great centerpieces. Today, the style of rehearsal dinners is way more laid-back. Couples request a more informal party, as a way to relax and not have too many formal events to attend in one weekend. The result is a great new wave of casual get-togethers that allow the couple to relax with their loved ones and enjoy the calm before all the frantic activity of the big day to come.

Whether the rehearsal dinner is in your future in-laws' hands or yours, here are some great budget-saving styles for your rehearsal and rehearsal dinner.

987. Don't buy a new outfit or dress for your rehearsal and rehearsal dinner. Just wear a great dress or work outfit you already own.

988. Don't hire a photographer or videographer to come to this evening's events. Just ask a friend to take pictures and roll video for you.

989. Keep your guest list at the rehearsal dinner small. Some couples invite only the people involved in the wedding itself, and others invite all of their out-of-town guests. For the rehearsal dinner, just host your bridal party, family, and ceremony participants. You can plan another activity for out-of-towners later.

990. Ask for a discount on a catered meal at the hotel where the wedding will take place and where many of your guests are staying. With so much investment from you, the hotel manager might be willing to give you a great break on your rehearsal dinner package and perhaps throw in some freebies like dessert or the use of their pianist for entertainment.

991 Choose a unique setting for the rehearsal dinner, such as a terrace overlooking the ocean, or a restaurant's outdoor seating area. In fresh scenery, even an informal menu seems more impressive.

992. Have a cocktail party rather than a sit-down dinner.

993. Choose less expensive menu items for a catered party, such as pasta and chicken dishes. Your guests will get the "good stuff" tomorrow.

994. If you're cooking or having the dinner at home, choose a family-style menu, such as big platters of lasagna, salad, and garlic bread.

995. Order party-style platters like buffalo wings, sandwiches, and salads. Platters like these go over well at informal dinners.

996. Host a laid-back pizza party with a selection of great pizzas: ham and pineapple, spinach, bruschetta, Sicilian, and so on. Take advantage of two-for-one offers at your pizza delivery place for even greater savings, and buy sodas in bulk at the warehouse store.

997. Offer just one dessert option, such as a cake or chocolate mousse, rather than an extended dessert bar.

998. Shop for great wines and champagnes in a budget range (www.winespectator .com).

999. Skip the champagne at this party. Guests can toast you with their drinks-in-hand.

1000. No favors are needed at this event. This is where you'll be giving gifts to your family and bridal party, so no extra trinkets are needed.

Don't Forget the Tips!

Of course, there's always the issue of tipping. There's no budget shortcut for tips— you reward great service with the customary amount. No cutting corners here! In fact, I encourage you to be generous with all of the professionals and volunteers who are doing their best to make your wedding incredible. If they have done you great favor by giving you freebies and add-ons or if they've gone above and beyond the call of duty to meet your needs, tip them well. Each of these people play a part in the success of your wedding day, including how you'll look, so they're very important to you.

Here's a general primer on the usual amounts given in tips to the various professionals and helpers who are giving their best efforts to you.

Wedding coordinator: 10 to 20 percent of your bill, depending on the terms of your contract

Officiants: $75 to $100 tip is usually expected as a "donation"

Ceremony site staff: $20 to $30

Organists and ceremony musicians: $20 to $50, depending on length of service

Site manager: 15 to 20 percent of entire bill for the reception

Valets: $1 per car

Waiters: $20 to $30 each, depending upon quality of service

Bartenders: 15 percent of liquor bill

Coat check: $1 per coat

Limousine drivers: 15 to 20 percent of transportation bill (Remember, though, some limousine companies already add in a generous 18 percent gratuity to your bill, so be aware of such fine print in your contract before you fork over 38 percent by accident!)

Delivery workers: $10 each if just dropping items off, $20 each if dropping off and setting up to great extent

Tent assemblers and rental agency assemblers: $20 each, more if it's a complicated, custom job

Entertainers: $25 to $30 each

Beauticians and barbers: 15 to 20 percent of beauty salon bill

Cleanup crew: $20 each

Babysitters: $30 to $40 each, plus a gift; more if the babysitter is putting in extra hours or caring for several children

EXTRA CASH

You'll need cash on hand for the wedding day for the various expenses that spring up, such as:

- Parking
- Cab fare for guests at the end of the night
- Extra supplies, ice, or liquor needed during the event
- Delivery fees for the dropping off of flowers and rental items, and tipping of each delivery worker
- Extra soft drinks
- Items for your appearance, like an extra pair of stockings when yours run
- Overtime payment for babysitters when the party lasts longer than expected
- Cash to pay for spontaneous outings, like ordering room service at midnight when you realize you didn't eat very much at the wedding

A NOTE FROM THE AUTHOR

You can have your dream wedding for less money! You've just learned a thousand ways to get more wedding on a lower budget, without an ounce of the savings showing to anyone! You found out where and how to get some of your wedding for free and how to bring in friends and family so that they not only help you out, but also are a part of the day. It all adds up to twice the wedding at your original budget, if not more! With money stress behind you, you're free to plan the wedding of your dreams that showcases your personalities, your sense of humor, your own personal style, and cherished beliefs and values.

I wish you luck and enjoyment of every minute from now until the wedding night, and forever after. You're planning a day of a lifetime, but there's also a lifetime to live after the big day—always keep that in mind. Prepare for the marriage and not just for the wedding, so that both will be priceless.

If you would like to contribute your most successful bridal budget-saving strategies for possible inclusion in future editions of this book, I'd love to hear from you. Just contact me through my site at www.sharonnaylor.net, and you could see your name in print!

All the best,
Sharon Naylor

ADDITIONAL BOOKS BY SHARON NAYLOR

The Mother of the Groom Book

1000 Best Secrets for Your Perfect Wedding

Your Special Wedding Toasts

Your Special Wedding Vows

The Groom's Guide

Your Day, Your Way: The Essential Handbook for the 21st Century Bride, co-authored with celebrity bridal gown designers Michelle and Henry Roth

The Ultimate Bridal Shower Idea Book

The New Honeymoon Planner

How to Have a Fabulous Wedding for $10,000 or Less

The Complete Outdoor Wedding Planner

How to Plan an Elegant Wedding in 6 Months or Less

The Mother of the Bride Book

1001 Ways to Have a Dazzling Second Wedding

The 52 Most Romantic Places In and Around New York City (Contributor)

and others as listed at www.sharonnaylor.net

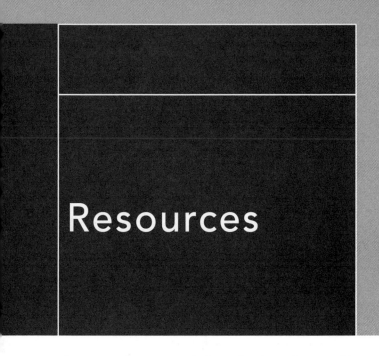

Resources

Please note that contact information does change with the advent of new area codes and changes in Web addresses. All contact information was current at the time of this writing. We apologize if such a change has occurred since the publication of this book.

AIRLINES
Air Canada: 888-247-2262, www.aircanada.ca
 Air France: www.airfrance.fr
AeroMexico: 800-237-6639, www.aeromexico.com
Alaska Airlines: 800-ALASKAAIR (800-252-7522),
 www.alaskaair.com
Alitalia: www.italiatour.com
Aloha Airlines: 800-367-5250,
 www.alohaairlines.com
America West: 800-2FLY-AWA,
 www.americawest.com
American Airlines: 800-433-7300, www.aa.com

British Airways: 800-AIRWAYS,
 www.britishairways.com
Continental Airlines: 800-523-3273,
 www.continental.com
Delta Airlines: 800-221-1212, www.delta.com
Hawaiian Airlines: 800-367-5320,
 www.hawaiianair.com
KLM Royal Dutch Airlines: www.klm.com
Northwest Airlines: 800-225-2525, www.nwa.com
Southwest Airlines: 800-435-9792,
 www.southwest.com
Ted: 800-225-5833, www.flyted.com
TWA: 800-221-2000, www.twa.com
USAir: 800-428-4322, www.usair.com
United Airlines: 800-864-8331, www.united.com
Virgin Atlantic Airways: 800-862-8621,
 www.virgin-atlantic.com

DISCOUNT AIRFARE

Air Fare: www.airfare.com
Cheap Fares: www.cheapfares.com
Cheap Tickets: www.cheaptickets.com
Discount Airfare: www.discount-airfare.com
Priceline: www.priceline.com
You Price It: www.youpriceit.com

BEAUTY PRODUCTS AND SERVICES

Check these sites for sales on makeup and skin care products, assessments, and services, even articles:

Avon: www.avon.com

Bobbi Brown Essentials: www.bobbibrown.com

Clinique: www.clinique.com

Clairol: www.clairol.com

Elizabeth Arden: www.elizabetharden.com

Estee Lauder: www.esteelauder.com

iBeauty: www.ibeauty.com

Lancome: www.lancome.com

Laura Geller: www.laurageller.com

L'Oreal: www.loreal.com

Mac: www.maccosmetics.com

Max Factor: www.maxfactor.com

Maybelline: www.maybelline.com

Neutrogena: www.neutrogena.com

Pantene: www.pantene.com

Reflect.com (customized beauty products): www.reflect.com

Rembrandt (tooth-whitening products): www.rembrandt.com

Revlon: www.revlon.com

Sephora: www.sephora.com

BRIDAL GOWNS

Alfred Angelo: 800-531-1125, www.alfredangelo.com

America's Bridal Discounters: 800-326-0833, www.bridaldiscounters.com

Amsale: 212-971-0170, www.amsale.com

Birnbaum and Bullock: 212-242-2914, www.birnbaumandbullock.com

Bonny: 800-528-0030, www.bonny.com

Bridal Originals: 800-876-GOWN,
www.bridaloriginals.com

Brides-R-Us.com: 800-598-0685,
www.brides-r-us.com

Carolina Herrera: 212-944-5757,
www.carolinaherrera.com

Christos, Inc.: 212-921-0025;
www.christosbridal.com

David's Bridal: 800-399-BRIDE,
www.davidsbridal.com

Demetrios: 212-967-5222,
www.demetriosbride.com

Diamond Collection: 212-302-0210,
www.diamondbride.com

Eden Bridals: 800-828-8831, www.edenbridals.com
(check out their values collection!)

Emme Bridal Inc.: 281-634-9225,
www.emmebridal.com

Forever Yours Intl. Corp.: 631-951-4500,
www.foreverbridals.com

Gowns Online: www.gownsonline.com

Group USA: www.groupusaonline.com

Henry Roth Designs: 212-245-3390,
www.henryroth.com

Janell Berté: 717-291-9894, www.berte.com

Jasmine: 800-634-0224, www.jasminebridal.com

Jessica McClintock: 800-333-5301,
www.jessicamcclintock.com

Jim Hjelm: 800-686-7880,
www.jimhjelmvisions.com

Lila Broude: 212-921-8081

Manalé: 212-944-6939, www.manale.com

Marisa: 212-944-0022, www.marisabridals.com

Melissa Sweet Bridal Collection: 404-633-4395,
www.melissasweet.com

Michelle Roth: 212-245-3390,
www.michelleroth.com

Mon Cheri: 609-530-1900, www.mcbridals.com

Mori Lee: 212-840-5070, www.morilee.com

Priscilla of Boston: 617-242-2677,
www.priscillaofboston.com

Private Label by G: 800-858-3338,
www.privatelabelbyg.com

Roaman's Romance (Plus-Sizes): 800-436-0800

Sweetheart: 800-223-6061, www.gowns.com

Tomasina: 412-563-7788,
www.tomasinabridal.com

Venus: 800-OH-VENUS

Vera Wang: 212-575-6400, www.verawang.com

Yumi Katsura: 212-772-3760,
www.yumikatsura.com

BRIDAL SHOWS AND CONFERENCES

Great Bridal Expo: 800-422-3976,
www.bridalexpo.com

BRIDESMAIDS' AND MOTHER OF THE BRIDE GOWNS

After Six: 800-444-8304, www.aftersix.com

Alfred Angelo: 800-531-1125,
www.alfredangelo.com

Bill Levkoff: 800-LEVKOFF, www.billlevkoff.com

Chadwick's of Boston Special Occasions:
 800-525-6650
Champagne Formals: 212-302-9162,
 www.champagneformals.com
David's Bridal: 888-399-BRIDE,
 www.davidsbridal.com
Dessy Creations: www.dessy.com
Group USA: 1-877-867-7600, www.groupusa.com
JC Penney: 800-222-6161, www.jcpenney.com
Jessica McClintock: 800-333-5301,
 www.jessicamcclintock.com
Jim Hjelm Occasions: 800-686-7880,
 www.jimhjelmoccasions.com
Lazaro: 212-764-5781, www.lazarobridal.com
Macy's: 877-622-9274,
 www.macys.weddingchannel.com
Melissa Sweet Bridal Collection: 404-633-4395,
 www.melissasweet.com
Mori Lee: 212-840-5070, www.morileeinc.com
Roaman's Romance (plus sizes): 800-436-0800
Silhouettes: www.silhouettesmaids.com
Spiegel: 800-527-1577, www.spiegel.com
Vera Wang: 800-VEW-VERA, www.verawang.com
Watters and Watters: 972-960-9884,
 www.watters.com

CAKE SUPPLIES

Wilton: 800-794-5866, www.wilton.com

CALLIGRAPHY

Calligraphy by Kristen:
www.calligraphybykristen.com
Petals and Ink: 818-509-6783,
www.petalsnink.com

CAMERAS

C&G Disposable Cameras:
www.cngdisposablecamera.com
Kodak: 800-242-2424, www.kodak.com
Michaels: www.michaels.com
Wedding Party Pack: 800-242-2424

CEREMONY SITES

USA Citylink: www.usacitylink.com

CHILDREN'S WEDDING WEAR

David's Bridal: 888-399-BRIDE,
www.davidsbridal.com
Finetica Child: www.Fineticachild.com
Katie and Co.: www.katieco.com
Posie's: www.posies.com
Storybook Heirlooms: www.storybookonline.com

CRUISES

Cruise Lines International Association:
www.cruising.org
Porthole Cruise Magaine: www.porthole.com
A Wedding For You: 800-929-4198 (Weddings
Aboard a Cruise Ship),
www.aweddingforyou.com

American Cruise Line (east coast from Florida to
 Maine): www.americancruiselines.com
Carnival Cruise Lines: 888-CARNIVAL,
 www.carnival.com
Celebrity Cruises: 800-722-5941,
 www.celebrity.com
Cunard: 800-7CUNARD, www.cunardline.com
Delta Queen: 800-543-1949, www.deltaqueen.com
Cruise.com: 888-333-3116, www.cruise.com
Disney Cruises: 800-951-3532,
 www.disneycruise.com
Holland America: 877-724-5425,
 www.hollandamerica.com
Norwegian Cruise Lines: 800-327-7030;
 www.ncl.com
Princess Cruises: 800-PRINCESS,
 www.princess.com
Radisson 7 Sevens Cruises: 877-505-5370,
 www.rssc.com
Royal Caribbean: 800-398-9819,
 www.royalcaribbean.com

DISCOUNT STORE FINDERS
Consignment Shop Finder:
 www.consignment-shops-stores.com
Outlet Finder: www.outletbound.com

FABRICS
Fabric Depot: 800-392-3376
Fabric Mart: 800-242-3695
Greenberg and Hammer: 800-955-5135
Jo-Ann: www.joann.com
Michael's: 800-MICHAELS, www.michaels.com

FAVORS AND GIFTS:

Chandler's Candle Company: 800-463-7143,
www.chandlerscandle.com
Eve.com: www.eve.com
Exclusively Weddings: 800-759-7666,
www.exclusivelyweddings.com
Favors by Serendipity: 800-320-2664,
www.favorsbyserendipity.com
Forever and Always Company: 800-404-4025,
www.foreverandalways.com
Gift Emporia.com: www.giftemporia.com
Godiva: 800-9-GODIVA, www.godiva.com
Gratitude: 800-914-4342,
www.giftsofgratitude.com
Illuminations: 800-621-2998,
www.illuminations.com
Personal Creations: 800-326-6626,
www.personalcreations.com
Pier 1 Imports: 800-245-4595, www.pier1.com
Service Merchandise: 866-978-2583,
www.servicemerchandise.com
Things Remembered: 800-274-7367,
www.thingsremembered.com
Tree and Floral Beginnings (seedlings, bulbs, and
candles): 888-315-7333, www.plantamemory.com

FLOWERS

About.com: www.about.com
Association of Specialty Cut Flower Growers:
440-774-2887, www.ascfg.org
Flowersales.com: www.flowersales.com
International Floral Picture Database:
www.flowerweb.com
Romantic Flowers: www.romanticflower.com

HOTELS

To find a suitable hotel in your destination, look
 up the All Hotels on the website at
 www.all-hotels.com
Beaches: 800-BEACHES, www.beaches.com
Club Med: www.clubmed.com
Couples Resorts: 800-268-7537, www.couples.com
Disney: www.disneyweddings.com
Hilton Hotels: www.hilton.com
Hyatt Hotels: www.hyatt.com
Marriott Hotels: www.marriott.com
Radisson: www.radisson.com
Sandals: 888-SANDALS, www.sandals.com
Super Clubs: 877-GO-SUPER, www.superclubs.com
Westin Hotels: www.westin.com
Bed and Breakfasts, Country Inns, and Small Hotels:
 www.virtualcities.com/ons/Oonsadex.htm
Bed and Breakfast—International Guide:
 www.ibbp.com
Fodors: www.fodors.com
Hilton: www.hilton.com
Hyatt: www.hyatt.com
Leading Hotels of the World: www.lhw.com
Marriott: www.marriott.com
Radisson: www.radisson.com

INVITATIONS

An Invitation to Buy—Nationwide: 708-226-9495,
 www.invitations4sale.com
Anna Griffin Invitation Design: 404-817-8170,
 www.annagriffin.com
Botanical PaperWorks: 888-727-3755,
 www.botanicalpaperworks.com

Camelot Wedding Stationery: 800-280-2860

Crane and Co.: 800-572-0024, www.crane.com

Evangel Christian Invitations: 800-457-9774,
http://invitations.evangelwedding.com

Invitations by Dawn: 800-332-3296,
www.invitationsbydawn.com

Julie Holcomb Printers: 510-654-6416,
www.julieholcombprinters.com

Now and Forever: 800-451-8616,
www.now-and-forever.com

PaperStyle.com (ordering invitations online):
770-667-6100, www.paperstyle.com

Papyrus: www.papyrusonline.com

Precious Collection: 800-537-5222,
www.preciouscollection.com

PSA Essentials: www.psaessentials.com

Renaissance Writings: 800-246-8483,
www.RenaissanceWriting.com

Rexcraft: 800-635-3898, www.rexcraft.com

Vismara Invitations:
www.vismarainvitations.com

Willow Tree Lane: 800-219-9230,
www.willowtreelane.com

LIMOUSINES

National Limousine Association: 800-NLA-7007,
www.limo.org

WEDDING COORDINATORS

Association of Bridal Consultants: 860-355-0464,
www.bridalassn.com

Association of Certified Professional Wedding
 Consultants: 408-528-9000, www.acpwc.com
June Wedding Inc. (Consultants in the Western
 US): 702-474-9558, www.junewedding.com

LINGERIE
Bloomgindales: www.bloomingdales.com
Lord and Taylor: www.lordandtaylor.com
Macy's: www.macys.com
Target: www.target.com
Victoria's Secret: www.victoriassecret.com

MEN'S WEDDING WEAR
(Check designer sites for big seasonal sales and
clearances on men's ties, vests, shirts and suit
separates!)
After Hours: www.afterhours.com
Bloomingdales: www.bloomingdales.com
Brooks Brothers: www.brooksbrothers.com
Burberry: www.burberry.com
Dante Zeller: www.zellertuxedo.com
Gingiss: www.gingiss.com
Hugo Boss: www.hugoboss.com
J. Crew: 800-562-0258, www.jcrew.com
Lord and Taylor: www.lordandtaylor.com
Macy's: www.macys.com
Marrying Man: www.marryingman.com
Ralph Lauren: www.polo.com

PAPER PRODUCTS

OfficeMax: 800-283-7674, www.officemax.com
Paper Access: 800-727-3701,
 www.paperaccess.com
Paper Direct: 800-A-PAPERS
Staples: 800-333-3330, www.staples.com
The Wedding Store: www.wedguide.com/store
Ultimate Wedding Store:
 www.ultimatewedding.com/store
USA BRIDE: 800-781-9129,
 www.usabridewedding.com
Wedmart.com: 888-802-2229, www.wedmart.com

PHOTO ALBUMS

Exposures: 800-222-4947,
 www.exposuresonline.com

WEDDING REGISTRIES

Bed Bath and Beyond: 800-GO-BEYOND,
 www.bedbathandbeyond.com
Bloomingdales: 888-269-3187,
 www.bloomingdales.com
Bon Ton: 800-9BONTON, www.bonton.com
Crate and Barrel: 800-967-6696,
 www.crateandbarrel.com
Dillards: 800-345-5273, www.dillards.com
Filene's: 800-9-SAY-I-DO,
 www.FilenesWeddings.com
Fortunoff: 800-FORTUNOFF, www.fortunoff.com
Greenfeet (organic items): 888-5-NATURE,
 www.greenfeet.com
Gump's: 800-444-0450, www.gumps.com

Hecht's: 800-9-SAY-I-DO, www.hechts.com

Home Depot: 800-553-3199,
 www.homedepot.com

HoneyLuna (honeymoon registry): 800-809-5862,
 www.honeyluna.com

The Homeymoon: 888-796-7772,
 www.thehoneymoon.com

JC Penney: 800-322-1189, www.jcpgift.com

Just Give (charitable): 866-587-8448,
 www.justgive.org

Kohl's: 800-837-1500

Linens-N-Things: 866-568-7378, www.lnt.com

Macy's Wedding Channel: 888-92-BRIDES,
 www.macys.weddingchannel.com

Neiman Marcus: 888-888-4754,
 www.neimanmarcus.com

Pier 1 Imports: 800-245-4595, www.pier1.com

Pottery Barn: 888-779-5176,
 www.potterybarn.com

Sears: 800-349-4358, www.sears.com

Service Merchandise: 866-978-2583,
 www.servicemerchandise.com

Sharper Image: 800-344-5555,
 www.sharperimage.com

Sur La Table: 800-243-0852, www.surlatable.com

Target's Club Wedd Gift Registry: 800-888-9333,
 www.target.com

Tiffany: 800-526-0649, www.tiffany.com

Wedding Channel.com:
 www.weddingchannel.com

Williams Sonoma: 800-541-2376,
 www.williams-sonoma.com

RINGS

American Gem Society: 800-346-8485, www.ags.org

Benchmark: 800-633-5950,
www.benchmarkrings.com

Bianca: 888-229-9229, www.BiancaCollection.com

Blue Nile: www.bluenile.com

Bulgari: 212-717-2300, www.bulgari.com

Cartier: 800-CARTIER, www.cartier.com

Christian Bauer: 800-228-3724,
www.christianbauer.com

DeBeers: www.adiamondisforever.com

A Diamond is Forever: www.adiamondisforever.com

EGL European Gemological Society: www.egl.co.za

Fortunoff: www.fortunoff.com

Honora: 888-2HONORA, www.honora.com

Jeff Cooper Platinum: 888-522-6222,
www.jeffcooper.com

Lazare Diamond: www.lazarediamonds.com

Michael C. Fina: www.michaelcfina.com

Novell: 888-916-6835,
www.novelldesignstudio.com

OGI Wedding Bands Unlimited: 800-578-3846,
www.ogi-ltd.com

Paul Klecka: www.klecka.com

Rudolf Erdel Platinum: www.rudolferdel.com

Scott Kay Platinum: 800-487-4898,
www.scottkay.com

Tiffany: 800-526-0649, www.tiffany.com

Wedding Ring Hotline: 800-985-RING,
www.weddingringhotline.com

Zales: 800-311-JEWEL, www.zales.com

For information on how to design your own
rings, check out www.adiamondisforever.com

SHOES AND HANDBAGS

Bloomingdales: www.bloomingdales.com
Kenneth Cole: 800-KENCOLE
David's Bridal: www.davidsbridal.com
Dyeables: 800-431-2000
Fenaroli for Regalia: 617-723-3682
Macy's: www.macys.com
Nicole Miller: www.nicolemiller.com
Nina Footwear: www.ninashoes.com
Payless: 877-474-6374, www.payless.com
Target: 800-800-8800, www.target.com
Salon Shoes: 650-588-8677, www.salonshoes.com
Watters and Watters: 972-960-9884,
 www.watters.com

STATE AND LOCATION TOURISM DEPARTMENTS

Tourism Office Worldwide Directory:
 www.towd.com

TRAIN TRAVEL

Amtrak: 800-872-7245, www.amtrak.com
Eurailpass: www.eurail.com
Orient Express Hotels, Trains and Cruises:
 www.orient-express.com

VEILS AND HEADPIECES

Bel Aire Bridals: 310-325-8160,
 www.belaireveils.com
David's Bridal: 800-399-BRIDE,
 www.davidsbridal.com

Fenaroli for Regalia: 617-723-3682
Homa Creation: 973-467-5500,
 www.homabridal.com
Reneé Romano: 312-943-0912,
 www.Renee-Romano.com
Winters & Rain: 401-848-0868,
 www.wintersandrain.com

WAREHOUSE STORES
BJ's Wholesale Club: www.bjswholesale.com
Costco: www.costco.com
Sam's Club: www.samsclub.com

WEATHER SERVICE AND SUNSETS
For checking the weather at your ceremony,
reception, or honeymoon sites, including five-day
forecasts and weather bulletins:

AccuWeather: www.accuweather.com
Rain or Shine: Five-day forecasts for anywhere in
 the world, plus ski and boating conditions:
 www.rainorshine.com
Sunset Time: (precise sunset time for any day of
 the year) www.usno.navy.mil
Sunset Time: (precise sunset time for any day of
 the year): www.noaa.gov
Weather Channel: www.weather.com

WEDDING EXPERT ASSOCIATIONS

National Association of Catering Executives:
 410-997-9055, www.nace.net
American Federation of Musicians: 212-869-1330,
 www.afn.org
American Rental Association: 800-334-2177,
 www.ararental.org
American Society of Travel Agents: 703-739-2782,
 www.astanet.com
Better Business Bureau: www.bbb.org
Professional Photographers of America:
 800-786-6277, www.ppa-world.org
Wedding and Portrait Photographers International:
 www.eventphotographers.com
Association of Professional Videographers:
 209-653-8307
American Disc Jockey Association: 301-705-5150,
 www.adja.org

WEDDING ITEMS (TOASTING FLUTES, RING PILLOWS, ETC.)

Affectionately Yours: www.affectionately-yours.com
Beverly Clark Collection: 800-888-6866-3933,
 www.beverlyclark.com
Bridalink Store: www.bridalink.com
Butterfly Celebration: 800-548-3284,
 www.butterflycelebration.com
Chandler's Candle Company: 800-463-7143,
 www.chandlerscandle.com
Keutbah Ketubah: 888-KETUBAH, www.ketubah.com
Magical Beginnings Butterfly Farms:
 888-639-9995, www.butterflyevents.com
 (live butterflies for release)

Michaels: 800-642-4235, www.michaels.com
The Wedding Shopper:
 www.theweddingshopper.com/catalog.htm

WEDDING PLANNING WEBSITES

The Best Man: www.thebestman.com
Bliss Weddings: www.blissweddings.com
Bridal Guide: www.bridalguide.com
Bride's Magazine: www.brides.com
Della Weddings: www.della.com
Elegant Bride: www.elegantbride.com
The Knot: www.theknot.com
Martha Stewart Living: www.marthastewart.com
Modern Bride: www.ModernBride.com
Premiere Bride: www.premierebride.com
Sharon Naylor's Wedding Website:
 www.SharonNaylor.net
Today's Bride: www.todaysbride.com
Town and Country Weddings (upscale):
 www.tncweddings.com
Wedding Bells: www.weddingbells.com
Wedding Central: www.weddingcentral.com
The Wedding Channel:
 www.weddingchannel.com
Wedding Details: www.weddingdetails.com

WEDDING SUPPLIES

Amazon.com: www.amazon.com
Barnes and Noble: 800-242-6657; www.bn.com
Beverly Clark Collection: 800-888-8686,
 www.beverlyclark.com
Borders: www.borders.com

WINE AND CHAMPAGNE

Wine.com: www.wine.com
Wine Searcher: www.wine-searcher.com
Wine Spectator: www.winespectator.com

Your Budget Worksheet

Here is where you'll create your budget, filling in your financial details, who's paying for each element, and—best of all—how well you've "beaten" your initial, estimated budget figures with the great bargains you've found and created for yourselves along the way.

Staying organized with your budget figures helps keep your spending in line, preventing those tempting impulse buys that can drive up your wedding's cost. So keep this worksheet handy and current. It's a part of your winning strategy to get more of your dream wedding for less money.

ITEM/SERVICE	WHO'S PAYING
Engagement announcement	
Newspaper announcement	
Wedding website	
Engagement party	
Ceremony site fee	
Ceremony décor	
Officiant's fee	
Marriage license	
Blood tests	
Pre-wedding counseling/classes	
Reception site fee	
Rentals for reception site	
Preparation of reception site (landscaping, cleaning, etc)	
Additional permits for parking, liquor, etc.	
Wedding gown	
Wedding gown fittings	
Veil and headpiece accessories	
Shoes	
Bride's manicure, pedicure, and hair	
Groom's wardrobe	
Groom's accessories	
Groom's shoes	
Wedding coordinator	
Save the date cards	
Invitations	
Postage	
Programs	
Additional printed items	
Thank-you notes	
Caterer's menu	

BUDGETED	ACTUAL COST

ITEM/SERVICE	WHO'S PAYING
Liquor	
Cake	
Additional desserts	
Flowers	
Candles	
Reception décor	
Reception entertainment	
Photography	
Gift photo albums	
Videography	
Gift videotapes/DVDs	
Throwaway wedding cameras	
Limousines or classic cars	
Other guest transportation	
Lodging	
Babysitting	
Wedding weekend activities #1	
Wedding weekend activities #2	
Wedding weekend activities #3	
Favors	
Gifts	
Toss-its	
Honeymoon	
Tips	
Cash on hand	
Other:	
Other:	
Other:	
Other:	
TOTALS	

BUDGETED	ACTUAL COST

ABOUT THE AUTHOR

Sharon Naylor is the author of twenty-five wedding books, including *Your Special Wedding Vows*, *Your Special Wedding Toasts*, *1000 Best Secrets for Your Perfect Wedding*, *The Complete Outdoor Wedding Planner*, *The Mother of the Bride Book*, *The Groom's Guide*, and *The Ultimate Bridal Shower Idea Book*. She has also written for *Bridal Guide*, *Bride's*, *Self*, *Health*, *Shape*, and *Good Housekeeping*, among many others, and she answers real couples' wedding-planning questions on www.njwedding.com. She has appeared on *Lifetime*, *Inside Edition*, *Fox 5 News*, and in the wedding ideas section of the Bed Bath & Beyond website. She is the founder of the first national book club for brides, which you will find on her website www.sharonnaylor.net. She lives in Madison, New Jersey, and is at work on additional titles in the Sourcebooks wedding series.

If you would like to share your bargain secrets for a perfect wedding (which we may include in future editions of this book) or find out more about the author, visit www.sharonnaylor.net.